WESTERN AMERYKAŃSKI

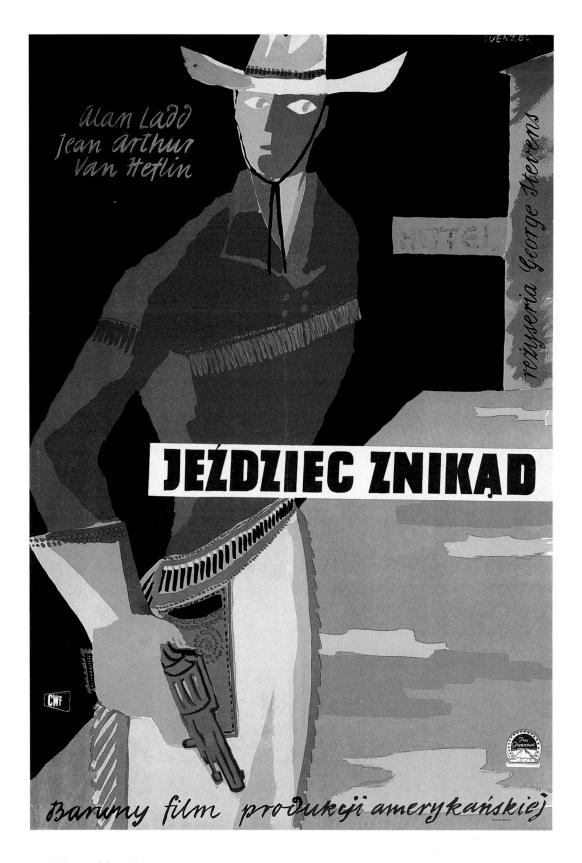

Wojciech Wenzel (b. 1925)

Jeździec znikąd, 1959

Polish poster for the American film

Shane (1953)

Lithograph: 86 × 59 cm

WESTERN AMERYKAŃSKI

POLISH POSTER ART AND THE WESTERN

EDITED BY KEVIN MULROY

AUTRY MUSEUM OF WESTERN HERITAGE *Los Angeles*

IN ASSOCIATION WITH THE

UNIVERSITY OF WASHINGTON PRESS *Seattle & London*

This book is published in conjunction with the exhibition, *Western Amerykański: Polish Poster Art and the Western*, opening at the Autry Museum of Western Heritage in Los Angeles in October 1999.

All illustrations, unless otherwise stated, are from the collection of the Autry Museum of Western Heritage. Photographs of objects from the Autry Museum's collection (with the exception of plate 2) are by Susan Einstein.

Copyright © 1999 by the University of Washington Press
05 04 03 02 01 00 6 5 4 3 2 1
Printed in Hong Kong by Dai Nippon
Designed by Audrey Meyer

Library of Congress Cataloging-in-Publication Data
Western amerykanski : Polish poster art and the Western / edited by
Kevin Mulroy.
p. cm.
Catalog of an exhibition held at the Autry Museum of Western
Heritage, Los Angeles, Calif., Oct. 1999.
Includes bibliographical references and index.
ISBN 0-295-97812-0 (cloth : alk. paper)
ISBN 0-295-97813-9 (paper : alk. paper)
1. Film posters, Polish—Exhibitions. 2. Western films—United
States—Exhibitions. I. Mulroy, Kevin. II. Autry Museum of Western
Heritage.
PN1995.9.P5 W47 1999
741.6′74′09438—dc21 98-52392
 CIP

The paper used in this publication meets the minimum requirements of American National Standard for Information Sciences—Permanence of Paper for Printed Library Materials, ANSI Z39.48-1984.

Cover art. *Front*: based on *Szalony koń*, by Wiktor Górka, 1969. Polish poster for the American film *The Rounders* (1965). *Back*: based on *Kiedy legendy umierają*, by Jerzy Flisak, 1974. Polish poster for the American film *When the Legends Die* (1972). Images modified by permission of the artists.

CONTENTS

PREFACE

"WHY POLAND?" PEOPLE IMMEDIATELY ASK WHEN TOLD OF this book or the exhibition it accompanies. Known more for its World War II experiences, Pope John Paul II, and Lech Wałęsa, Poland does not generally feature prominently in discussions on John Ford or Clint Eastwood. Indeed, until recently, Poland's relationship with America was typically defined in terms of the Cold War. That relationship seemed to represent the epitome of opposites: communism and capitalism; East and West. Polish emigrants who came to the United States usually settled in the eastern states, and most of us know of the strong Polish ties with large industrial cities east of the Mississippi, such as Chicago, Cleveland, Detroit, and New York. Less well known is Poland's long interest in the American West, and its important connection with the Western.

Looking back, *Western Amerykański* really began many, many years ago in England. As a young boy growing up in the industrial north in the late fifties and early sixties, I became an avid fan of television Westerns such as *The Lone Ranger* and *The Range Rider*. But far and away my favorite was the *Adventures of Champion*. How I looked forward to the episodes about young Ricky, his dog Rebel, and his horse Champion, and to Frankie Laine singing the haunting theme song: "The time will come when everyone will know the name of Champion the Wonder Horse. . . ." Ricky lived in wide open spaces in the sun. He didn't have to go to school in the rain, and his Uncle Sandy didn't read news-

papers or watch rugby. They had better things to do. They beat the bad guys.

My relatives remind me that I annually requested toy Winchesters, cowboy hats, sheriffs' badges, and other Western paraphernalia for birthdays and Christmas presents, and that I spent countless hours keeping the Sheffield suburbs free of outlaws. Now, Americans ask in astonishment how somebody from England (with all that history) could become so interested in the American West. It all began with Ricky. Many not from America feel a similar passion for the West. Almost invariably it began with a Western. Ed Buscombe, another British contributor to this book, fondly remembers as a boy reading the *Buffalo Bill Annual* and the thrill of discovering that his grandfather actually saw Buffalo Bill in Cornwall. Prince Charles has admitted that his favorite TV show was *Tales of Wells Fargo*. Reflecting back on seeing the Gene Autry film *South of the Border* in England, Ringo Starr has said, "It's one of those impressions that just blew me away at the time. It just knocked me out and I always remember it. . . . I was eight years old and wanted to be a cowboy. Still do!"

Through its galleries, changing exhibitions, educational programs, and publications, the Autry Museum examines the history of the American West in its widest sense. But in keeping with the career of its founder, it also explores imaginary Wests of all types. It seemed a good match to build at the Autry a research collection focusing on how people outside America have viewed the West. One imperative would be to document responses to that supreme disseminator of the American myth, the Western. Graphic representations, especially posters, offer a particularly fertile resource. While there is a long and respectable tradition of collecting American film posters, their foreign equivalents, with some notable exceptions, are less prized. This meant that a good collection could be built quite affordably, but finding the posters would be logistically challenging.

Western Amerykański really began in earnest when I saw an ad in *Big Reel* for posters offered by Global Cinema, which turned out to be a small operation run from the residence of Grant Underwood, a law student at Texas Tech University in Lubbock. During a trip to Europe, Grant had tried to purchase inexpensive John Wayne posters in the hope of selling them for a profit stateside to support his studies. However, the more European poster artwork he saw, the more he liked it, and the more he bought. His interests and stock grew beyond John Wayne, beyond Westerns, even beyond American film. A true innovator with a great eye, Grant also ventured into the still largely unexplored world of Eastern European poster art.

After some initial telephone conversations, we agreed that Grant would send incrementally to the Autry Museum his entire stock of Western posters on approval. Within a few weeks, the first packages arrived. Suddenly the museum's receiving areas were filled with colorful and dramatic posters from Italy, France, Britain, Germany, Spain, Belgium, the Netherlands, and Scandinavia. Other pieces from more exotic places in Africa, Asia, Australia, South and Central America, and the Caribbean also came. There were old

posters and more recent pieces. They varied widely in quality, but all were fascinating. Each arrival was like Christmas. We hurried to open the packages to see if a favorite country or artist was included in the latest offering.

Before long, it became clear that something extraordinary had taken place in Eastern European poster art after World War II, and particularly in Poland. Posters from Western Europe mostly remained faithful to the plot of the film. With few exceptions, this also can be said for Western film posters from around the world. They tended to be more dramatic than their American counterparts—Indians were always more bloodthirsty in England, France, and Italy—but they remained advertising vehicles for the films they illustrated. Film posters were not separate and independent works of art in their own right, and they contained no additional messages or hidden agendas. But when the Western traveled beyond the Iron Curtain, clearly all bets were off. Out of the packages spilled Polish posters showing cowboys mutilated, at the gates of hell, or crawling headfirst down giant gun barrels.

Western Amerykański dates most directly from the day I first saw the startling and powerful Polish poster for George Stevens's beloved 1953 movie *Shane*. I remembered the film from my youth, and especially the relationship that grew between Brandon de Wilde and Alan Ladd. Who could forget the boy's poignant plea, "Shane, come back," at the end of the movie? But nobody would want the gunfighter pictured in Wojciech Wenzel's poster *Jeździec znikąd* (see frontispiece) to come back. Shane is seen here as a paranoid psychotic killer, colored ashen gray, looking anxiously over his shoulder and fingering his revolver nervously. Created in 1959, Wenzel's work portrays Shane as the archetypal Cold Warrior of the McCarthy era, seeking on the one hand to survive and on the other to rule in a world gone mad.

Not only is the Polish poster for *Shane* beautifully executed as a work of graphic art, but it also presents a fascinating and important Eastern European perspective on America's national epic. As more Polish posters arrived at the museum, it became clear that this body of work demanded attention and further investigation, through exhibition and publication. The film poster became an outlet for the repressed artist in Poland. Ostensibly merely advertising a Western, the artist was able to include in the poster statements about America, Poland, individual experience, and universal values. The poster provided only a small space, but, like fireworks, creativity exploded within its confines. Jan Lenica has compared the Polish poster to a Trojan horse, with the artist smuggling messages onto the streets in the guise of ephemera. It provided an outlet for the artist and for the viewer.

Working with other specialist dealers and collectors, the Autry Museum has continued to build its collection of Western posters designed outside the United States. Its holdings now consist of several hundred pieces, including some 115 created in Poland. The Polish Western film poster collection, now the largest outside Poland, is the basis for *Western Amerykański*. Though the museum's film posters include many other striking

examples from around the world, the Polish works represent the cream of the collection. They say a picture is worth a thousand words. That would be a conservative estimate if one were trying to describe these beautiful and complex images. It is difficult to respond succinctly when asked "Why Poland?" But spend some time with the posters, and the answer will come quickly and easily.

KEVIN MULROY
Los Angeles, November 1998

WESTERN AMERYKAŃSKI

THE WESTERN WORLDWIDE

Edward Buscombe

Kevin Mulroy

L ONDON, EASTER MONDAY, 1887: A FAMILY PREPARES TO JOIN THE throngs flocking to see Buffalo Bill's Wild West show at Earl's Court. They have heard that the Queen will be there. *Sydney 1891*: The *Herald* complains about the effect the Doc Carver Wild West show is having on local children. *Christmas 1893*: A boy in Munich receives a copy of Karl May's latest Western epic, *Winnetou*. *Dublin 1939*: Gene Autry is mobbed by record crowds of fans during a street parade. *Summer 1960*: A boy in Rio de Janeiro receives his *Aventuras de Monte Hale* comic book through the mail. *Warsaw, 1989*: Solidarity sweeps to power behind a campaign poster of Gary Cooper in *High Noon*. The image helps change the face of Eastern Europe. *Udine, Italy, April 1997*: scholars, fans, filmmakers, and celebrities gather for a week-long festival of Westerns produced in Europe. *And in 1998*: in Senohraby, Czechs dressed as Pony Express riders deliver the local mail on horseback; huge crowds of Parisians turn out to see a reenactment of Buffalo Bill's Wild West show at Euro-Disney; and a student in Los Angeles finds information on country and western dancing at a Finnish Web site. What in the world . . . ?

People everywhere, it seems, have been captivated by stories of the American West. Not only that, they can picture themselves in those stories. From the earliest dime novels to the most recent movies, Westerns have addressed universal issues (right versus wrong, good versus evil) and values (human dignity, and the power of the individual to make a difference). These have been mixed with adventure and entertainment in large doses. Action heroes with wonder horses and comic sidekicks typically have battled cadres of evil bad guys in epic conflicts, all played out against a majestic landscape. Westerns tell morality tales, triumphal narratives typically related from the perspective of the victor. The

package has proven irresistible to audiences all over the world, but particularly to young boys, and men young at heart. On the one hand, by reading or watching a Western, people everywhere could escape from the dreariness of their daily lives, yet at the same time Westerns have handed out lessons, and affirmed a universal code of ethics. Everyone could relate to the hero in the white hat. As a result, stylish and expert Western showmen have captured the hearts and souls of audiences worldwide.

So universal are the ideas contained in the Western that other countries have appropriated its imagery and symbols. Monument Valley has been used to sell European cars, and many other products not made in the United States. Western music and fashion, meanwhile, continue to be massively popular worldwide. Even the genre itself could be borrowed by others to make statements of various types. Westerns made outside of the United States have appealed to their audiences by including notions or issues familiar to them. Thus Spaghetti Westerns not only include Europeans in starring roles but also contain some very Italian ideas. A film such as the French *Touche pas la femme blanche!* (*Don't Touch White Women!* 1974), meanwhile, could use American Indian genocide to comment on French neocolonial intervention in Indochina (plate 1). The Western genre has been malleable enough to accommodate the requirements of a host of filmmakers and product advertisers throughout Europe and elsewhere.

Worldwide interest in creative representations of the American West has a long history. In fact, the first commercial exhibitions of the West—its peoples, artifacts, and scenery—began to appear in England as early as the 1840s, when George Catlin, who had traveled west of the Mississippi to paint scenes of Indian life, took his collection of canvases and artifacts to London. Catlin's exhibition marked the beginning of a close relationship between Britain and the mythical West. He managed to attract no less than 32,500 visitors to his "Indian Gallery" within the first year, among them the Duke of Wellington. By 1843 Catlin was exhibiting at Lord's cricket ground, and the paintings were augmented by a group of fourteen Iowa Indians, originally brought to London by the showman Phineas T. Barnum. In 1845 Catlin moved on to Paris, where he was granted an audience with King Louis-Philippe. His collection was displayed in the Louvre and attracted the attention of Charles Baudelaire, George Sand, and Eugène Delacroix before returning to London (plate 2).[1]

Not everyone was impressed with Catlin's Indians. Writing in retrospect, Charles Dickens was brutally dismissive:

Mr. Catlin was an energetic earnest man, who had lived among more tribes of Indians than I need reckon up here, and who had written a picturesque and glowing book about them. With his party of Indians squatting and spitting on the table before him, or dancing their miserable jigs after their own dreary manner, he called, in all good faith, upon his civilised audience to take notice of their symmetry and grace, their perfect limbs, and the exquisite expression of their pantomime; and his civilised audience, in all good faith, complied and admired. Whereas,

1. *Touche pas la femme blanche!*

(*Don't Touch White Women!* 1974)

French poster for the French film starring

Marcello Mastroianni as Custer

as mere animals, they were wretched creatures, very low in the scale and very poorly formed; and as men and women possessing any power of truthful dramatic expression by means of action, they were no better than the chorus at an Italian Opera in England.[2]

Dickens surely would have been more enthusiastic about a later visitor, had he survived to see the great Western showman William F. "Buffalo Bill" Cody, whose first trip to Europe took place in 1887. It would be hard to overestimate the influence that Cody's successive visits had on European perceptions of the West. His first season at Earl's Court in London attracted huge crowds. On Easter Monday, it was reported, 83,000 people passed through the turnstiles.[3] The show even drew the aging Queen Victoria out of her self-imposed seclusion following the death of Prince Albert. In her diary she wrote:

All the different people, wild, painted Red Indians from America, on their wild bare backed horses, of different tribes—cow boys, Mexicans, etc., all came tearing round at full speed, shrieking & screaming, which had the weirdest effect. An attack on a coach & on a ranch, with an immense amount of firing, was most exciting, so was the buffalo hunt, & the bucking ponies, that were almost impossible to sit. The cow boys are fine looking people, but the painted Indians, with their feathers & wild dress (very little of it) were rather alarming looking, & they have cruel faces.[4]

On June 20, another performance for Queen Victoria saw the kings of Belgium, Denmark, Greece, and Saxony, together with the Prince of Wales, all aboard the Deadwood Stage in the arena. Cody's company then traveled to Birmingham, Manchester, and Hull. By May 1889 they were in Paris, then on to Spain, and by 1890 they had begun a tour of Italy, taking in Naples, Rome, Florence, Bologna, Milan, Venice, and Verona (plate 3). Then it was back to Britain by way of Germany, including visits to Munich, Berlin, Dresden, Leipzig, Frankfurt, and Stuttgart. Annie Oakley wrote that on this tour they were closely observed by officers of the German army, who found the logistics of Cody's operation a valuable lesson in the movement of men and materials:

We never moved without at least forty officers of the Prussian guard standing all about with notebooks, taking down every detail of the performance. They made minute notes on how we pitched camp—the exact number of men needed, every man's position, how long it took, how we boarded the trains and packed the horses and broke camp; every rope and bundle and kit was inspected and mapped.[5]

While the show was appearing at Earl's Court again, in May 1892, it was observed by Frederic Remington, the foremost Western artist of his day, who recorded the deep impression that had been made on the British:

The Tower, the Parliament, and Westminster are older institutions in London than Buffalo Bill's show, but when the New Zealander sits on the London Bridge and looks over his ancient

2. (*upper left*) This 1848 broadsheet, a precursor of color posters used later to promote Wild West shows, melodramas, rodeos, and Westerns, advertises the exhibition of Catlin's Indian Collection in London. The collection, which had just returned from the Louvre in Paris, included "Several thousand Indian curiosities brought from the prairies and Rocky Mountains of the 'Far West' of America." Photograph by Howard Levine

3. (*bottom*) A master of the photo opportunity, Buffalo Bill had this publicity shot taken on the Grand Canal in Venice in 1890. Bill is seated in the nearest gondola. In front of him are Rocky Bear and Black Heart, who performed in the show.

4. (*upper right*) Doc Carver's saddle, displaying coins from around the world. A feature act during the Wild America show's overseas tours had Carver shooting holes through coins tossed by royalty or other dignitaries. Gift of Mr. and Mrs. Howell H. Howard. Photograph by Tessa Jenkins. Courtesy Buffalo Bill Historical Center, Cody, Wyoming

CATLIN'S NORTH AMERICAN
Indian Collection
AND
MODEL OF THE FALLS OF NIAGARA,

Which have just returned from the Louvre in Paris, are
now being Exhibited, for a very short time, at

No. 6, WATERLOO PLACE, PALL MALL.

The INDIAN COLLECTION, the result of eight years spent by
Mr. CATLIN amongst forty-eight of the Wildest Tribes in America,
contains

SIX HUNDRED PAINTINGS,
AND SEVERAL THOUSAND
INDIAN CURIOSITIES,
Brought from the PRAIRIES and ROCY MOUNTAINS of
the "FAR WEST" of America.

THE MODEL OF NIAGARA, the labour of one
year, which was made from actual Survey, on a perfect scale of pro-
portion, with every House, Bridge, and other objects in due elevation
and colour, has been examined and approved by

Her Majesty the Queen and Prince Albert.

Open Daily, from Nine till Six.
ADMISSION ONE SHILLING,
CHILDREN, HALF-PRICE.

PROMENADE LECTURE
On THURSDAY and FRIDAY EVENINGS,
From 8 till 10 o'clock (the Rooms being brilliantly Illuminated),

On which occasion Mr. CATLIN, its proprietor and author, conducts
his Audience around the Rooms, fully explaining the *Model of
Niagara* in all its leading features, and also the various Paintings
and Indian Curiosities on the walls; whilst he describes the *Num-
bers, Condition, Character, Costumes, Religious Ceremonies,
Games and Amusements, &c.* of these interesting people.

ADMISSION, THE SAME AS BY DAY.

Printed by W. J. GOLBOURN, 6, Princes Street, Leicester Square.

1848

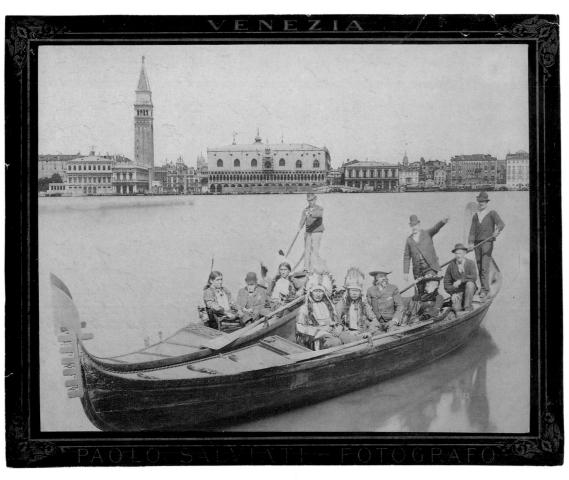

manuscripts of Murray's Guide-book, he is going to turn first to the Wild West. At present everyone knows where it is, from the gentleman on Piccadilly to the dirtiest coster in the remotest slum of Whitechapel. The cabman may have to scratch his head to recall places where the traveller desires to go, but when the "Wild West" is asked for he gathers his reins and uncoils his whip without ceremony. One should no longer ride the deserts of Texas or the rugged uplands of Wyoming to see the Indians and the pioneers, but should go to London.[6]

Cody toured England yet again in 1902, and over the next two years the show visited major provincial cities and a number of smaller venues throughout the country. During 1905 and 1906, Buffalo Bill performed in many other countries in both Western and Eastern Europe.

Nor was Buffalo Bill the only Western showman touring Europe at this time. Gordon W. "Pawnee Bill" Lillie toured Belgium in 1894, and Doc Carver, a noted marksman, traveled extensively in England, France, Belgium, Germany, and Austria between 1879 and 1882, demonstrating his shooting skills. In 1889 Carver returned to Europe. While in Hamburg he crossed paths with Buffalo Bill. The fierce competition between the two shows led to an anxious report in the *San Francisco Examiner* of August 28, 1890:

Hamburg is filled with a howling mob of Indians and cowboys who are awaiting the chance to scalp each other. The town is crowded with the posters of both parties. As soon as Cody's bills are posted, Carver's assistants come along and tear them down and put up their own. The bad blood between Cody and Carver has also aroused such a jealous feeling among their Indian and cowboy followers that serious trouble is expected any moment.[7]

By 1891 Carver had traveled as far as Australia, with a show that included Sioux Indians and Mexican ropers (plate 4). Its success led the *Sydney Herald* to comment:

Dr Carver's Wild West show appears to have aroused in the hearts of Sydney youngsters a desire to emulate the deeds of cowboys, and become proficient in lassoing. . . . Ladies complain that they confiscate clotheslines for lassos and then proceed to hunt tame goats in various neighborhoods. . . . The worst part of it is that they lasso and attempt to string up small children. . . . This will have to be stopped.[8]

Buffalo Bill's imitator, Samuel Franklin Cody, toured England with his family in the 1890s, giving trick shooting performances in provincial music halls, and acting in a series of Western melodramas with titles such as *The Klondyke Nugget*, *Nevada*, and *Calamity Jane* (plate 5). In France in 1892, he challenged the French cycling champion to a three-day race between bicycle and horse, which Cody narrowly won. The following year, he contested two men on a tandem and even a team of three men on a bicycle in epic spectacles in French *vélodromes* (plate 6). S. F. Cody engaged in similar racing competitions in Germany, Italy, and England until the late 1890s.[9]

The Miller Brothers' 101 Ranch Wild West Show played in Mexico City in December 1908. In 1909, several members of the 101 Ranch joined the IXL Ranch Wild West Show

5. Samuel F. Cody tried to appeal to a broad international audience, as can be seen in this English poster from around 1900. Cody's Western melodrama *The Klondyke Nugget* quickly spread word of the Alaska gold rush to such provincial venues as Neath, South Wales.

6. This French poster announces a challenge race between Wild West showman Samuel F. Cody and champion tandem cyclists in Paris in November 1893.

for a winter tour of South America, the first performance taking place in Buenos Aires on December 18. During the winter of 1913–14, the 101 Ranch toured South America, playing Buenos Aires, Montevideo, and Rio de Janeiro. In 1914, the British invited the 101 to London to help celebrate the Century of Peace between English-speaking nations by taking part in the Anglo-American Exposition at Shepherd's Bush. One of the highlights of the tour came when African American cowboy Bill Pickett successfully bulldogged a wild Scottish Highland steer before a full house. The show played to record crowds and distinguished guests, including King George V and Queen Mary of England, and Empress Alexandra and Dowager Empress Marie of Russia.[10]

Following the success of these live shows, rodeo also was exported, reaching Europe in the 1920s. Rodeo star Tex Austin took a rodeo company to London in 1924, and the sport enjoyed considerable success in Australia, beginning in the 1930s.[11] Following the lead of Buffalo Bill, celebrity showmen typically headed these international extravaganzas. Singing cowboy star Tex Ritter appeared in an indoor Western show at the London Herringay Arena in 1952. His wife, Dorothy Fay Ritter, recalled:

It was somewhat like our American Rodeos but without certain events—such as calf roping, bulldogging, or anything that might be construed by the English to be harmful to the animals. They did have trick riders and ropers as well as Osage Indians displaying colorful wardrobes while performing tribal dances. There was a large brass band playing while chuck wagons raced around the arena, after which Tex appeared on White Flash, featuring some trick riding in addition to his songs. During six weeks of this event they played to standing room only.[12]

Gene Autry took his rodeo to Cuba in March 1958, at the time Che Guevara and Fidel Castro were trying to overthrow the Batista dictatorship. Threatened with kidnapping and violence, the cowboy star was escorted to the arena by armed guards. Autry later commented, "I played in a New Hampshire blizzard and a Florida hurricane and an Oklahoma dust storm. And once, just that once, in the middle of a revolution."[13]

Many of the Wild West shows had married typical Western acts with exotic spectacles from across the globe. In addition to U.S. cavalrymen, cowboys and cowgirls, and American Indians, Buffalo Bill's show came to include German and English soldiers, Argentinean gauchos, Mexican charros, and Russian Cossacks. From 1893 on, "Congress of Rough Riders of the World" was attached to the show's title. The 101 Ranch show came to include the "Real Wild West & Great Far East" (plate 7). Pawnee Bill's spectacle became known as the "Historic Wild West and Great Far East Show." It included Hindu magicians, Singhalese dancers, Madagascar oxen cavalry, Australian aborigines with boomerangs, Zulus, Japanese cavalry, Cossacks, gauchos, and Zouave horsemen from North Africa.[14]

The Victorian era was a great age of travel; intrepid explorers from Europe and America set out across the uncharted regions of the globe in search of exotic plants, animals, landscapes, and peoples. They returned with their trophies, which were displayed in

7. Program for the Miller Brothers' 101 Ranch Real Wild West
& Great Far East, about 1925. Horsemen from around the world
appear alongside American cowboys, cowgirls, and Indians.

the frequent great expositions, at public lectures, in the huge new museums being erected, and in the illustrated magazines of the period. The American West was only one such object of public fascination, alongside Africa, the Orient, and South America. Yet by the beginning of the twentieth century, its popular appeal outweighed all other geographical spectacles.

Why did the West achieve such preeminence around the world? One should never underestimate the exuberance and panache of American showmanship. Never had a place been sold abroad so well. The Wild West shows incorporated sophisticated public relations machines, offering press releases, interviews with celebrities, and accompanying photographs. They widely disseminated a plethora of promotional imagery, including posters, handbills, programs, and other colorful ephemera. And the creation of ancillary products to cash in on the popularity of a spectacle is not the invention of contemporary Hollywood. The Wild West shows found that selling such merchandise brought additional profit and spread the word ever further. This entrepreneurial flair, inherited later by the American cinema, was already manifest in the promotion of live entertainment, magazines, and cheap fiction. For mass spectacle, Africa, South America, and the East could not compete: they had no Buffalo Bill.

But achieving the success the American West gained abroad required a strong basic appeal. Without question, it represented the great American creation myth: an epic tale of frontier pioneering that people everywhere could understand and appreciate. The West, a faraway place peopled by romantic heroes pursuing dramatic quests, seemed to offer unlimited opportunity for adventure, and captured the imagination of nineteenth-century Europe. Accounts emphasized its vast open spaces, untamed animals, and even wilder human inhabitants. In the eighteenth century, wilderness regions had been looked on with distaste, even fear. But at the beginning of the nineteenth century, an aesthetic appreciation of open country free of the traces of human habitation became the dominant view of nature.

Hence, the English Lake District, with its mountains and remote bodies of water, appealed strongly to Wordsworth and his fellow Romantic poets. The rugged Yorkshire moors, meanwhile, became the setting for great works of fiction by the Brontës. Yet it is significant that Heathcliff, the very symbol of the primeval forces of nature in Emily Brontë's *Wuthering Heights*, left England and found success in the United States. Compared to Europe, America was a far larger and more open country, in every way. Even the remotest regions of Europe were not beyond the bounds of civilization. There was no frontier in the American sense, and most of the landscape of Western Europe had long since been domesticated. England, even more densely populated than most of Europe, by mid-nineteenth century already had become predominantly urban. Europe had nothing to compare with the vast uncharted wilderness of North America and the unfettered inhabitants who roamed its empty spaces. This notion still remains strong. Advertisers

seeking to sell products in European markets frequently will draw upon nostalgia for the majesty of a bygone American West.

During the Victorian Age, Europe was becoming a more regulated society. Social controls of all kinds were increasing with the rise of the factory system, mass education, military conscription, and other bureaucracies. America, and especially the West, offered an escape from order and regimentation. This had a powerful appeal, particularly to children, and above all to young boys. In *Peter Pan* (1904) the Scottish author J. M. Barrie captured this when he introduced a band of wild Indians. By contrast, other areas of the world, though savage or exotic, did not appeal so directly to children. The Orient had a powerful attraction for Victorians, but in part because it was tinged with the odor of forbidden sexuality, stirred by a prurient fascination with the harem and polygamy. The American West, by contrast, seemed relatively innocent of sexuality and therefore suitable for youthful minds.

But it was not a matter entirely of its appeal to children. Much of the vast outpouring of literature about America during the nineteenth century made a point of the political freedom of American society, of its liberation from the class inequalities of a still largely feudal Europe. More than two hundred travelers' accounts of America had already been published in England by the time of the American Civil War.[15] Many of these were intended to stimulate emigration to a land where status and money did not confer privilege, and crucially, where there was a seemingly endless supply of free land for all to the west. Foremost among European commentators on the political virtues of America was the French nobleman Alexis de Tocqueville, whose *Democracy in America* first appeared in English translation in 1835. Tocqueville believed that the openness of the frontier would preserve America from the tyranny of the majority that democracy might otherwise engender. A host of other European visitors during the nineteenth century attested to the lack of a rigid class structure in America and to its relative economic and social equality. Many of the guide books published in Europe in the mid-nineteenth century were unscrupulous attempts by land speculators to woo the unwary into a rosy view of their prospects in the new land. But much that was published was of genuine value, reflecting the hunger in Europe for knowledge of a country that offered real opportunities to the poor and oppressed of the Old World.

Despite the outpourings of travelers and commentators, it was fiction that most stirred the imagination. Even before Buffalo Bill's foreign tours, stories about the frontier had flooded Europe. James Fenimore Cooper was enormously popular. *The Pioneers*, the first of his Leatherstocking Tales, was published in England and France in 1823. Within five years it had appeared in German, Swedish, Spanish, and Danish. Thirty-two of Cooper's works had appeared in Russia by the Revolution of 1917, and he was even translated into Turkish, Persian, and Arabic. Other American authors of the period profited from the vogue for the frontier which Cooper had helped create. Robert Montgomery Bird's lurid

Nick of the Woods, for instance, was published in nine separate editions in England, and was translated into German, Danish, Dutch, and Polish.[16]

American Indians had a special fascination for Europeans, and were a major reason for Cooper's popularity. In *Les Mohicans*, a dramatized version of his most famous novel, *The Last of the Mohicans*, performed at the Paris Opera in 1837, the Indians far outnumbered the white characters. Written and visual accounts of Indians had been appearing since the sixteenth century, but interest heightened toward the end of the eighteenth, as Romanticism took hold in the European imagination. Influenced especially by the ideas of the French philosopher Jean-Jacques Rousseau, the concept of the noble savage emerged. According to Rousseau, the American Indian lived free from the corruptions of civilization, in an ideal form of society from which "all subsequent advances have been so many steps, in appearance towards the perfection of the individual, in reality towards the decrepitude of the species."[17]

As the nineteenth century dawned, and the fate of the Indian began to unravel, his "nobility" took on an ever more tragic tone. The "melancholy" Indian was the theme of *Atala*, a widely influential book published in 1801 by the French author François-René, vicomte de Chateaubriand. This is the story of Chactas, a warrior of the Natchez tribe, who is rescued from torture by Atala, a beautiful half-Indian girl. After many adventures, Atala poisons herself rather than betray the vow of virginity she had made to her dying mother. This tragic end seemed emblematic of the doom that was apparently facing the Indian; and dozens of European artists, including Gustave Doré and Eugène Delacroix, rushed to illustrate the touching scene of Atala's death.[18]

For writers and artists, the American Indian offered plentiful opportunities for speculating on the nature of civilization, at a time when revolutionary movements were intensely interested in such questions as the perfectibility of human society. As the century wore on and many of those movements failed to achieve emancipation for oppressed peoples, some began to perceive an analogy between the fate of American Indians, driven from their lands, and that of nations such as Poland and Hungary that had failed to gain liberation from foreign domination. The Polish writer Ludwik Powidaj published an article, "Poles and Indians," after Poland's abortive revolt of 1863, in which he foresaw his fellow countrymen sharing the fate of the displaced and doomed Native American.[19]

For people at large, Indians were less an occasion for philosophical speculation, and more a source of excitement. Not only were they visually exotic but their presumed savagery also provided vicarious thrills in plenty. Few accounts of life among the American Indians failed to include hair-raising episodes of torture and other barbaric practices. In 1858 the staid and respectable *Illustrated London News* ran a series of articles on Indian life, documenting the visit of Pawnees and Poncas to President James Buchanan, and illustrating typical costumes of various tribes. But the documentary impulse was spiced by the lurid appeal of the captivity narrative, already established as a staple of frontier fiction. One striking woodcut in the March 20 issue shows Comanche warriors aboard a raft with

a captured white woman: a fate worse than death clearly threatens. Captivity art, narratives, and pulp fiction fed into melodrama, which became central to early film. In time, such stories became a popular subgenre of Western movies and television, and the theme's drama has continued to appeal to audiences worldwide.

Frontier and Indian melodramas became a mainstay of the American stage during the nineteenth century, and many of these plays traveled to Europe. One of the most popular was Frank Murdoch's *Davy Crockett; or, Be Sure You're Right, Then Go Ahead* (1872), performed in Liverpool in 1879. Joaquin Miller's California play, *The Daneites in the Sierras* (1877), was highly successful in England, as was *Across the Continent; or, Scenes from New York Life and the Pacific Railroad* (1870), by James J. McCloskey. The play contained exciting scenes of an Indian attack on a railroad station and a telegraphed message for help, which arrives at the last moment. It played the Royal Alfred Theatre in London in 1871, and again in 1875, 1876, and 1882. Another popular frontier play was William Vaughn Moody's *The Great Divide* (1909), set in Arizona. It opened at the Adelphi Theatre, London, that year and in 1913 played at the Théâtre des Arts in Paris. Edwin Milton Royle's play *The Squaw Man*, which had opened in New York in 1905 and was filmed no less than three times by Cecil B. DeMille, played London, under the title *The White Man*, in 1908.[20]

David Belasco's *The Girl of the Golden West* (1905) is perhaps the most spectacular example of how drama was spreading abroad an image of the American West. The Italian composer Giacomo Puccini had been captivated by Buffalo Bill's Wild West when he saw the show in Milan during the 1890 tour. In 1907, Puccini attended Belasco's play on Broadway and three years later premiered his operatic version, *La Fanciulla del West*, at New York's Metropolitan Opera House, with Caruso playing the lead and Toscanini conducting. Immediately afterward, the production traveled to Milan and London (plate 8).[21]

American authors soon found they had European imitators. The Scottish adventurer Sir William George Drummond Stewart wrote two fictional works, *Altowan* (1846) and *Edward Warren* (1854), loosely based on his extensive travels in the American West and Pacific Northwest during the 1830s and early 1840s.[22] Captain Mayne Reid, an Anglo-Irishman, turned his experience of America, gained while fighting in the U.S.–Mexican War of 1846–48, into no less than fifty novels about the West. One of the most successful of Reid's works was *The Scalp Hunters; or, Romantic Adventures in Northern Mexico* (1851), which had sold over a million copies by the end of the century. English novelists with more literary pretensions, such as George A. Henty, better known for his tales of empire written for Victorian boys, also produced a number of Western tales such as *In the Heart of the Rockies* (1895).[23]

In Germany, Charles Sealsfield, a monk whose real name was Karl Postl, wrote a series of popular novels, beginning with *Tokeah; or, The White Rose* (1829), which has a theme of Indian decline not unlike *The Last of the Mohicans*. Friedrich Armand Strubberg produced sixty Western novels in the middle of the century. The German novelists Friedrich Gerstacker and Balduin Möllhausen (known as the German Cooper) had both

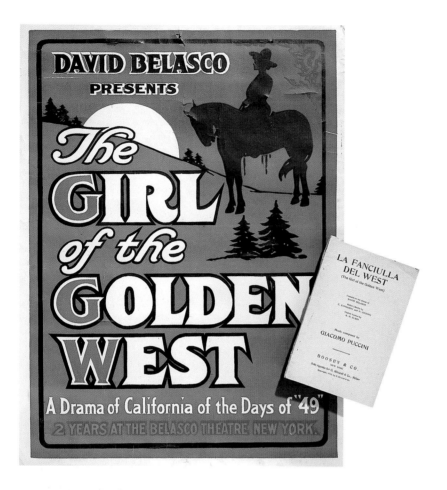

8. American poster for David Belasco's Western melodrama *The Girl of the Golden West*, about 1908, and the libretto in English and Italian for Puccini's operatic version, *La Fanciulla del West*, 1910

9. These three European "dime novels" show their illustrators' reference points and use of creative license. The cover portrait of the abridged and sensational 1882 English Yellowback edition of Bret Harte's classic of the California gold rush, *The Luck of Roaring Camp* (center), shows Mliss looking like a Molly Malone. *Bell the Wolf, or the Backwoodsman's Triumph, and Other Tales* (left), a Scottish piece from about 1885, shows heavily forested James Fenimore Cooper landscapes rather than the Washita Mountains of western Indian Territory (now Oklahoma) in which it is set. *Negertrouw en Negerwraak* (right), a Dutch work from around 1890, is set in Texas but features African Americans resembling Surinam maroons.

traveled in the United States before producing their novels of lurid adventure in the Far West. Möllhausen's *Der Halbindianer* (*The Half-Breed*), published in 1861, is full of authentic Western lore, much of it gleaned from the author's journeys in the Rocky Mountains.[24]

The French author Gustave Aimard had spent almost a decade in the American Southwest. His novel *Les trappeurs de l'Arkansas* appeared in 1858 and was subsequently translated and published in London. Aimard produced in all some eighty such works, many featuring his hero Valentine Guillois, a nonchalant Parisian who wanders the West fighting Indians, alligators, and cougars.[25]

The British equivalent of dime novels began to appear in England in 1861, when Edward Ellis's *Seth Jones* was published in London. A further sixty titles were published in the next five years, precursors of the Buffalo Bill stories that poured from the British presses after 1887, when Cody first visited London. Soon, German publishers followed suit with such titles as *Buffalo Bill die Sioux-schlacht am Grabstein*.[26] By the late nineteenth and early twentieth century, European-produced pulp Western fiction had become a popular read for a large and widespread audience (plate 9).

Of the European writers who drew for inspiration on the American West, none was more influential than the German Karl May (figure 1). During several years spent in prison on various charges of fraud, May began writing the series of novels that made him famous. Foremost among these is the trilogy of works he published between 1893 and 1910. Their heroes are Old Shatterhand, a blond German adventurer who gets his nickname from his boxing ability, and Winnetou, an Apache chief. The two become blood brothers, in a relationship owing much to Cooper's pairing of Natty Bumppo and Chingachgook. Together they roam the West, defeating villainous Yankees and malevolent half-breeds. May's West is thoroughly Germanic, full of hearty frontiersmen singing German songs, and Indians accustomed to pronounce "Ich habe gesprochen." The author became carried away with his fantasies to the point where he claimed his work was based on his own experiences, but not until the end of his life, after this deception and his earlier criminal career were exposed, did May travel to America, and then no further west than Buffalo, New York.[27]

Fig. 1. Karl May (1842–1912)
Courtesy German Information Center

It would be difficult to overestimate May's influence on popular perceptions of the American West. Figures as notable as Albert Einstein, Albert Schweitzer, and Adolf Hitler were avid readers. More than seventy million copies of May's works have been sold in Germany, and his books have been translated into many other languages.[28] Every year there are Karl May festivals in Germany and Austria, featuring dramatic performances of his novels and other spectacles. In 1998, the Karl May festival of Radebeul, near where May had his villa, planned a series of events, previewed on its official World Wide Web site:

This largest and most popular of all Karl May events, which has attracted over 40,000 spectators on past occasions and continues over two days, will once again embark on a journey into the wonderfully diverse culture described by the great writer. . . . The organizers make every effort to ensure authenticity. The spirit of Karl May's stories will be brought to life for two days in Loessnitzgrund, and thus tolerance, understanding and respect for foreign cultures will be stimulated.[29]

The mass of Western fiction published in Europe has continued unabated throughout the twentieth century. Beginning in the 1920s, George Fronval, a Frenchman, was credited with an amazing six hundred books, fifty-four of them pulp novels about Buffalo Bill. In Spain, Zane Grey proved hugely popular in the 1930s and 1940s, with forty-nine titles in print by 1953. And, since the 1950s, Spanish authors have produced a prodigious amount of Western pulp fiction, frequently using pseudonyms such as Joe Bennett and Leo Mason, and for the most part published by two specialist firms, Bruguera and Toray. It has been claimed that one author, Lafuente, produced as many as ninety-four titles in a single year, 1958. The Norwegian Kjell Hallbing, who uses the pen name Louis Masterson, has sold almost twenty million copies of his books about Morgan Kane, a Leatherstocking type of hero who also has become popular in English translations.[30]

In Germany, the popularity of Western fiction continued undiminished. In 1964, German libraries had no less than 626,000 Western volumes in circulation. In England one paperback publisher estimated in 1975 that it had sold more than three million Westerns a year for the past five years.[31] Although many of these were written by Americans, British authors were making their mark. Among the best known is J. T. Edson, a former fish and chip shop owner and postman from Leicester, who since 1961 has published 136 Western novels totaling over 25 million sales. Unlike most, he does not use a pseudonym. Other British authors of Westerns include Terry Harknett, who writes under the pen name George G. Gilman, and whose novels include more than forty titles in the Edge series, and Henry Keevill, whose many aliases include Clay Allison, Virgil Earp, and Wes Harding. Peter Christopher Watts, writing as Matt Chisholm, was another prolific British writer, penning the successful McAllister series published in the 1970s and early 1980s. Even more productive was David Bingley, writing as Christopher Wigan and a score of other pen names from the late 1950s onward. More recently, John B. Harvey has had considerable success with his Herne the Hunter series (written under the name John J.

McLaglen).[32] Female writers are conspicuously absent from this roll call, but as proof of the adaptability of the Western genre, a recent addition to Black Lace, a British soft pornographic fiction series published for women, is *Western Star* by Roxanne Carr, which sets its story in 1851 among a group of pioneers heading for Oregon.

Europeans and South Americans have been prolific producers and consumers of comic books on Western themes. As early as 1913, *Pluck*, a weekly for British boys, ran a story titled *Blood Will Tell*, a version of a Universal film about Buffalo Bill. In 1933 came the first British cartoon strip, a Buck Jones adventure called "Rogues of the Rockies," which appeared in *Film Fun*. Most of the other strips also chose movie cowboys as their heroes, and by the end of the 1930s Randolph Scott, Ken Maynard, Tim McCoy, and Gary Cooper had made an appearance in one British comic or another. After World War II, *Film Fun* continued to feature Westerns, producing cartoon versions of such movie successes as *Yellow Sky*, with Gregory Peck, and *Law and Order*, with Ronald Reagan. Other B-Western cowboy heroes, such as Gene Autry, Roy Rogers, and Monte Hale, appeared regularly in adventure comics printed in Mexico, Argentina, and Brazil (plate 10).[33]

One of the most successful British illustrators in the postwar period was Denis McLoughlin, who worked on a number of the Buffalo Bill comic books issued by the T. V. Boardman company of London. These were developed into the *Buffalo Bill Annual*, published every year from 1949 until 1961. These handsome volumes contain full-color plates by McLoughlin, as well as comic strip narratives he illustrated. The 1955 *Annual* includes, besides text-only fiction stories, nine picture strips, some in color, on topics like Indian sign language, great Indian leaders such as Geronimo and Crazy Horse, and General Custer. Aimed at children and distributed mainly through Woolworth department stores, the *Annuals* were selling a quarter of a million copies a year at their height.

Buffalo Bill has also appeared in several French comic books (or *bandes dessinées*), such as the first edition of the magazine *Tarzan* in 1946. Other real life characters in French comics have included Davy Crockett, who was featured in the Communist Party magazine *Vaillant* between 1957 and 1969. Like the Catholic Church in France, the Communist Party regarded itself as having a mission to save French youth from the influence of American pulp fiction. That is why it produced its own magazine, in which it portrayed Crockett as antiracist, fighting on the side of the Indians. In the early 1960s, the *cinéroman* gained popularity in France and other French-speaking countries. These film photo novels included a number of Western titles (plate 11).

Since 1968, most French comics have been produced primarily for adults and have accordingly become more sophisticated in their politics and humor. Probably the best-known French Western strip is *Lucky Luke*, created by Morris (real name Maurice de Bevere). Beginning in 1946, *Lucky Luke* was featured regularly in the magazine *Spirou*, and from 1968 in *Pilote*. By 1960 *Spirou* was selling 150,000 copies per week in France and another 85,000 in Belgium. More recently, comic strips have tended to appear in self-contained book form, rather than in magazines. In all, there have been sixty-three such

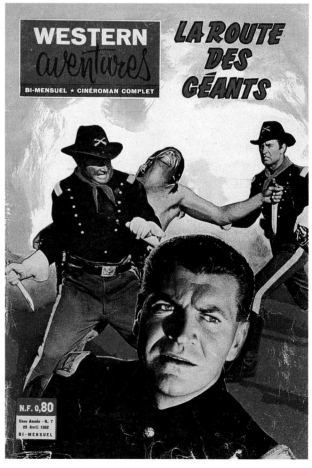

10. *Aventuras de Monte Hale*,
a Brazilian Superxis comic book, 1960

11. *La route des géants (Union Pacific)*,
a 1962 *cinéroman complet* produced in Italy
for distribution in France, Canada, and
French-speaking countries in the Caribbean,
Southeast Asia, North and West Africa,
and the South Pacific

Lucky Luke book titles, with combined sales estimated at seventy-two million copies. The character was popular enough to become the subject and title of an animated movie in 1971 and a live-action feature made in Italy in 1990 and starring Terence Hill, veteran of many Spaghetti Westerns. The Lucky Luke World Wide Web site claims that rights have been sold in seventeen languages.[34]

The other French Western comic that merits attention is *Blueberry*, the adventures of a cavalry officer, written by Jean-Michel Charlier and drawn by Jean Giraud. Frequently accused of crimes he has not committed, and a fierce defender of Indians, Blueberry has so far appeared in thirty-nine titles, with total sales of twelve million copies. The prestigious French newspaper *Le Monde* serialized the latest *Blueberry* adventure, *Ombres sur Tombstone* (*Shadows Over Tombstone*), in August 1997.[35]

By the time Western movies came along at the beginning of the twentieth century, therefore, an audience was already in place. Silent movies were exported widely, since their subtitles were easily translated into other languages. Westerns, which relied more on action than dialogue anyway, became especially popular. Stephen Bottomore has documented the rapid and almost complete spread of the Western throughout the world in the period up to World War II.[36] The British film trade journal *The Bioscope* claimed by 1910, "Undoubtedly Western films are the favourites of an audience." Commentators remarked that the appeal was particularly strong for boys, who, one British author observed in 1911, "Have an inbred love of adventure; especially when laid in the Wild West." Iona and Peter Opie, authorities on children's games, record that at this time "Cowboys and Indians" became a common game, not only in England, but in France as "le cowboy et l'Indien," in Germany as "Cowboy und Indianer," and in Italy as "Caw-boys e Indiani." In *Dubliners* (1914), James Joyce recalls such games:

It was Joe Dillon who introduced the Wild West to us. He had a little library made up of old numbers of *The Union Jack*, *Pluck* and *The Halfpenny Marvel*. Every evening after school we met in his back garden and arranged Indian battles. He and his fat young brother Leo the idler held the loft of the stable while we tried to carry it by storm. . . . He looked like some kind of an Indian when he capered round the garden, an old tea-cosy on his head, beating a tin with his fist and yelling: "Ya! yaka, yaka, yaka!"

Even at this early date there was concern over the possible bad effects of Westerns. In 1910 a British writer recounted how on the day after a visit to a cinema showing an Indian film, one child was discovered "dancing round the garden, with his head decked with chicken's feathers, in one hand swinging the family hatchet, whilst with the other he made sundry lunges with a carving knife at his unfortunate little brother, who he had bound to a neighbouring tree."

Americans abroad sent back accounts of the spread of the Western film. In 1912 one reported from Rome on "red and yellow posters of cowboy heroes on bucking broncos

and lovely Indian maidens." An American film trade representative in Germany wrote in 1911, "I simply could not get enough America pictures to supply the demand. The Western cowboy films, manufactured by the American Film Manufacturing Company, were the most popular of all and I ran them constantly in all the houses over which I had jurisdiction." In 1914 the American consul in Madrid wrote, "The only American films in great favor are those showing far-west scenes with cowboys and particularly Indians."

Westerns were popular even further afield, in Syria, Burma, China, Siam, Egypt, and South Africa. "They simply love 'em in Melbourne," said an Australian film man in 1911. *Sunset* magazine gave a fascinating account of a film show in Tahiti in 1913. The loyalties of the crowd bear testimony to the power of the Western to sway sympathies:

And always reserved as the last item on the programme is the cow-boy picture—they pronounce it 'com-boy' down there; during the final interval the house resounds with the impatient call "com-boy, com-boy," and if there is any failure in the supply of Wild West reels the ticket office would surely be wrecked. . . . It is curious also to note that when it comes to a battle between white men and those we are pleased to call the inferior races, his sympathies are always intensely with the whites; he shouts with joy when the black fellows or the redskins are mowed down.

By 1916, Broncho Billy was the favorite film star in China. *Collier's* magazine reported:

As soon as a three-sheet cowboy poster goes up a crowd gathers around it. There isn't a single word on it that they can read, but it shows a sombrero hero on a pitching cayuse, and that is enough; that means there is to be a cowboy picture that night, and they must hustle around and get their work done.

As suggested here, countries outside the United States often imported promotional imagery as well as the film, typically attaching local screening information to the posters. But from an early date, Western Europe began to produce original graphics to illustrate and advertise Westerns. In the 1923 Swedish poster *För äran, vännen, o. flickan* for the 1921 Custer movie *Bob Hampton of Placer*, a mounted cowboy abruptly pulls up his horse to face the huge specter of a bright red American Indian. Adding a Swedish title to the poster made the film meaningful to its intended audience, and supporting it with dramatic imagery was sure to stimulate interest (plate 12).

Another good example is furnished by the Dutch poster *De Razende Ruiter* for Tom Mix's final film, the fifteen-chapter Mascot serial *The Miracle Rider* (1935). Mix's six-gun, bandanna, and distinctive hat clearly identify him as a cowboy, yet even though *The Miracle Rider* was a Texas Ranger movie set in the modern West and shot in Southern California, the Dutch poster features lush green grass and snow-covered mountains, giving a very European, almost Alpine, look (plate 13). Monument Valley also appears verdant and lush in the Belgian poster *La prisonnière du désert* for John Ford's 1956 classic *The Searchers* (plate 14). Tom Mix and John Wayne could now pursue their adventures within a landscape more familiar to European audiences.

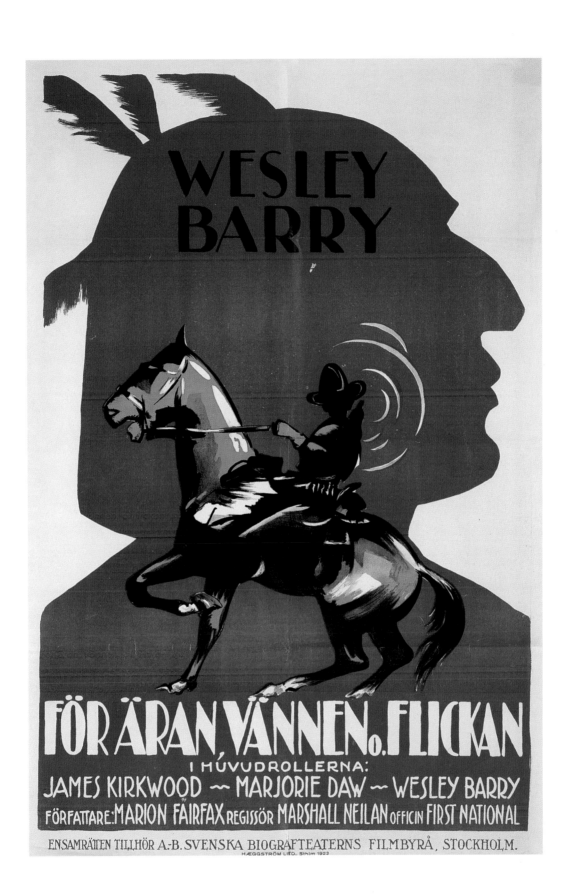

12. **För äran, vännen, o. flickan**, 1923

Swedish poster for the 1921 American film

Bob Hampton of Placer

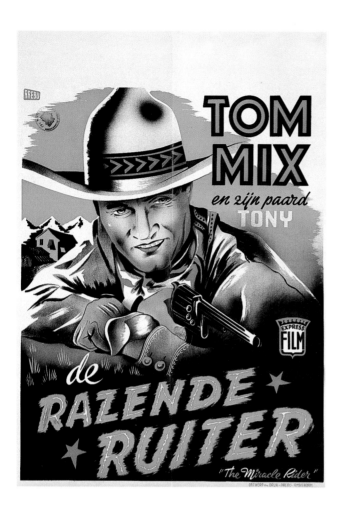

13. **De Razende Ruiter**
(*The Miracle Rider*, 1935)
Dutch poster for Tom Mix's
final movie

14. **La prisonnière du désert**
(*The Searchers*, 1956)
Belgian poster for the
John Ford classic

Britain, France, Germany, Italy, and a host of other Western European nations also produced original posters to illustrate Westerns. Often these differed substantially from their American counterparts. For example, the American one-sheet for Paramount's 1923 epic *The Covered Wagon* shows the wagon master and an Indian leader peacefully saluting each other prior to engaging in negotiations (plate 15). But the French equivalent portrays a wide-eyed and impassioned Indian, with raised tomahawk, letting out a war cry (plate 16). Film poster artists in Western Europe tended to sensationalize aspects they considered most marketable to their target audience. Indians became wilder, women sexier or more imperiled, and the whole more colorful and dramatic.

The same can be said for posters designed in other areas of the world. The Argentinean poster for Fred Zinnemann's 1952 classic *High Noon* displays a colorful, dramatic image of Gary Cooper, legs astride and guns blazing, in the archetypal gunfighter pose (plate 17). The Mexican poster *Furia desbocada* for the sixty-sixth and last Hopalong Cassidy feature, *Strange Gamble* (1948), presents an action portrait of the hero in attractive sepia tones (plate 18). Wording adds to the excitement: "Hopalong Cassidy en tremenda lucha a muerte contra una banda de renegados!" (Hopalong Cassidy in a tremendous fight to the death with a gang of renegades!). Yet the film has been described as "sad and lackluster," and "one of the most disappointing in the series' history." The "Stampede Fury" of the Spanish title is "the clumsiest action scene in any Cassidy film [as] Longhorn and his men stampede a herd of stock-footage cattle into a blatantly indoors set meant to represent Hoppy's campsite."[37] Clearly, foreign poster designers were not afraid to exercise creative license with the Western.

In the Japanese poster for the 1954 Marilyn Monroe vehicle *River of No Return*, dramatic action elements from the movie provide a backdrop for the central image (plate 19). Here, Monroe is pictured as the saloon girl turned sex goddess in red lingerie, high heeled shoes, and fishnet tights. She strums a guitar, presumably to accompany sexy lyrics, delivered huskily. At bottom right a lips motif with "Love Monroe" hammers home the point. The poster also includes tastefully designed Japanese typographical elements. The whole makes for an attractive and powerful advertising package. Western European, Central and South American, and Asian poster designers might have embellished the films they were illustrating, but they made no effort to give an alternative viewpoint, or add a message to the film. That would come from Eastern Europeans.

In 1923 Colonel Tim McCoy, special adviser on *The Covered Wagon*, and later a performer in Westerns, brought a band of Arapahos to London for the film's British premiere. They stayed for six months and were a great success, putting up at a rooming house in Russell Square (where they complained bitterly at the constant diet of steak and kidney pudding), dining at the Savoy, and visiting Baden-Powell, hero of the siege of Mafeking during the Boer War and founder of the Boy Scouts. A character by the name of Montana Joe also was touring provincial British cinemas in the late teens, showing films and delivering lectures on the West, "assisted by his world-renowned pony Snowball. Together they

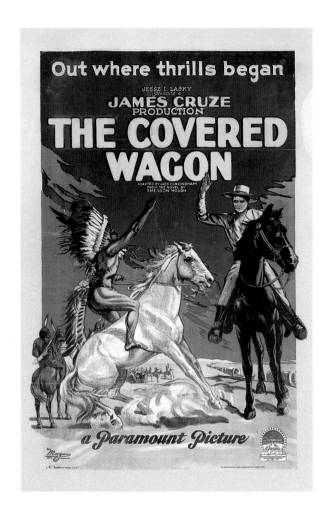

15. American one-sheet poster for the 1923
American Western *The Covered Wagon*

16. *La caravane vers l'ouest*

French poster for *The Covered Wagon*

17. **A la hora señalada** (*High Noon*, 1952)
Argentinean poster for the American film

18. **Furia desbocada** (*Strange Gamble*, 1948)
Mexican poster for the Hopalong Cassidy film

19. Japanese poster for the American film

River of No Return (1954)

have done some hair-raising things in the film world," notes a newspaper announcing his appearance in Merthyr, South Wales. Although Buck Jones, the iconic cowboy film star of the 1920s and 1930s, never toured overseas, his movies became so popular abroad that he had fan clubs not only in England but even in the Philippines.[38]

Many other Western movie celebrities traveled abroad between the wars, and again after World War II. Tom Mix, the biggest star at Fox Studios in the 1920s, became the first international movie cowboy celebrity. His early films were as popular in China and the Middle East as they were in Europe. Wishing to cash in on this eastern interest and on the popularity of Rudolph Valentino, in 1922 he released a five-reel cowboy comedy romance titled *Tom Mix in Arabia*.[39] In April 1925, Mix visited Europe for the first time. In London, hundreds of children turned out to see him ride his horse Tony "Indian style (sliding down on one side of the horse so that he could not be seen from the other side)" down the King's Way, from Hyde Park Corner to Kensington Gate. Mix also visited Paris, Brussels, Amsterdam, and Berlin. He was promoting Stetson on the tour and handed out white hats to royalty and dignitaries. Everywhere he went, Mix was met by large and enthusiastic crowds.[40]

In May 1938 Tom Mix made a second European tour: "He arrived in England on May 20, and the police promptly took eight pistols and five rifles away from him because he had no import license. One reporter wrote that Tom's arrival in England 'must have been the largest armed force that has tried to land on British soil since the last attempt by the Stuarts almost 200 years ago.'" He left England for continental Europe in April 1939. It has been estimated that Tom Mix had more than five million fans in Germany alone in the twenties and thirties, but he did not visit Hitler's Germany. Instead, he arrived in Horsens, Denmark, on April 18, 1939, where he was greeted by an enthusiastic crowd of more than 10,000 people. Mix signed on with Circus Belli and played to packed houses in a 3,000 person arena during the summer. He was traveling with the circus through Denmark when World War II broke out.[41]

Gene Autry also toured Europe in 1939. He already had a large fan-club following in England and Ireland. Much of the popular support of the Singing Cowboys and B-Western stars lay in industrial blue collar areas, so most of their tours to Europe hit the trail to the provinces. Autry later recalled: "Everywhere we appeared—London, Liverpool, Dublin, Glasgow, Danzig—the theaters were filled and the streets jammed for blocks with thousands of fans, waiting to see 'the American cowboy.' My films, and their notions of the Old West, had made me a romantic figure." At one point, Autry was honored with a luncheon at the famous Savoy Hotel in London. His horse Champion was also invited: "I led him through the lobby of that elegant hostelry, where the princes of Europe have met, and later he walked among the tables at my reception, while the startled guests protected their plates. A cowboy was such a novelty over there. It was almost like being from another planet." The highlight of the tour was a trip to Ireland (figure 2): "In Dublin, when we paraded through town with Champion, 300,000 lined the streets to watch, what was then

thought to be a world record for anyone less than the Pope. It was a record that stood, I think, until the Beatles toured New York, creating their own brand of hysteria."[42]

During the winter of 1954, Roy Rogers and Dale Evans traveled to Europe and toured Scotland, England, and Ireland. The theaters were sold out even before they left the United States. At one point, overly enthusiastic fans pulled at the fringes of Roy and Dale's clothing, and their car was nearly toppled. Rogers later described an incident on this tour that suggests the attraction of Western showmanship to European audiences:

The opening scene of our stage show in Glasgow had called for our singing group, dressed as outlaws—neckerchief masks and all—to enter from stage right and to shoot blanks towards the opposite side of the stage, where I was to make my entrance on Trigger. It had been my responsibility to load all guns used in the show, including those for a shooting act later in the program which used live ammunition. By accident I had loaded one of their guns with bird shot. I realized the error of the load as the "outlaws" began to shoot; I felt Trigger flinch and noticed several burning places on my face and in my arms and legs. You know the show must go on; I went to the microphone with blood streaming down my face and said, "You know, they've been shooting at me for twenty years, and this is the first time they've hit me."[43]

Clayton Moore also traveled to Britain during the heyday of the Western. By 1958, *The Lone Ranger* television show had been airing for more than a year, and Moore appeared in costume: "Meeting me at Heathrow Airport was a cheering throng, thousands of excited kids and adults as eager to make the acquaintance of the Lone Ranger as any American audience I had ever seen. This enthusiasm continued throughout the entire tour. In fact, I remember a policeman in Cardiff saying to me with a smile, 'I'll be glad when you get out of here, so we can get the trains running again.'" British fan interest in Western celebrities remains strong. The 250 members of the British B-Western Association held their annual meeting in March 1998 at the Victory Services Club in London, honoring veteran "heavy" Pierce Lyden in his ninetieth year.[44]

Not all responses to the spread of the Western were enthusiastic. Intellectuals often resisted the allure of cinema generally, and of American Westerns in particular. Herbert Jhering, a left-wing German film critic, wrote in 1926: "American film is the new world-militarism. It is advancing. It is more dangerous than Prussian militarism. It does not devour single individuals, it devours the individuality of peoples."[45] In *From Caligari to Hitler: A Psychological History of the German Film*, his influential study of German cinema in the twenties, Siegfried Kracauer saw Westerns as contributing to the demoralization of the German nation in the pre-Hitler period:

The success of the American Westerns was particularly sweeping. Broncho Bill and Tom Mix conquered the hearts of the young German generation. . . . To staid and settled adults the spell this shoddy stuff exerted on boys in the early teens was inexplicable. By their simple manner and untroubled outlook, their ceaseless activity and heroic exploits, the American screen cowboys also attracted many German intellectuals suffering from lack of purpose. Because they

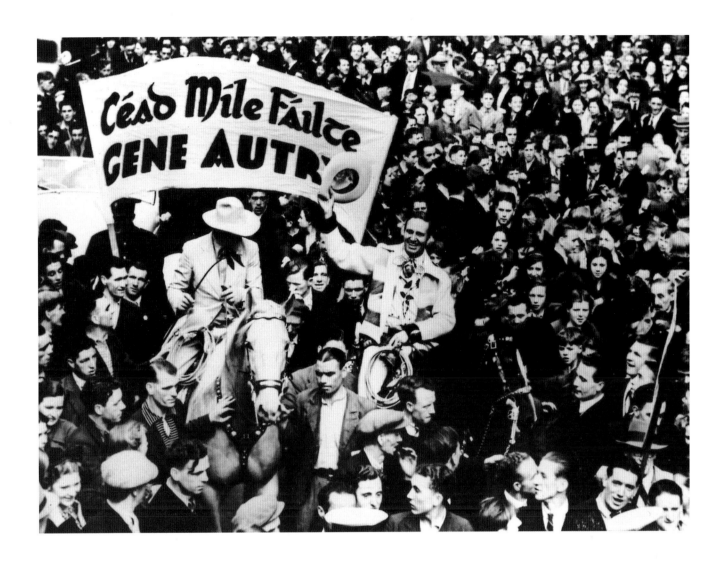

Fig. 2. Singing cowboy star Gene Autry

parades through the streets of Dublin in 1939.

The Gaelic banner translates as

"One hundred thousand welcomes,"

but that day it was more like 300,000.

were mentally tossed about, the intelligentsia welcomed the simplifications of the Westerns, the life in which the hero has but one course to follow.[46]

The lofty disapproval of intellectuals did nothing to dent enthusiasm for Westerns. The flood of books and magazines that had poured forth in the nineteenth century, and the appearance of live spectacles of the West, had, by the time movies were invented, created an apparently insatiable appetite in Europe and the rest of the world for all things Western, and for American films generally. The economic domination secured by Hollywood by the beginning of the 1920s produced an unstoppable momentum. And World War I had worked in America's favor. While the industries of its major rivals in Europe were severely handicapped by wartime restrictions and shortages, American film production had surged ahead. By the mid-1920s, America had achieved a virtual stranglehold on world film markets. In 1926 it held more than 40 percent of the German market, nearly 80 percent of the French, and no less than 83 percent of the British market.[47] In other countries, its dominance was often even greater. And by that time, somewhere between a fifth and a quarter of all American feature films were Westerns.[48]

The moral and intellectual objections to the cinema often concealed an anti-Americanism fueled by the huge imbalance of trade in films between Europe and America. This also affected other kinds of trade. Will Hays, the chairman of the powerful Motion Picture Producers and Distributors of America, had visited Britain in 1923 and was reported to have said that the aim of the American film industry was to "Americanise the world"; and in 1925 the Federation of British Industries sent a memo to the British government voicing its concern: "At the present moment, cinema audiences in this country and the Dominions are being shown almost entirely American films, depicting American life and ideas. This is actually having a reaction upon the demand for goods in favour of American styles."[49] The result of this growing anxiety was the initiation of a quota system in 1927, designed to limit the number of Hollywood films on British screens. Other European countries followed suit with protectionist measures. Yet this did little to stem the tide of enthusiasm for American films.

Such success owed much to American business acumen. But show-business razzmatazz was only effective if the product itself was salable. American pictures generally had two great advantages. First of all, they almost invariably were technically superior. They had more money poured into them, and it showed. Even though many of the series Westerns produced in the 1920s, the forerunners of the B-Westerns of the 1930s and 1940s, were among the cheaper products of Hollywood, they still provided exciting stunts and action sequences and impressive location shooting. American films also were produced unashamedly for the mass market. In Europe, cinema often seemed inhibited by the prestige of older art forms such as the novel and the theater. By contrast, American cinema seemed free of deference to middle-class tastes. Hollywood knew what a mass audience wanted, and had no inhibitions about delivering it. Thus, slapstick comedies, crime

thrillers, romantic dramas, and above all Westerns, emerged in an endless stream from the Los Angeles dream factories. While intellectuals fulminated that popular cinema lowered artistic standards, the mass audience welcomed Hollywood films with open arms. "Escapist" was the charge most often leveled at Western movies; but for those living in dreary cities or suburbs in Europe, an imagined escape to the prairies or plains often provided much needed relief.

The remarkable success of American Westerns abroad soon led to imitations. The French film industry, one of the world's strongest in the years before World War I, proved especially productive. Pathé soon entered the field; its 1904 production, *Indians and Cowboys*, survives. In the 1907 Pathé film *Les Apaches du Far West*, Indians steal horses, capture a white man, and attack a train. In 1910, Pathé launched its own Western series, produced in a brand new studio in Jersey City. The Eclair company had a Western series named Riffle [*sic*] Bill, and between 1911 and 1913 another French company, Eclipse, produced the Arizona Bill series, featuring the premier French cowboy star Joë Hamman and using locations in the Fontainebleau woods. In 1909 Hamman had played Buffalo Bill in a series of five films made by an English company, Safety Bioscope, and he later made a number of Western films under the direction of Jean Durand, including *Le railway de la mort* (*Railway of Death*, 1912), shot at La Camargue in southern France. Hamman became an ambassador for all things Western as president of the Paris Club de Lasso, founded to promote cowboy riding skills.[50] French enthusiasm for the Western found its way into the films of perhaps that country's greatest director, Jean Renoir. In *Le crime de M. Lange* (1935), the title character is a writer of pulp Westerns featuring "Arizona Jim." Monsieur Lange's crime is to shoot the owner of the Parisian publishing house for which he works.

Renoir was not the only director influenced by the Western. In *The Third Man*, the British film noir written by Graham Greene and directed by Carol Reed in 1949, Joseph Cotten plays Holly Martins, another author of cheap Westerns. Obliged to deliver a lecture on the modern novel, he is asked which author has influenced him most. "Zane Grey," he replies. The Soviet director Sergei Eisenstein was invited to Hollywood in 1930, where he wrote a screenplay for Paramount of *L'Or*, a novel by the French author Blaise Cendrars about the discovery of gold in California in 1848, though the film was never made. The Japanese director Akira Kurosawa made samurai films that are often referred to as Eastern Westerns. His most notable effort, *The Seven Samurai* (1954), was later remade by Hollywood as *The Magnificent Seven* (1960). Kurosawa wrote in his 1983 autobiography, "An image remains emblazoned in my mind of William S. Hart's face. He holds up a pistol in each hand, his leather armbands decorated with gold, and he wears a broad-brimmed hat as he sits astride his horse. Or he rides through the snowy Alaskan woods wearing a fur hat and fur clothing. What remains of these films in my heart is that reliable manly spirit and the smell of male sweat."[51]

The Scandinavian company Nordisk produced *Texas Tex* in 1907, with a cast of Indians recruited from a touring Wild West show. The British film industry made at least

thirty Westerns before 1913, with such titles as *An Indian's Romance* and *The Sheriff's Daughter*. These were shot in Epping Forest and other locations within easy reach of London. One of the few to survive is *The Squatter's Daughter* (1906), an exciting tale of capture by Indians and last-minute rescue, reputedly shot on Putney Common. Since that time, British production has largely confined itself to parodies, including *The Frozen Limits* (1939), in which the Crazy Gang go looking for gold in Alaska; *Ramsbottom Rides Again*, an Arthur Askey outing (1956); and *Carry On Cowboy* (1965), in which Sid James plays the Rumpo Kid from Stodge City.[52]

Germany produced a number of Westerns in the period after World War I. Several were shot just south of Munich by Arnold and Richter, the company that invented the famous ARRI movie camera. In 1920 the Luna company made a Cooper adaptation, *Lederstrumpf* (*Leatherstocking*), with no less than Bela Lugosi, the future Dracula, as the Indian chief Chingachgook. A Heidelberg company, Chateau-Kunst-Film, made a series of *Ersatzwesterns*, of which two survive: *Bull Arizona, der Wüstenadler* (1919) and *Das Vermachtnis der Prairie* (*The Legacy of the Prairie*, 1920), another Bull Arizona adventure. It seems likely the actor playing Bull Arizona had seen William S. Hart Westerns while visiting the United States between 1916 and 1918, since as a *zwei-revolver-mann* he echoes Hart's character of the "two-gun man."[53] Occasional Westerns were produced in Germany during the 1930s, including a big-budget production about the discovery of gold in California, *Der Kaiser von Californien* (1936). But the German Western really only came into its own in the 1960s.

In 1962, producer Horst Wendlandt spent 3.5 million Deutschmarks (the largest sum spent on a German film to that date), to make *Der Schatz im Silbersee* (*The Treasure of Silver Lake*). Based on a Karl May novel, the movie starred the former Tarzan Lex Barker as Old Shatterhand and Pierre Brice as Winnetou (figure 3). Its success led to sixteen more May adaptations, most of them filmed in the mountains of Yugoslavia, and starring other Hollywood names, such as Stewart Granger and Rod Cameron. The title song from the first film, *Old Shatterhand Melodie*, topped the German singles charts for seventeen weeks, and it was followed by board games, comics, cookbooks, towels, shoes, and a brand of cigarettes, all based on characters from the films. A host of other German-made Westerns followed, including a series of Cooper adaptations (plate 20).[54]

The German films' popularity with Italian audiences was quickly noted. Sergio Leone, the director of *Per un pugno di dollari* (*A Fistful of Dollars*, 1964), has said that the Karl May adaptations had a direct influence on the wave of Italian Westerns, some six hundred in all, which began in 1963. Leone's so-called dollar trilogy (the other two films being *For a Few Dollars More*, 1965, and *The Good, the Bad, and the Ugly*, 1966) made a star out of Clint Eastwood, who until then was known only for his role as Rowdy Yates in the *Rawhide* television series (plate 21). Many other Hollywood performers, long-time stalwarts of the Western, followed Eastwood to the studios of Cinecittà in Rome, including Henry Fonda, Charles Bronson, James Coburn, Eli Wallach, Rod Steiger, Jack Elam,

Fig. 3. French actor Pierre Brice starred as the Apache Winnetou in *Der Schatz im Silbersee* (*The Treasure of Silver Lake*, 1962), and in numerous other German film adaptations of Karl May novels. Brice has made a career playing Winnetou in movies, on television, and at Karl May festivals throughout Germany. Courtesy German Information Center

20. *Der letzte Mohikaner*, 1965
West German poster for the West German film

21. This Argentinean poster from the early 1960s advertises a film created from two episodes of *Rawhide*. Clint Eastwood's Spaghetti Western career was about to take off in Italy. *Il magnifico stragnero* was the working title for Sergio Leone's 1964 landmark *Per un pugno di dollari* (*A Fistful of Dollars*). Eastwood wore the sleeveless sheepskin jacket pictured in the poster in Leone's movie, but not *Rawhide*. Argentina enjoyed a close relationship with Italy. The film producer and poster designer borrowed from Leone both the title for the movie and the image used to promote it. See Richard Schickel, *Clint Eastwood: A Biography* (New York: Knopf, 1996), 128–34, 152–53.

22. Italian Westerns were enormously popular worldwide. This Australian poster for Sergio Leone's *Per qualche dollaro in più* (*For a Few Dollars More*, 1965) appeals directly to an adult audience by promoting the greed, sex, and violence in the movie, noting conspicuously that it is "not suitable for children."

Woody Strode, Jack Palance, Lee Van Cleef, Jason Robards, and Rod Cameron. The Italian directors and scriptwriters frequently assumed American pseudonyms to lend authenticity to the films. Leone was for a time "Bob Robertson"; Gian-Maria Volonté, Eastwood's costar in *A Fistful of Dollars*, became "John Wells"; and Sergio Corbucci, director of the first of the *Django* films, was known as "Stanley Corbett."

Sardonic, fixated on violence, death, and the grotesque, with strong musical scores by the likes of Italian composer Ennio Morricone, and with a baroque shooting style that relied on big close-ups, odd angles, and rapid cutting, these Spaghetti Westerns appealed strongly to a younger audience that found the Hollywood take too traditional. By emphasizing family loyalty, pride and shame, exile and vengeance, these films offer a peculiarly Italian slant. In a curious echo of nineteenth-century Europe's enthusiasm for American progressiveness, the films often adopted an overtly political stance. Many of them, ostensibly set in Mexico, took the side of the poor peasants against both corrupt local generals and those gringos bold enough to venture south. In the process, they opposed the monopoly power of the capitalist railroads, and even attacked the Catholic Church.[55]

Spaghetti Westerns enjoyed great success in Western Europe and the United States, and also had huge followings in South America, Australia, and Japan (plate 22). Of the ten Italian films which grossed most internationally between 1956 and 1971, Leone's trilogy came second, third, and sixth. In turn, Italian Westerns have influenced the American-produced variety. Eastwood has become one of the foremost contemporary American directors, but he has not forgotten his Italian mentor, and his most recent Western, *Unforgiven* (1992), is dedicated in part to Leone. Sam Peckinpah, arguably the greatest Western director since John Ford, acknowledged the trail blazed by the Spaghetti Western, and his masterpiece *The Wild Bunch* (1969) shows just how deep the influence ran.[56]

Though a comparatively short-lived phenomenon (by the mid-1970s the Italian boom was over), the films have retained their popularity, as the plethora of World Wide Web sites devoted to them testify (plate 23). A Japanese Web site enthuses, "There are full of charm in them that we cannot find out from most recent movies."[57] And now visitors may frequent not only virtual sites but also actual ones. Many of the Spaghetti Westerns were filmed not in Italy but in Spain, and the area around Almeria on the southern coast was especially popular. The original sets have been turned into a Western theme park called Mini Hollywood, where actors engage in gunfights daily in the Poblado del Oeste (Western Village) (plate 24).

A selection of Euro-Westerns, including such obscure films as the Finnish *Villin pohjolan kulta* (*Gold of the Wild North*, 1963), were shown at a festival in northern Italy in April 1997, organized by the Centro Espressioni Cinematografiche of Udine (plate 25).[58] The festival brought together filmmakers, fans, and academics. Europeans have always been at the forefront of scholarly work on the Western movie. The great French critic André Bazin wrote several seminal essays on the topic in the 1950s, including "The Western, or the American Film par excellence," a title that gives some idea of the importance

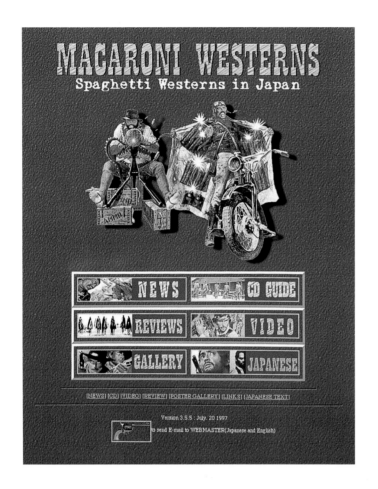

23. The continuing appetite for Spaghetti Westerns can be seen in this home page from a Japanese World Wide Web site. The image is from Sergio Leone's "post-Western" *Giù la testa* (*Duck, You Sucker / A Fistful of Dynamite*, 1971). This extensive site, with text in English and Japanese, offers links to numerous other kindred spirits in cyberspace: www.pscweb.com/macaroni/. Courtesy Ishikuma Katsumi. Image prepared by Mac McClelland

24. Promotional brochure for Mini Hollywood, Poblado del Oeste, a Western theme park near Almeria in southern Spain featuring original sets from Spaghetti Westerns shot in the area. Courtesy Edward Buscombe

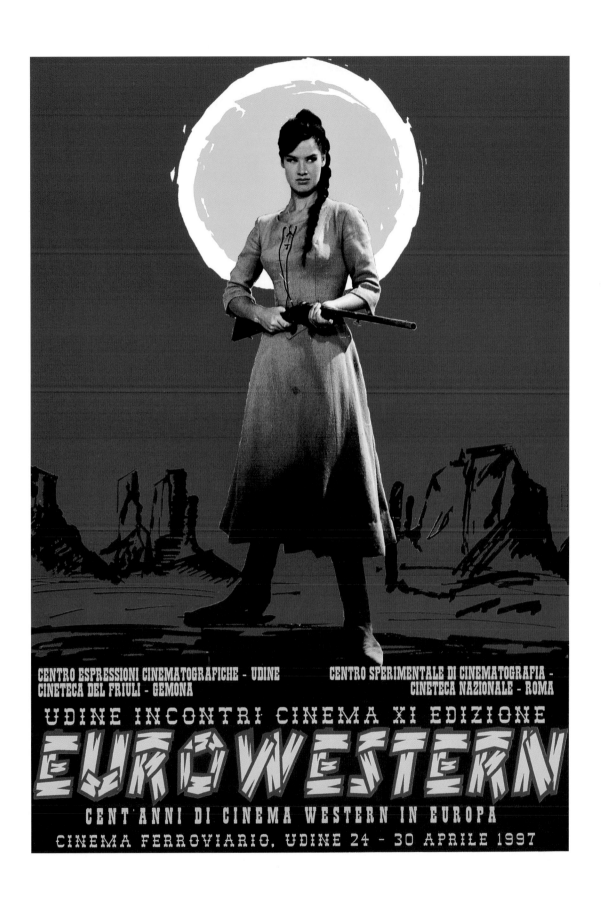

25. A suitably colorful and dramatic advertising poster
designed for the Euro-Western film festival
in Udine, Italy, in April 1997

he attached to the genre.[59] Since then, the French have produced a number of notable books, including J.-L. Rieupeyrout's landmark work, *La grande aventure du western, 1894– 1964*, and a series of highly original books by J.-L. Leutrat. Perhaps most typically French is a volume entitled *Géographies du western* by J. Mauduy and G. Henriet, crammed with maps, diagrams, and graphs detailing the Western's use of physical space, a truly eccentric but madly enthusiastic work.[60]

The Germans too have produced some serious scholarship, most notably Joe Hembus's classic *Das Western-lexicon: 1324 filme von 1894–1978*.[61] Deutsche Gesellschaft zum Studium des Western (German Association for the Study of the Western) was founded in Freiburg in March 1990 during celebrations marking the one hundredth anniversary of the closing of the American frontier (plate 26). The founding constitution clearly stated the association's mission:

Its aim and purpose is the study on a scholarly and didactic level of the Western in its many and various forms and spheres of influence both within and outside the United States of America. This is to be achieved by means of conferences, academic publications, the establishment of a specialized library, further education and research and other means, all of which shall further the understanding of the Western in the German-speaking countries.

The editorial statement of the inaugural *Newsletter* addressed the association's scope of activity:

To make one thing clear: Our society is devoted to the study of the Western, not the West. Since the Western grew out of both the historical and mythic West, the genre is inextricably bound up with history and myth. However, the West as history and myth is but an indispensable starting point for our scholarly and didactic pursuits of a genre unanimously accepted by the name Western. Over and above all other things, the Western means literature and film. In addition to literature and film, we include in our definition of the Western the visual arts (e.g. painting, photography, and sculpture) and the auditory arts (e.g. music, drama, radioplay, and musical) as well as imaginative expressions of popular culture.[62]

In 1992, the *Newsletter* was replaced by the scholarly biannual *Studies in the Western*, published in English and German.

The British also have played a part. One of the most distinguished scholars of the Western was William K. Everson, a longtime resident of New York who never lost his British accent and who with George N. Fenin wrote what was for many years the standard history of the genre, *The Western from Silents to the Seventies* (1973). Edward Buscombe's *The BFI Companion to the Western*, first published by the British Film Institute in 1988, is now considered the standard reference. Since 1987, the scholarly biannual *European Review of Native American Studies* has provided its readers with articles, exhibition and book reviews, news and reviews of conferences, and the "Current European Bibliography of Native American Studies." With editorial offices in Vienna at the Museum für

THE GERMAN ASSOCIATION
FOR THE
STUDY OF THE WESTERN

(Deutsche Gesellschaft zum Studium des Western)

A TEXAS COW BOY
OR
FIFTEEN YEARS ON THE HURRICANE
DECK OF A SPANISH PONY.
TAKEN FROM REAL LIFE BY
Chas. A. Siringo.
AN OLD STOVE UP COW PUNCHER WHO
HAS SPENT NEARLY A LIFE TIME ON THE
GREAT WESTERN
CATTLE RANGES.

NEWSLETTER Vol. I (1990/91), No. 1

26. The premier issue of the *Newsletter* of the German
Association for the Study of the Western (Deutsche
Gesellschaft zum Studium des Western), 1990, featuring
an image from the first cowboy autobiography, by
Charles Siringo

Völkerkunde and in Budapest, the *Review* serves as a clearinghouse for information on European scholarship on all aspects of American Indian studies. Encompassed is wide coverage of portrayals of Indians in popular media, including the Western.

Perhaps the most extraordinary achievement of European scholarship to date has been that of Carlo Gaberscek, a schoolteacher from Udine, who for the past ten years has spent every summer roaming the American West, researching the location of Hollywood Western movies. During that time, he has published several books which document, in detail, the camera setups for the most memorable shots in classic films. The most comprehensive result of his investigations thus far is his 1995 work *Sentieri del western: Dove il cinema ha creato il west* (*Western Trails: Where the Cinema Made the West*).[63]

Today, Westerners International is the largest and most active organization in the world devoted to stimulating and supporting interest in all aspects of the American West, including Westerns. Nearly 5,000 members are associated with some 125 corrals in 22 countries. The Westerners came into being in Chicago in 1944. The English Corral was founded in Liverpool a decade later. British membership quickly grew to more than 200, with corresponding members in Malta, Egypt, Australia, Germany, and Switzerland. The French Corral was founded in Paris in September 1955, and the following report was furnished by the Chicago Corral soon afterward:

The activities seem quite diverse; there is notice of a motion picture club to see and discuss Westerns, square dancing, fancy roping, riding ranch style, and some hopeful discussion of a Rodeo American. We gather that riding is available twice a week, square dancing every Wednesday, and a session on Indian dances every Tuesday.[64]

In 1959, Westerners' corrals were formed in Alpirsbach, West Germany, and Gothenberg, Sweden, and by 1974 ten international corrals had been formed, five in West Germany, two in Mexico, and one each in England, France, and Sweden. By 1998, the number of international corrals had increased to twenty-eight. In Denmark, we find the John Wayne Corral, founded in 1980. The Czech Republic currently boasts five corrals. Here, "tramping," or dressing as cowboys and Indians, has been a popular activity for seventy-five years. Members of the Pony Express Corral dress as cowboys and deliver the local mail on horseback. The Trappers Corral members dress as mountain men, buffalo hunters, and scouts and take part in rendezvous. The Western Dancing Corral, formed in 1992, is one of three Czech corrals with its own World Wide Web site. In addition to the countries mentioned above, there are now Westerners International corrals in Austria, Belgium, Finland, Japan, Norway, and Switzerland.[65]

Though the movie Western experienced a decline during the 1960s, Westerns became the most successful genre on television in the late fifties and early sixties, and U.S. exports grew rapidly. Already by 1958, *Gunsmoke*, *Rin Tin Tin*, and *The Lone Ranger* were in Mexico's top ten TV shows; and by 1960, *The Lone Ranger* had appeared in twenty-four coun-

tries. By 1964 *Bonanza* was seen in nineteen countries and dubbed into seven languages. In Britain, 1958 saw the first screenings of *Wagon Train* and the following year *Rawhide* and *Maverick* were added. On occasion, British television has made Westerns for itself. In 1971, for example, the BBC shot *The Last of the Mohicans* in the Scottish Highlands. Certainly the most unusual was *Four Feather Falls*, a children's string-puppet Western series, made for Granada TV in 1960 (figure 4).[66]

The continuing domination of the world's cinema and television screens by Hollywood has ensured the free passage of American Westerns into virtually every country. New Westerns may appear only occasionally on the world's cinema screens, but television has ensured the continued circulation not only of Western TV series but also of the outstanding works of Hollywood's golden age. The deregulation of European television that began in the 1980s, eroding the dominance of state-financed public service broadcasting and opening up the airwaves to commercial broadcasters, had as one of its effects a large increase in the number of American films being screened. In Italy the amount of money spent on importing foreign material for television screening (most of it American) increased fourfold between 1980 and 1982. A similar pattern was repeated elsewhere. The output of fifty years of Hollywood production, much of it in the Western genre, has been put into constant recirculation on the television screens of Europe.[67]

Culture worldwide is becoming increasingly Americanized. In Western Europe the appeal of America is no longer that it represents an ideal of political freedom, since most Europeans have long since secured that for themselves. What America now represents is the freedom to consume. Since World War II, the huge growth of consumer and leisure industries has been the energizing force in the Western European economy. In cinema and television, American products continue to dominate. And in other consumer industries, such as fashion and popular music, America has had an equally massive influence. For the advertising industry, which needs instantly recognizable images to work with a mass audience, the iconography of the Western is universally understood.

This is nothing new. In the 1960s, the French magazine *Paris Match* carried an advertisement for barbed wire named Cactus Texas, showing a cowgirl gleefully making a lasso from a coil of wire (plate 27). The ubiquitous Marlboro Man has probably done as much as anything to spread abroad the image of the cowboy and of the West generally. Monument Valley in Arizona, thanks to Western director John Ford, is now one of the most familiar landscapes in the world. Over the past decade it has been used in Britain to advertise everything from computer hardware to cigarettes, Rebel Yell whiskey to British Airways.

In TV commercials, also, the West still delivers that automatic recognition advertisers prize. Here, too, Monument Valley has been a popular location for British commercials—on one memorable occasion for Levi jeans without crotch rivets, using a Johnny Cash soundtrack to humorous effect. The American hamburger giant McDonald's most recent TV advertising campaign in Britain uses a Spaghetti Western theme. Recently also, Rollo chocolate caramels have been advertised on British television using a spoof Lone

Fig. 4. Publicity still from the 1960 British string-puppet Western television series *Four Feather Falls*. The adventures of Tex Tucker (at left), sheriff of Four Feather Falls, were featured in thirty-nine fifteen-minute episodes. Magic feathers in Tex's hatband allowed his horse Rocky and dog Dusty to talk and his six-guns to fire by themselves. Westerns were magical, especially to young boys everywhere. Talking animals and self-firing guns were but an exaggeration of the companions and skills of the movie and TV cowboy hero. Courtesy British Film Institute Stills, Posters and Designs

27. *Paris Match* advertisement from the 1960s for Cactus Texas barbed wire. Image courtesy Colin McArthur

28. (*bottom*) Run in Britain in 1977, this Clarks advertisement for a line of shoes shows the ability of the Western to change with the times and remain meaningful. The dress and body language reflect the more overt sexuality of 1970s Westerns. With modern accessories added, the Western still offered marketers an attractive vehicle for selling products. Image courtesy Colin McArthur

Ranger ad shot on location in California, in which Tonto stakes the Lone Ranger to the ground and makes off with his toffees.

Fashion continues to draw inspiration from Western motifs. Blue jeans are now so universally the preferred clothing of youth worldwide that perhaps their reference is no longer specifically Western. But designers like Ralph Lauren have consistently gone back to the roots of Western fashion to spread contemporary variations on boots, denim, and accessories. European designers and manufacturers have followed suit. The British shoe company Clarks was advertising its "Rawhide" range of footwear for both men and women in 1977 (plate 28). American Indian design first became fashionable in the 1920s, influenced by the Taos school of painters, and was popularized by the likes of the Fred Harvey Company, but it has again come to the fore during the racially and ethnically sensitive nineties, with the British edition of *Elle* linking an article on the environmental and spiritual virtues of Native Americans to some fetching dress designs. The *Guardian* of March 9, 1992, profiled a collection by designer Rifat Ozbek thematically inspired by Kevin Costner's *Dances With Wolves*. Many of the accessories, such as Native American silver jewelry, could, it said, be bought at such stores as "Santa Fe" in London's West End, or at "Cowboys and Indians" in the fashionable King's Road.

More recently, both London and Paris haute couture designers have revived Western themes. In London the *Sunday Times* reported on November 9, 1997:

Several other designers have also explored the [Western] theme for next spring. At the catwalk shows last month, Givenchy sent out outrageous pink leather fringed miniskirts, suits that sparkled with rhinestones and splendid 10-gallon hats. Valentino did fringes and western waistcoats, while Tristan Webber, the young British designer, showed leather waistcoats and jackets with cowboy stitching, rubber chaps and high-heeled cowboy boots. . . . The British milliner Philip Treacy has produced a splendid stetson for this season that was recently modelled by the designer Selina Blow at the British Fashion Awards ceremony. "The cowboy look is one with a lot of baggage, it's part of popular culture," Treacy says. . . . "It's also about being an outlaw, an outsider."

Treacy may be stretching a point, but no doubt a large part of the appeal of Western fashion is its lack of formality, its easygoing image, which fits with the industry's need to reach the youth market. Few young people can afford haute couture, but increasingly the fashion industry makes its money through the adaptation of its prototypes by chain stores, whose customers are predominantly young. And at the mass-produced end of the market, Western wear is more popular than ever. The American company H Bar C California Ranchwear, longtime producer of classic Western wear, now sells a third of its output abroad. The Japanese like theirs eye-catchingly bright: "Last year," said company president Elizabeth Wallenius in 1998, "we made them neon green, yellow, and hot pink shirts." In Germany the motorcycle crowd orders fancy cowboy shirts with appliqué and embroidery. The line-dancing craze in England produced orders for shirts with covered-

wagon motifs and dresses with Western yokes. A store in London's King's Road called Wallenius recently, saying they were all out of Western shirts. The Rolling Stones had bought nearly everything in the shop for a fancy dress party.[68]

Most of all, perhaps, it is music that keeps creative notions of the West alive. Worldwide interest in Western music goes back a long way. Many of the traditional cowboy ballads sung on the open plains, in fact, featured older European lyrics and melodies. Later, during the 1930s, Gene Autry's music became popular in Europe. On November 8, 1939, a special correspondent with the British forces in France reported in the *New York Times* that troops all along the front lines were singing the doleful Western ballad *South of the Border*. Why the song had become such a favorite with the British soldiers was a mystery to the reporter: "It has nothing to do with England, France or war," he explained. But although Autry had introduced it earlier in the year during his British tour, the song was not of American origin. This Western classic was the work of two Irishmen, Jimmy Kennedy and Michael Carr, and had been presented to the singing cowboy during his Dublin tour. When Autry returned to America, Republic purchased the song, had a script written, and filmed the movie *South of the Border* before the year ended. In 1943, the studio used the second line of the song lyrics as the title for another blockbuster Western, *Down Mexico Way*.[69]

The music of Gene Autry and the other singing cowboys, in particular Roy Rogers, the Sons of the Pioneers, and Tex Ritter, reached large audiences in Canada, Mexico, South America, Australia, and elsewhere during the 1930s, 1940s, and 1950s. It influenced the likes of New Zealand-born Tex Morton, who helped popularize country and western music in Australia in the 1930s and 1940s. Western swing musicians, especially Bob Wills and his Texas Playboys, also enjoyed widespread popularity outside the United States. These artists sold records in foreign markets, and promoted their products with overseas tours. In their wake came a host of truly international Western stars such as Marty Robbins, Johnny Cash, Waylon Jennings, and Willie Nelson. More recently, such Western showmen as Clint Black, Garth Brooks, Michael Martin Murphy, and Randy Travis have wowed audiences around the world with their recordings and live appearances. Britain now boasts 20,000 line-dancing clubs, with names such as Rodeo Ruth and Stallion Steve.[70]

Less to be expected is the spread of country and western music to more exotic spots. "There's country dancing in Japan?! Really? Yes, it's true." These are the opening words of the World Wide Web site of Nagoya "Crazy Feet" country dancing club.[71] The Web site of the Country and Western Society of Finland is based in "down home Helsinki (the capital of Finland, guess y'all knew THAT?)." Founded in 1994, with 300 members, its aims are to "promote Country Music in Finland, make the Western life-style better known," and to "have fun."[72] The German company Bear Family Records, founded by Richard Weize in 1975, is now the biggest country and western reissue label in the world.[73] Some might say that it is the simplicity of line-dancing steps, and the lack of sophistication in country

and western music, that make them so available for export, but another view is that the absence of snobbery, the preference for the democratic over the hierarchic, is what makes all things Western so universally accessible.

A number of theme parks have sought to recreate the West abroad. In Brazil, it was reported in 1993, investors led by Ladisael Bernardo, a lawyer and John Wayne fan, were transforming the town of Gratai into a cowboy village. Each Saturday afternoon, Bernardo and others dressed as cowboys and staged fake shootouts for visitors. Future plans for Gratai called for a Western movie theater, a fort, and an attraction where tourists could tote guns that shoot paint.[74]

When Disney exported its theme parks abroad, the West was a major part of the attraction. Tokyo Disneyland opened in 1983. Its Westernland, says Michael Steiner, was "designed to provide a crowded island-bound people—especially Japanese men—with the illusion of open space and plenty of swagger-room where good always defeats evil."[75] Also in Japan, at Nikko National Park, is Western Village, a California frontier theme park where 750,000 visitors annually take stagecoach rides and eat chuckwagon barbecue. Takeui Yoshida, head of Western Village's overseas marketing in 1993, remarked, "The Japanese are fascinated with the idea of the U.S. West, the ingenuity of the pioneers, and the freedom and wide open spaces they sought. It's a contrast to the controlled Japanese regimen of living, where space is so carefully planned." The Japanese also have embraced the idea of living in Western style log cabins. American companies have successfully exported prefabricated log homes for reassembly not only to Japan but also to Korea, Thailand, and countries in Western and Eastern Europe and South America.[76]

When Disneyland opened in Paris in 1992, the Southwest frontier was a major focus. As a Disney executive explained, the designers sought a deliberate contrast with the French landscape, "A stunning red environment, that is as much in contrast with the Marne valley here as the greenery of our Disneyland River is with the dry Southern California climate. Our aim is to give people a fresh, startling impression."[77] Euro-Disney's most popular attraction is a recreation of Buffalo Bill's Wild West, complete with riding, roping, and shooting exhibitions, a cattle drive, a buffalo hunt, and an attack on a stagecoach (plate 29). The master Western showman has been lionized in Europe by the greatest popular imager of America. To date over 1.5 million people have seen the show. Ivan Naranjo, of the Blackfoot and Ute tribes, has played Sitting Bull since the opening in 1992. "Audiences," he says, "get a chance to experience a flavor of the American west during that time when it was so romantic."[78]

Cultural theorists might argue that this production is a perfect example of what the French philosopher Jean Baudrillard calls a "simulacrum," a peculiarly postmodern phenomenon in which media spectacles have parted company with the real world and become a completely self-supporting and self-referential system. Euro-Disney's show is not a representation of the West, but the pastiche of an earlier, romantic representation. What we see is not the West as it was, not even the West as Buffalo Bill imagined it was,

29. La légende de Buffalo Bill, Wild West Show exterior marquee,
Disneyland Paris. Copyright Disney

but the deliberate reconstruction of a myth. But then, the myth of the West has always captured the imagination.

The reasoning behind making Buffalo Bill's Wild West a vital component of Euro-Disney has been described by Jean-Luc Choplin, the show's artistic director:

Michael D. Eisner, chairman of the Walt Disney Company, decided that nothing less than a re-enactment of this symbol of America's untamed past could lie at the heart of Disneyland Paris. In a wonderful juxtaposition with the very best of modern architecture, Buffalo Bill's Wild West Show now thrills visitors to Franck (*sic*) O. Gehry's Disney Village nightly.

Buffalo Bill, Annie Oakley, Sitting Bull, all the legendary names that starred in the legendary show have returned to Paris for the fourth time with their horses and buffalo, in an up-to-the-minute production that blends the very best of the Hollywood Western with modern rodeo riding. . . .

The show features real-life cowboys and Indians, brought together to pay homage to a way of life that endures even today. This is America with a capital "A", the America that Europeans dream of.[79]

At Euro-Disney every day, the showman and the promoter emerge triumphant as reality slips seamlessly and stylishly into myth. Buffalo Bill would have been proud; and the audience applauds.

Although the Western has traveled a long way, it has remained intact. Many countries have embraced it to a greater or lesser extent, adopting its symbols, wearing its clothing, playing its music, and advertising its imagery. In promoting Westerns, various countries have emphasized aspects they believe will appeal to their audiences, but attacks on the genre have been restricted mostly to harmless satire. The Western's basic premises were not fundamentally challenged until it entered Eastern Europe.

Eastern Europe has enjoyed a long, interesting, and important relationship with what the Goetzmanns have called "The West of the Imagination."[80] Doc Carver was the first to introduce Western showmanship there when in 1890 he presented his "Wild America" show in Budapest and Warsaw before traveling to Russia. In Moscow, a special display area had to be built, police guarding the facility because of the excitement among the spectators. After a four-week stand, the show went on to St. Petersburg, where a three-mile street parade from the railroad station to the amphitheater provided a free spectacle for the Russians (plate 30). A special performance was given for the royal family, but there were rumblings of revolution. It was publicly stated that the tsar dared not enter the city. When the show began, more than 500 secret police were on the grounds, and the amphitheater was surrounded by soldiers and Cossacks. Grand dukes, a duchess, and the queen of Greece were present, but it was not until later that Carver learned that the tsar was so intrigued by "Wild America" that he had risked his life by attending in disguise. Carver journeyed on to Helsinki, in Russian Finland, before crossing the Baltic to Stockholm.[81]

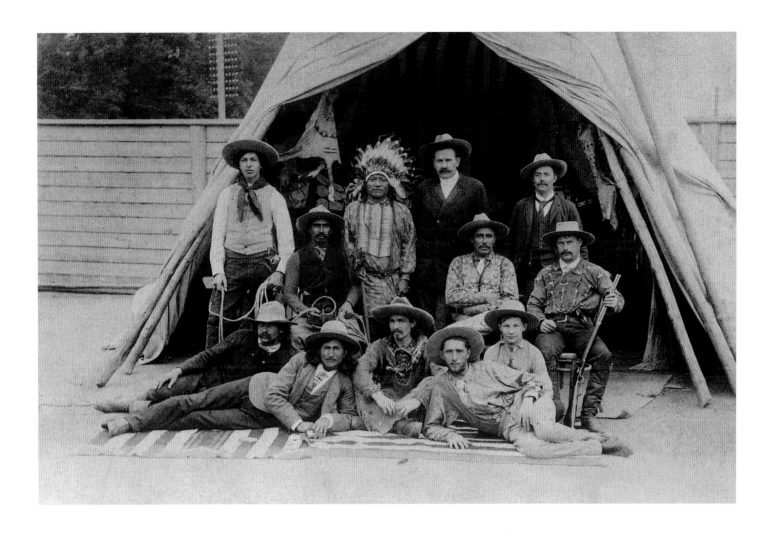

30. Doc Carver's "Wild America" troupe in St. Petersburg,
Russia, 1890. Carver stands at the back, second from right.
Courtesy Buffalo Bill Historical Center, Cody, Wyoming

Buffalo Bill also visited Eastern Europe with his Wild West show, in 1906 appearing in Austria, Hungary, and Austrian Poland.[82]

Eastern Europeans also were reading in translation Cooper's Leatherstocking Tales and the Western novels of Karl May. By the time American movies arrived during the second decade of the twentieth century, people were receptive, and silent Westerns proved popular almost immediately. In Belgrade, the genre had an immediate and dramatic effect on fashion. The American consul reported in 1912 that Western style hats, boots, and other items were all the rage with the youth of Serbia.[83]

Silent Westerns gained popularity in Russia during the middle to late 1920s. Almost simultaneously with the production of some of the most renowned Russian films, the Soviet government imported hundreds of foreign movies. This was both to raise revenue from the paying audience and to analyze the relationship between a film's technique and the effect on the viewer. "Although viewed with contempt by the Soviet government, American comedies, adventure films, westerns and serials were tolerated because of their popularity with the public," notes Susan Pack in her book on Russian film posters of the 1920s.[84] But "the Bolshevik government frequently changed intertitles so that the plot would communicate the desired political message," John Cuadrado points out in a recent article.[85] American silent film stars such as Charlie Chaplin, Douglas Fairbanks, William S. Hart, Buster Keaton, and Gloria Swanson became prominent in the Soviet Union. By 1928, the number of movie tickets sold yearly had risen to three hundred million and the number of theaters had expanded to seventy-five hundred.[86]

The importing of silent Westerns into the Soviet Union coincided with the peak period of Russian avant-garde film poster production, 1925–29. In 1925, Mikhail Dlugach (1893–1989) designed *Chelovek neizvestno otkuda*, a poster for the 1915 William S. Hart film *The Man from Nowhere* (plate 31). Dlugach's work presents a truly remarkable image, differing completely from American film posters or from any other known image produced before to advertise a Western. In this startling portrait, Hart appears as a snarling and menacing green "incredible hulk," set against a blood-red background. Dlugach explores the character's emotions, and there is no suggestion that Hart is a cowboy hero or that the film is a Western. Unlike its American counterparts, the poster seems mainly intended not to promote the film but to make artistic statements. This proved prototypical of Eastern European film posters in later years. Dlugach's work offered an early indication that when the Western entered Eastern Europe, anything could happen. After World War II, designers of posters for Westerns in Poland, Czechoslovakia, and Yugoslavia, in particular, followed in the footsteps of this master of the Russian avant-garde.

Bolshevik Russia's continuing interest in the Western is graphically illustrated by two other original posters designed by anonymous artists for William S. Hart films screened in Russia around this time. Clearly, Russian poster designers could draw on American promotional materials that accompanied the movies, since both works are based on publicity stills. The poster *Khishchniki Floridy*, from around 1927, is a rich and detailed rendition

31. Mikhail Dlugach (1893–1989)
Chelovek neizvestno otkuda, 1925
(*The Man from Nowhere*, 1915)
Russian poster for the William S. Hart film

of Hart, cornered in a shack, peering anxiously out the window (plate 32).[87] He wears the vest, neckerchief, cuffs, and hat that distinguish him as a cowboy. The artist incorporates interesting angular typographical elements into the poster, some within the rays of a sun. A divided gold and white oblong inset at top left, or to the West, gives the suggestion of a desert. The complex composition, innovative angular elements, subtle use of color, rich detailing, incorporation of typography, and accomplished draftsmanship are typical of the highest quality Russian avant-garde film posters. The poster *Pevets dzhimmi* (after 1926, around 1930?) for Hart's penultimate film *Singer Jim McKee* (1924) uses ten black and white publicity stills from the movie to instill a sense of action into the work (plate 33). The poster itself becomes a kind of moving image.[88] Polish film poster artists followed in the tradition of the Russian avant-garde. After World War II, basing works on "situations" from scenes in the film itself,[89] producing rich color lithographs from publicity materials, and incorporating photographic elements into the design—all became important ingredients of Polish poster art of the Western.

During the interwar years, Eastern European audiences were fed an irregular diet of American silent Westerns, Singing Cowboy movies, nonmusical B-Westerns, and German *Ersatzwesterns*. After World War II, America continued to send films to Eastern Europe. Although international relations between the United States and the Eastern bloc remained at a low ebb throughout the Cold War, the Western again displayed its uncanny ability to transcend political boundaries. Now the primary American export became the A-Western, and the likes of John Wayne, Randolph Scott, Gary Cooper, Kirk Douglas, and James Stewart were added to the pantheon of cowboy heroes.

Eastern Europe also imported American TV Westerns, as well as films produced in Western European countries such as Britain, France, Italy, and Germany. But in addition, Poland, East Germany, Romania, and Czechoslovakia began to make Westerns of their own. *Rancho Texas*, an obscure Polish production made in the late 1950s, was one of the first (plate 34). In the mid-1970s, the amateur Polish filmmaker Jósef Kłyk began making what have become known as Kiełbasa Westerns. Combining Polish and American history, and employing a wide variety of symbols, themes, and icons associated with the genre, thus far Kłyk has completed more than fifty of them.[90]

Less well known than the outpouring of West German or Italian Westerns is the simultaneous flourishing of Western production in the German Democratic Republic, where the state film company DEFA made sixteen Westerns between 1965 and 1985. Many of these were historical biographies of Indian chiefs, such as *Osceola* (1971), based on the life of the Seminole leader (plate 35). The film was shot in Cuba, the island standing in for Florida. Gojko Mitic, a Yugoslav actor who also played other leading Indian roles such as Tecumseh and Ulzana, starred as Osceola. Another frequent performer in these films was Dean Reed, an American Communist who had made his career in East Germany.[91]

Eastern Europeans clearly enjoyed zany humor and parody. The 1971 French-Belgian full-length animated film *Lucky Luke*, featuring look-alike Dalton Brothers,

32. **Khishchniki Floridy**, around 1927
Russian poster for a William S. Hart film

33. **Pevets dzhimmi**, after 1926, around 1930?
(*Singer Jim McKee*, 1924)
Russian poster for the William S. Hart film

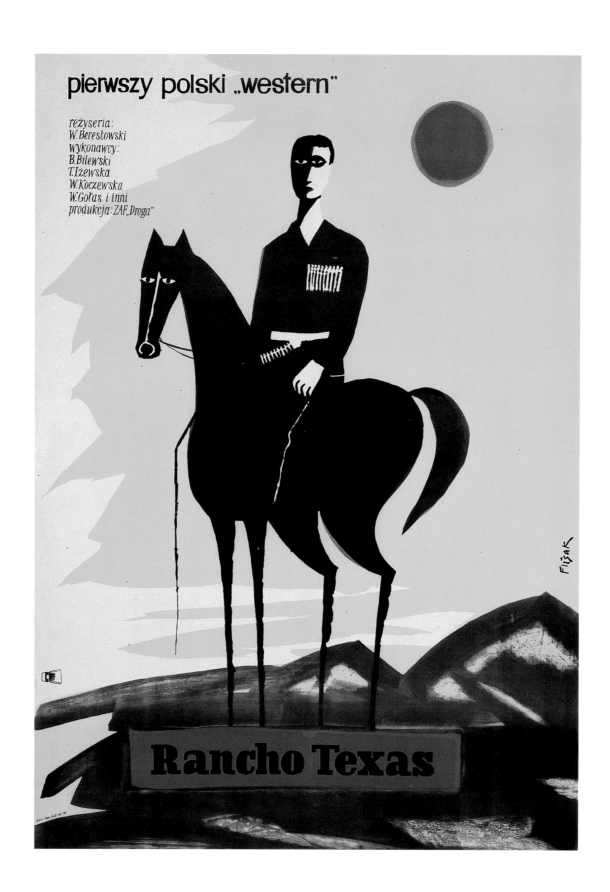

34. Jerzy Flisak (b. 1930)

Pierwszy polski "western," 1959

Polish poster for the Polish film *Rancho Texas*

Lithograph: 83 × 59 cm

35. *Osceola*

East German poster for the 1971

East German film, starring Gojko Mitic

36. *Šampion rodea* (*Junior Bonner*, 1972)

Yugoslav poster for the Sam Peckinpah Western

all of different sizes, an undertaker with a buzzard, and Indians wearing war paint resembling traffic signs, was shown in Czechoslovakia and Poland. The Romanian-produced and humorously titled Western parody *The Prophet, the Gold, and the Transylvanians* meanwhile was popular throughout Eastern Europe in the late 1970s. But surely the best example of how the East could turn the West on its head is provided by the 1964 Czech Western satire *Limonádový Joe* (*Lemonade Joe*). Based on the 1958 play and novel by Jiří Brdečka, this goofball comedy stars Karel Fiala as a singing cowboy hero who derives his strength from Kola-Loka lemonade.[92]

After World War II, and particularly during the thirty-year period that began in the late 1950s, Eastern European graphic artists designed a wide array of original posters for these Westerns. Like the Westerns produced in Eastern Europe, the posters varied substantially in quality, yet they always offered an original, interesting, and visually attractive take on the great American cultural icon. The East German poster for *Osceola* (1971) presents a dramatic image of the Seminole leader appearing Apache-like, mounted at the center of a blazing sun. The Yugoslav poster *Šampion rodea* for Sam Peckinpah's 1972 Western *Junior Bonner* offers a rich color composition of indigo on gold, the border resembling movie clapper boards (plate 36). Czech posters provide good examples of the originality of Eastern European graphic work for Westerns. *Limonádový Joe* shows two blazing guns emerging from a pop bottle bearing the film title (plate 37). The 1978 Czech poster *Prorok, zlato, a Transylvánci* (*The Prophet, the Gold, and the Transylvanians*), like the Romanian movie it illustrates, deconstructs the Western. In this piece, bullets resemble bombs, and our window to the past wears a cowboy hat (plate 38). The 1973 poster for *Šťastný Luke* (*Lucky Luke*, 1971), meanwhile, has the viewer looking down the barrels of a six-gun toting cartoon cowboy puffing skull-shaped smoke rings from his cigarette (plate 39).

Outside of Eastern Europe, only the Soviet satellite Cuba has produced Western film poster art of comparable quality and originality. A striking example is the 1974 work *El ocaso de los Cheyennes* for John Ford's last Western, the 1964 film *Cheyenne Autumn* (plate 40). A simple white cross rises against a matte-black background, its only means of elevation a colored feather. This starkly evocative Cuban poster furnishes a mournful elegy for the plight of the American Indian.

But it was the Poles who raised poster art for the Western to its highest level. Beginning in 1947, Polish artists received commissions to create posters to advertise Westerns. They have produced a truly extraordinary body of work of the highest quality in this genre. Polish posters for Westerns are technically superior, visually more interesting and complex, and intellectually more challenging than those of any other nation. Just as important, they contain messages additional to the films they illustrate, messages meaningful to all.

One need look no further than Andrzej Bertrandt's 1972 poster *Pojedynek rewolwerowców* (*A Gunfight*, 1971) (plate 41). In this extraordinary image, the artist presents a new type of Western superhero, resplendent in symbols and icons. A giant red and orange fist punches its way skyward from beneath the desert floor, its skin a parched and cracked

37. **Limonádový Joe** (*Lemonade Joe*, 1964)
Czech poster for the Czech Western satire

38. **Prorok, zlato, a Transylvánci**, 1978
Czech poster for the Romanian Western parody
The Prophet, the Gold, and the Transylvanians

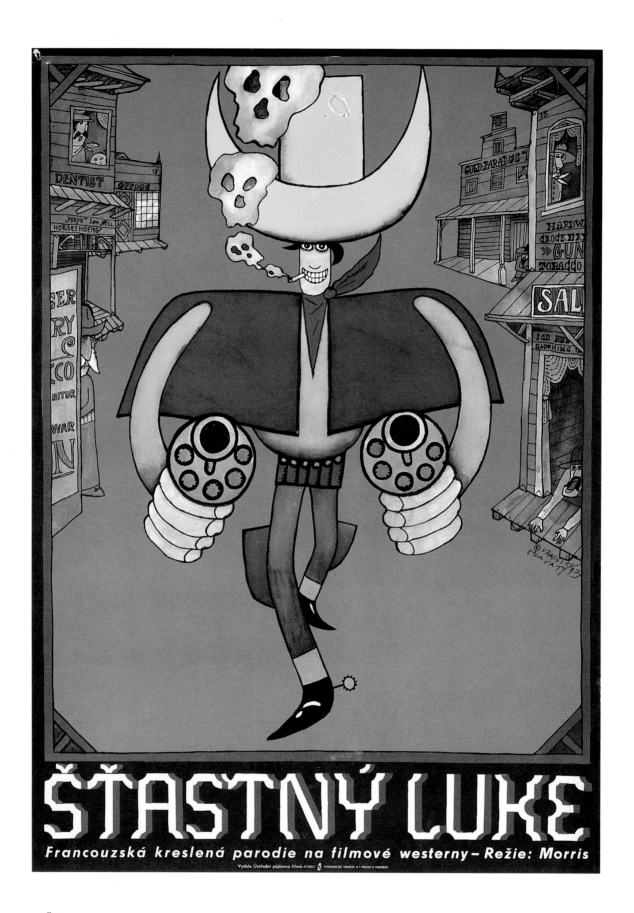

39. Šťastný Luke, 1973

Czech poster for the French-Belgian
animated film *Lucky Luke* (1971)

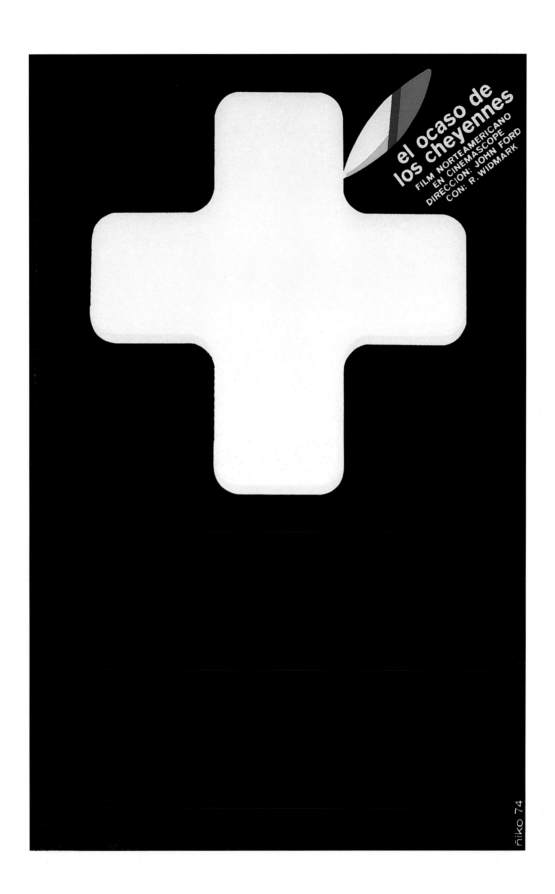

el ocaso de
los cheyennes
FILM NORTEAMERICANO
EN CINEMASCOPE
DIRECCION: JOHN FORD
CON: R. WIDMARK

ñiko 74

40. *El ocaso de los Cheyennes*, 1974

Cuban poster for John Ford's final Western

Cheyenne Autumn (1964)

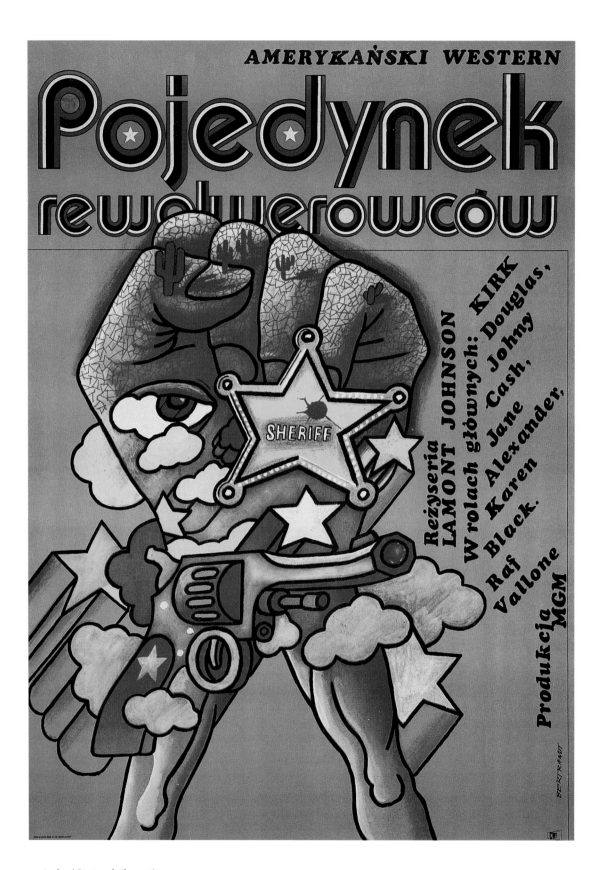

41. Andrzej Bertrandt (b. 1938)

Pojedynek rewolwerowców, 1972

Polish poster for the American film

A Gunfight (1971)

Lithograph: 82 × 58 cm

landscape, cacti protruding from the fingers. The clenched fist, its muscular legs, and its six-gun phallus spell power, but the blood-red bullet hole in the sheriff's badge and the sad eye's cloud teardrops suggest that violence has consequences. The subtly drawn long shadows of the cacti tell us that the sun is setting in the West. Bertrandt's poster is a work of the highest quality, colorful, powerful, dramatic, loaded with suggestion and meaning, and brilliantly executed.

Though highly sophisticated works of art, Polish Western posters are universally accessible. The message is compelling and direct. This is street art: ephemera pasted onto billboards for popular consumption. Through the use of imaginative subject matter, bold imagery, bright colors, and dark humor, Polish poster artists take the viewer to "the far side" of the Western. They challenge fundamental and cherished tenets of the genre. Unlike the films they illustrate, for example, Polish Western posters never portray violence positively. That violence can lead to pain, mutilation, and death is one of the strongest themes running through this body of work.

In these beautiful and complex posters, are the artists commenting on American imperialism, or responding to Poland's colonial history? Is it an American Indian facing the gun barrel or a victim of Nazi invasion or Stalinist occupation? Polish artists clearly see in Westerns themes of aggression and subjugation that reflect their country's recent past, and perhaps their own experience. But creating a poster for a Western becomes more than a way to comment on American imperialism or the Polish colonial experience; it allows the artist to express universal abhorrence of violence as a means of resolving conflict.

How Eastern Europeans have reacted to the Western is a fascinating story, but little known and even less understood. America exported an image of itself through the genre. This was its creation story, a rollicking historical adventure flavored with romance and authenticity. Surely, there could be but one interpretation: a triumph for Manifest Destiny. Yet others would see it another way, especially those with a different history or political viewpoint. In Eastern Europe, the Western became fair game for reinterpretation. Something got lost in translation: America could send out heroes, but villains might land in Poland.

Since the days of Buffalo Bill, Western stars have taken a carnival ride around the world, spreading the word through their movies, music, and appearances. Whether it be Doc Carver in Australia, Broncho Billy in China, Tom Mix in the Middle East, or Gene Autry in Cuba, celebrity showmen have served as international ambassadors for the genre. Now, Japanese World Wide Web sites feature Westerns produced in Italy, shot in Spain, and starring Europeans as cowboys and Indians. Parodies have been made in England, France, Italy, Czechoslovakia, and Romania. And a remarkable body of original poster artwork has been produced in Poland. It seems a long way from the American West, but something about this story has captivated audiences around the world. The Western

embodies the founding myth of the most powerful nation the world has ever known. It is the most successfully marketed national epic in history. It is everywhere. Though they may never visit the American West, people around the world feel at home in its mythology. They own it. Others question it. And still others take exception to it. Love it or hate it, the Western has commanded attention worldwide, and it has demanded a response.

1. See Brian W. Dippie, *Catlin and His Contemporaries: The Politics of Patronage* (Lincoln: University of Nebraska Press, 1990), 97 ff., and William H. Truettner, *The Natural Man Observed: A Study of Catlin's Indian Gallery* (Washington, D.C.: Smithsonian Institution Press, 1979).

2. Charles Dickens, "The Noble Savage," *Household Words*, June 11, 1853.

3. Don Russell, *The Wild West: Or, a History of the Wild West Shows* (Fort Worth, Tex.: Amon Carter Museum of Western Art, 1970), 27.

4. Queen Victoria's diary quoted in Joseph G. Rosa and Robin May, *Buffalo Bill and His Wild West: A Pictorial Biography* (Lawrence: University Press of Kansas, 1989), 118–19.

5. Annie Oakley quoted in Don Russell, *The Lives and Legends of Buffalo Bill* (Norman: University of Oklahoma Press, 1960), 371–72.

6. Remington quoted in Rosa and May, *Buffalo Bill*, 155–56.

7. Quoted in Raymond W. Thorp, *Spirit Gun of the West: The Story of Doc W. F. Carver* (Glendale, Calif.: Arthur H. Clark Co., 1957), 191.

8. Ibid., 198.

9. Posters, scripts, programs, sheet music, advertisements, and reviews for Western melodramas; posters, advertisements, programs, and press clippings for the Cody Family shooting act; posters, handbills, programs, and press clippings for racing tournaments in France, Italy, England, and Germany, are in the Samuel Franklin Cody Collection, Autry Museum of Western Heritage.

10. Bailey C. Hanes, *Bill Pickett, Bulldogger: The Biography of a Black Cowboy* (Norman: University of Oklahoma Press, 1977), 86–109, 122–23, 129–34; Russell, *Wild West*, 82–83.

11. Willard H. Porter, *Who's Who in Rodeo* (Oklahoma City: Powder River Book Co., 1982), 21; information provided by Richard Rattenbury, National Cowboy Hall of Fame.

12. Quoted in Johnny Bond, *The Tex Ritter Story* (New York: Chappell Music Co., 1976), 205–6.

13. Gene Autry, with Mickey Herskowitz, *Back in the Saddle Again* (Garden City, N.Y.: Doubleday, 1978), 127–31 (quotation, 131).

14. L. G. Moses, *Wild West Shows and the Images of American Indians, 1883–1933* (Albuquerque: University of New Mexico Press, 1996), 190–91; Russell, *Wild West*, 4, 40.

15. Ray Allen Billington, *Land of Savagery, Land of Promise: The European Image of the American Frontier in the Nineteenth Century* (New York: W. W. Norton & Co., 1981), 74.

16. Ibid., 30 (Cooper), 37 (Bird).

17. See Hugh Honour, *The New Golden Land: European Images of America from the Discoveries to the Present Time* (London: Allen Lane, 1976; New York: Pantheon Books), 229 (*Les Mohicans*), 120 (Rousseau).

18. Ibid., 220–25.

19. See Billington, *Land of Savagery*, 146.

20. Isaac Goldberg and Hubert Heffner, *America's Lost Plays*, vol. 4 (Bloomington: Indiana University Press, 1963), xix (Murdoch); Allen Gates Halline, ed., *American Plays* (New York: American Book Company, 1935), 379 (Miller); Richard Moody, ed., *Dramas from the American Theatre, 1762–1907* (New York: Houghton Mifflin, 1969), 504 (McCloskey), 727 (Moody); Lonn Taylor and Ingrid Maar, *The American Cowboy* (Washington, D.C.: Library of Congress, American Folklife Center, 1983), 73 (Royle).

21. Christopher Frayling, *Spaghetti Westerns* (London: Routledge and Kegan Paul, 1981), 63; Moses, *Wild West Shows*, 91.

22. Sir William George Drummond Stewart, *Altowan; or, Incidents of Life and Adventure in the Rocky Mountains*, edited by J. Watson Webb, 2 vols. (New York: Harper and Bros., 1846); Sir William George Drummond Stewart, *Edward Warren* (London: G. Walker, 1854). *Edward Warren* is described in the introduction as "a fictitious autobiography." On Stewart, see Dan L. Thrapp, *Encyclopedia of Frontier Biography*, 3 vols. (Glendale, Calif.: Arthur H. Clark Co., 1988), 3:1369–70.

23. Billington, *Land of Savagery*, 43–44 (Reid), 51 (Henty).

24. Ibid., 35–40. For a good recent study of Möllhausen in the American West, see Amon Carter Museum of Western Art, *Wild River, Timeless Canyons: Balduin Möllhausen's Watercolors of the*

Colorado / Ben W. Huseman (Fort Worth, Tex.: Amon Carter Museum, 1995).

25. Billington, *Land of Savagery*, 41–43.

26. Ibid., 48–50.

27. See Frayling, *Spaghetti Westerns*, 103–17.

28. Tassilo Schneider, "Finding a New Heimat in the Wild West: Karl May and the German Western of the 1960s," in Edward Buscombe and Roberta E. Pearson, eds., *Back in the Saddle Again: New Essays on the Western* (London: BFI Publishing, 1998), 143.

29. http://home.t-online.de/home/Karl-May/radebeul (translation by Deniz Göktürk). A number of other interesting Web sites are devoted to May. For a good introduction, see http://www.karl-may.de/ and its many links.

30. Billington, *Land of Savagery*, 317 (Fronval), 318 (Hallbing); Charles F. Olstad, "The 'Wild West' in Spain," *Arizona and the West* 6 (Fall 1964): 192 (Grey), 196 (Spanish authors).

31. Billington, *Land of Savagery*, 319.

32. See entries in James Vinson, ed., *Twentieth-Century Western Writers* (London: Macmillan, 1982).

33. See entry on "Comics" by Denis Gifford in Edward Buscombe, ed., *The BFI Companion to the Western* (London: André Deutsch/BFI, 1988; New York: Atheneum), 95–97.

34. http://www.dargaud.fr/world.luckylukeE.html.

35. Information on French comics supplied by Ann Miller, University of Leicester.

36. All quotations on the worldwide spread of the early Western film are taken from Stephen Bottomore, "'Oh! It's good to watch the guns go BANG!': Audiences for Early Westerns," unpublished paper delivered at a conference on the early Western, University of Utrecht, 1997.

37. Francis M. Nevins, *The Films of Hopalong Cassidy* (Waynesville, N.C.: The World of Yesterday, 1988), 251–53.

38. Tim McCoy, with Ronald McCoy, *Tim McCoy Remembers the West: An Autobiography* (Garden City, N.Y.: Doubleday, 1977), 184–98. *Merthyr Express*, May 20, 1916. Information on Buck Jones provided by Alex Gordon, Vice President, Flying A Pictures, Gene Autry Entertainment.

39. Robert S. Birchard, *King Cowboy: Tom Mix and the Movies* (Burbank, Calif.: Riverwood Press, 1995), 176; Paul E. Mix, *Tom Mix: A Heavily Illustrated Biography of the Western Star, with a Filmography* (Jefferson, N.C.: McFarland, 1995), 175–76, 278–79.

40. Mix, *Tom Mix*, 111–12. Information provided by James Nottage, Autry Museum of Western Heritage.

41. Ibid., 200–202.

42. Autry, *Back in the Saddle Again*, 69–72; Alex Gordon, "I Toured with Gene Autry," in David Rothel, *The Gene Autry Book*, rev. ed. (Madison, N.C.: Empire Publishing Co., 1988), 266–67; additional information provided by Alex Gordon.

43. Robert W. Phillips, *Roy Rogers: A Biography, Radio History, Television Career Chronicle, . . .* (Jefferson, N.C.: McFarland, 1995), 42 (enthusiastic fans); Roy Rogers and Dale Evans (with Carlton Stowers), *Happy Trails: The Story of Roy Rogers and Dale Evans* (Waco, Tex.: Word Books, 1979), 173–74 (quotation).

44. Clayton Moore, with Frank Thompson, *I Was That Masked Man* (Dallas, Tex.: Taylor Publishing Co., 1996), 185, 187, 189. *The Guardian*, March 28, 1998 (British B-Western Association).

45. Quoted in Deniz Göktürk, "How Modern Is It? Moving Images of America in Early German Cinema," in David W. Ellwood and Rob Kroes, eds., *Hollywood in Europe: Experiences of a Cultural Hegemony* (Amsterdam: VU University Press, 1994), 51.

46. Quoted in Göktürk, "How Modern?" 56. See also I. A. Richards, *Principles of Literary Criticism* (London: Routledge & Kegan Paul, 1960), 231.

47. Kristin Thompson, *Exporting Entertainment: America in the World Film Market, 1907–1934* (London: BFI Publishing, 1985), 125.

48. See Robert Anderson, "The Role of the Western Film Genre in Industry Competition 1907–1911," *Journal of the University Film Association* 31 (1979): 19–27.

49. Margaret Dickinson and Sarah Street, *Cinema and State: The Film Industry and the British Government, 1927–84* (London: BFI Publishing, 1985), 12, 17.

50. See Stephen Bottomore, "'One of them cowboy pictyers': Early Western Production Outside Hollywood," unpublished paper delivered at a conference on the early Western, University of Utrecht, 1997; Francis Lacassin, "Joë Hamman a donné aux Français le goût du Western," *Cinéma* 61, no. 59 (1961): 75–83.

51. Quoted in Göktürk, "How Modern?" 62.

52. Luke McKernan, "Cockney Cherokees on the Sky-line: The Peculiar Case of the British Western," unpublished paper. British interest in parodying Westerns was not confined to film. Popular musical recordings provided another vehicle. Charlie Drake's "Please Mr. Custer," 1960, and Benny Hill's chart topping "Ernie (He Drove the Fastest Milk Cart in the West)," 1971, are just two of the better known examples.

53. See the *Nickelodeon Gazette*, no. 70, April 24, 1997, 26–27, published by the Centro Espressioni Cinematografiche, Udine, Italy; see also Göktürk, "How Modern?" 61.

54. See Schneider, "Finding a New Heimat," passim. It was reported recently that a Winnetou revival is

under way, with talk of a Hollywood production. The German public channel ZDF recently broadcast a new two-part miniseries entitled *Winnetou's Return*, with the aging Indian still tracking down villains at sixty-seven. However, a trademark battle is being waged in Germany which threatens to keep May's seemingly ever popular Indian hero within Europe. See *Hollywood Reporter*, May 12–18, 1998, 14.

55. The definitive work on this topic remains Frayling's *Spaghetti Westerns*. See also Thomas Weisser, *Spaghetti Westerns—the Good, the Bad and the Violent: a Comprehensive, Illustrated Filmography of 558 Eurowesterns and Their Personnel, 1961–1977* (Jefferson, N.C.: McFarland, 1992).

56. Frayling, *Spaghetti Westerns*, 280.

57. http://www.pscweb.com/macaroni/.

58. http://www.pscweb.com/macaroni/eurol.html; *Nickelodeon Gazette*, no. 70, April 24, 1997, passim.

59. André Bazin, *What Is Cinema?* translated by Hugh Gray, vol. 2 (Berkeley: University of California Press, 1971).

60. J.-L. Rieupeyrout, *La grande aventure du western, 1894–1964* (Paris: Editions du Cerf, 1964); Jean-Louis Leutrat, *Le western* (Paris: Armand Colin, 1973); Leutrat, *L'Alliance brisée: Le western des années 1920* (Lyon: Presses Universitaires de Lyon, 1985); Leutrat, *John Ford: La prisonnière du désert* (Paris: Adam Biro, 1990); Leutrat and Suzanne Liandrat-Guigues, *Les cartes de l'ouest: Un genre cinématographique: le western* (Paris: Armond Colin, 1990); J. Mauduy and G. Henriet, *Géographies du western* (Paris: Nathan, 1989).

61. Joe Hembus, *Das Western-lexikon: 1324 filme von 1894–1978* (Munich: Heyne, 1978).

62. The German Association for the Study of the Western, *Newsletter* 1, no. 1 (1990–91): 2, 30–31.

63. Carlo Gaberscek, *Sentieri del western: Dove il cinema ha creato il west* (Pordenone: Edizioni Biblioteca dell'Immagine, 1995).

64. Chicago Corral of the Westerners, *The Westerners Brand Book* 13, no. 10 (December 1956): 76.

65. Information on Westerners International has been drawn from Julia Foster, "Spellbound by the West," *The Rotarian* 162, no. 3 (March 1993): 58; Paul Gelleher, *The Westerners: A Mini-Bibliography and a Cataloging of Publications, 1944–1974* (Glendale, Calif.: Arthur H. Clarke Co., 1974), 4, 5, 10, 16, and passim; J. E. Reynolds, *History of the Westerners*, reprinted from the Los Angeles Corral of the Westerners, *The Westerners Brand Book* no. 7 (Los Angeles: Press of Homer H. Boelter, 1957), passim; *The 1998 Tally Sheet*, Westerners International, 1700 Northeast 63rd Street, Oklahoma City, OK 73111; Fred Egloff, "WHA and Westerners Long-time Friends," *The WHA Newsletter* (Newsletter of the

Western History Association), Spring 1998, 2, 6. Thanks to Don Reeves of the National Cowboy Hall of Fame for providing additional information on the organization. For the Czech corrals' Web sites, see http://www.terminus.cz/wi-cz/ and its links.

66. Information on television Western exports supplied by William Boddy. See also *Business Week*, September 27, 1958, 156 ff., and April 23, 1960, 129 ff.; and *Look*, December 1, 1964. On Britain see Tise Vahimagi, *British Television: An Illustrated Guide*, 2d ed. (Oxford: Oxford University Press, 1996).

67. See Edward Buscombe, "Coca-Cola Satellites? Hollywood and the Deregulation of European Television," in Tino Balio, ed., *Hollywood in the Age of Television* (Boston: Unwin Hyman, 1990), 393–415.

68. Information provided by Elizabeth Wallenius.

69. Jim Bob Tinsley, comp., *For a Cowboy Has to Sing* (Orlando: University of Central Florida Press, 1991), 211–16.

70. Anita Chaudhuri, "Round 'Em Up," *Sunday Times* (London), November 9, 1997; Foster, "Spellbound," 33, 58.

71. http://www.asahi-net.or.jp/~DB5H-SZK/nagoyacf/Martha/country-dance-in-japan.html.

72. http://www.mad.fi/cwst/index.html.

73. See *Bear Family Records 20 Years, 1975–1995* (music catalog) (Vollersode, Germany: Bear Family, 1995?); and their Web site at http://www.bear-family.de.

74. Foster, "Spellbound," 33.

75. Michael Steiner, "Frontier as Tomorrowland: Walt Disney and the Architectural Packaging of the Mythic West," *Montana* 48 (Spring 1998): 4.

76. Foster, "Spellbound," 33.

77. Steiner, "Frontier as Tomorrowland," 5.

78. Shanna Smith, "Where the Buffalo Roam: 20 Kilometers de Paris," *Disney Magazine*, Fall 1995, 26–28.

79. *Buffalo Bill's Wild West Show, Disneyland Paris*, Programme (n.p.: n.d.), 32.

80. William H. Goetzmann and William N. Goetzmann, *The West of the Imagination* (New York: Norton, 1986).

81. Thorp, *Spirit Gun of the West*, 184–90.

82. Moses, *Wild West Shows*, 189.

83. Bottomore, "Audiences for Early Westerns."

84. Susan Pack, *Film Posters of the Russian Avant-Garde* (Cologne and New York: Taschen, 1995), 16–17.

85. John A. Cuadrado, "Russian Film Posters: Revolutionary Images from the 1920s Avant-Garde," *Architectural Digest* 55 (April 1998): 264.

86. Ibid.

87. This Russian poster draws heavily on a still for *The Silent Man* (1917), reproduced in Diane Kaiser Koszarski, *The Complete Films of William S. Hart:*

A Pictorial Record (New York: Dover Publications, 1980), 79.

88. Georgii and Vladimir Stenberg, the most famous of the Russian avant-garde graphic artists, also designed a poster for *Singer Jim McKee* in 1927. This dramatic work concentrates on the conflicts affecting Hart's character. See Pack, *Film Posters*, 156–57.

89. Mildred Constantine and Alan Fern, *Revolutionary Soviet Film Posters* (Baltimore: Johns Hopkins University Press, 1974), 9.

90. Information provided by Frank Fox.

91. See Frank-Burkhard Habel, *Gojko Mitic, Mustangs, Marterpfähle* (Berlin: Schwarzkopf & Schwarzkopf, 1997); and *Nickelodeon Gazette*, no. 70, April 24, 1997, 29.

92. Richard P. Krafsur, ed., *The American Film Institute Catalog of Motion Pictures: F6, Feature Films, 1961–1970* (New York: R. R. Bowker Co., 1976), 606–7.

42. Tomasz Sarnecki (b. 1966)

Solidarność, 1989

Polish election poster based on the

American Western *High Noon* (1952)

Lithograph: 100 × 70 cm

POLAND AND THE AMERICAN WEST

Frank Fox

I N INDEPENDENCE, MISSOURI, ON MARCH 12, 1999, BRONISŁAW Geremek, the Polish Minister of Foreign Affairs, concluded a speech celebrating Poland's entry into NATO by saying, "We have brought from Poland some records of history of our road to freedom, among them — the poster of [the] 1989 elections with a picture of Gary Cooper from the film *High Noon*. It helped us to win. For the people of Poland, high noon comes today."

Tomasz Sarnecki had transformed a publicity still of Cooper striding down the street in the famous film into a campaign poster designed for the crucial 1989 elections, which had helped to bring the outlawed Solidarity and its leader, Lech Wałęsa, to power. Significantly, in the new version, Cooper clutches in his right hand a folded ballot and sports the *Solidarność* logo above his sheriff's badge. The logo is also emblazoned in red across the poster, behind Cooper's head. The message at the bottom is short and to the point: "W Samo południe, 4 Czerwca 1989"—It's High Noon, June 4, 1989 (plate 42).

On the eve of balloting, the Sarnecki poster was displayed all over Poland. There was hardly a polling booth without it. Now, however, it is almost impossible to find, since it has become a valued historical artifact. Another poster that summoned people to vote for Solidarity that year featured an alarm clock, the hands fixed on the approaching noon hour (plate 43). It was clearly related to *High Noon*, for in that film, time's inexorable advance became the driving force behind the confrontation. At polling booths across the country, the alarm clock poster reminded the electorate, "Don't sleep because they will outvote you" (figure 5).

Fig. 5. Solidarity information table at a polling station, 1989

Photograph copyright Erazm Ciołek

High Noon, first released in Poland seven years after its 1952 American premiere, had been shown there several times since 1959. Two different posters were designed for the film. Marian Stachurski created the original poster in 1959, and Grzegorz Marszałek designed one for the reissue in 1987 (see plates 103, 157). Each displayed the heroic figure of the sheriff. Obviously something in this one man's act of courage and sense of honor appealed to the Polish people. A population frightened and forced into submission identified with someone who overcame fear and fought against all odds. In its June 1, 1997 analysis of the 1989 election, the Warsaw newspaper *Rzeczpospolita* (*Republic*) concluded, "Solidarity's list of virtues had in it something of a Western." Indeed, an American Western was an apt symbol for a political duel that marked the beginning of the end for communism in Eastern Europe. Gary Cooper would have approved.

Ironically, almost a decade before Solidarity supporters pasted up Cooper's image on walls and kiosks of Polish cities, Poland's Communist leaders and their patrons in Moscow launched a campaign to compare America to a different kind of Western. They dubbed President-elect Ronald Reagan a "reckless cowboy" and questioned "just what the new cowboy in the White House would do." Polish posters appeared with variations on this theme. In 1982, a dark and sinister poster by an unknown artist purported to advertise a movie titled *The World in the American Way*, produced by and starring Reagan, pictured in cowboy gear (plate 44).

Another of the anti-American posters of the early 1980s traced the voyage of Columbus from Spain to the New World and featured a telegram addressed to Reagan. It read, "Now why did I have to discover America?" and was signed "Christopher Columbus." The Polish Communist poster posed a question that has confounded many since the first colonists arrived on America's shores. Even those who saw America as a beacon of hope for mankind could not ignore the displacement of the indigenous populations, or the bloody conflict over slavery. Long before the Cold War controversies, Americans themselves had confronted the many meanings of Columbus's voyages and the continental expansion that followed.

It could be argued that America's relationship with its expanding frontiers has defined U.S. history. Conquest of territory and native peoples played a vital role in the development of a national identity. America has refashioned this theme in myriad ways. The expansionist rationale and the mythology that accompanied it have been deemed inevitable. President Theodore Roosevelt, who enjoyed celebrating heroes of the West, asserted that the United States had no choice: geography and history had made its leadership in the world unavoidable. The only question was how well America would discharge its mission.

Peter Schweizer's study of the Reagan administration provides an invaluable history of a president who sought to ensure America's role as world leader by hastening the end of a system he once called an "evil empire." Schweizer describes this as "the greatest geopolitical event since the end of the Second World War." The story reads like a movie

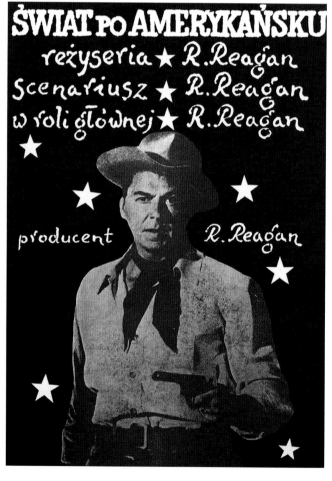

43. Nie śpij bo cię przegłosują, *Solidarność*, 1989

Polish election poster

Lithograph: 43 × 30 cm

44. *Świat po Amerykańsku*, 1982

Polish anti-America propaganda poster

Lithograph: 67 × 48 cm

script: An American president, aided by a Polish-born National Security Council adviser, Richard Pipes, and a Polish pope, John Paul II, not only elevated Solidarity to leadership in Poland but also brought about the end of an empire considered until then a super-power. Schweizer identifies a global strategy in which a succession of Russian leaders from Brezhnev to Gorbachev were outmaneuvered by the American "cowboy" until the Polish leader General Wojciech Jaruzelski, who had imposed martial law on his countrymen in December 1981, agreed to hold a national election in 1989.[1]

Michael Dobbs has commented on the importance of political posters in that election. Each of the candidates opposed to the Communist government had a photograph taken with Lech Wałęsa, the leader of Solidarity, for use in campaign posters. But, as Dobbs put it, the most famous poster of all was yet to come: "Shortly before the election Solidarity had designed a final campaign poster that summarized what was at stake after forty-four years of uninterrupted Communist rule. It was a photo of the actor Gary Cooper in full cowboy regalia." The election results were stunning, and even though Jaruzelski continued as president, Solidarity was transformed from an outlaw political organization into a governing party. Like Gorbachev in the Soviet Union, the Polish Communists thought they could control the elections by turning on a faucet, only to be confronted by a rushing river. The guys in white hats had won.[2]

I visited Warsaw in November 1989, a time filled with expectations in the wake of the preceding June's electoral victory. One of the artists I came to interview urged me to see the exhibit *Labirynt*, displayed in an unfinished church in the Warsaw suburb of Ursynow. He knew of my interest in Polish posters. "See it," he urged me. "It will tell you why our poster art is so different." To study Poland's history, it must first be exhumed. At *Labirynt* there were photographs of newly discovered mass graves side by side with old burial sites. The exhibit included small, chapel-like alcoves where artists had assembled discovered objects from that impoverished country. The final assemblage was the most moving. In a tiny room, faith was reduced to a single symbol, a loaf of bread in the middle of a crude table. The age of lies has left a terrible void. In Poland, perhaps more than in any other country, a land whose soil has absorbed the blood and ashes of millions of innocents, the veneration of symbols has assumed a deep spirituality. No one who has seen the tortured images in the work of Franciszek Starowieyski can doubt that this century's cataclysmic events have profoundly influenced Poland's poster artists.

The American West came to Poland with its own universally recognized symbols—the cowboy hat, the boots, the horse, the sheriff's star, and the revolver. Its remarkable history had already been reduced to a convenient set of icons. Polish poster artists, sensitive to the power of symbols, adopted Western iconography enthusiastically. Recognition saved time and space. A Colt, Winchester, or Stetson immediately placed the poster geographically and historically in the Old West. But Western symbols also brought associated ideas. This was America in microcosm. Polish poster artists might incorporate the West's symbols into their work, but they need not subscribe to the myth. The story could

be reinterpreted, and messages added. The revolver, classic symbol of "the winning of the West," could become a weapon of mass destruction, and its bearer a cold-blooded killer. The cowboy, American hero though he might be, could represent one of Stalin's henchmen. The cavalry could become Cossacks, or Nazi thugs. The Polish viewer, familiar with seeing and interpreting symbols, would find meaning in the artists' Western posters. The message found its way to the street.

Shortly after my visit to *Labirynt*, I became aware of another reason why Polish posters are so unique. I was still in Warsaw when Soviet monuments were being dismantled, and statues of Lenin and Stalin were being knocked off their pedestals all over Eastern Europe. The day before I was to leave, I read in a newspaper account that the Mayor of Warsaw proposed moving into storage the statue of Feliks Dzerzhinski, founder of the Soviet secret police and inventor of state terrorism. It was explained, though no one believed it, that this was necessary for the construction of the subway, a project begun before World War II. The statue had been the object of public scorn for some time—with students painting the nose and fingers different colors each week. When a friend phoned to tell me that students were making their way to the statue, I grabbed my camera and tape recorder and hurried to Dzerzhinski Square.

By the time I arrived, a crowd had assembled. A young girl draped herself with a black shawl and mockingly placed a bunch of flowers at the base of the statue. Another student pried the brass letters off the front so what had previously read *Duch* (soul) of the revolutionary movement now, with other letters crayoned in, spelled *Dupa* (behind). Hand-painted posters were taped to the base of the statue. "Keep your hands off Feluś" (a diminutive for Feliks), one poster proclaimed. Another pleaded, "Felek, don't leave us." A third was signed "The Association for the Defense of Feliks Dzerzhinski," with the lettering resembling that in the famous *Solidarność* logo. These posters were made on the spot by students from the nearby school of architecture, painted on the back of drafting sheets. Here was an example of Polish poster-making at its best: impulsive and daring, with a wicked sense of humor. The *Labirynt*, with its iconography of suffering, was one source for the symbols that have characterized so many Polish posters. The spontaneous, playful defiance of authority as displayed by the students in Dzerzhinski Square was another.

The evening before I was to leave Poland, I sat with the well-known poster artist Jan Młodożeniec in his living room and watched Lech Wałęsa on TV giving a speech before a joint session of the U.S. Congress. This was indeed a great honor, and the ovation Wałęsa received lasted for more than ten minutes. Młodożeniec and his wife were visibly moved. I remembered that Młodożeniec enjoyed designing posters for American Westerns. When I bought my first poster collection from a young Polish student of filmmaking in New York, he compared Młodożeniec's style to that of a sheep shearer. He likened the artist's rough and angular cut-paper effect to the quick and precise snipping that takes place at

wool-shearing time. Młodożeniec's art also has the intensity and directness of a cartoon or a cinematic cut, and seemed to me to draw its strength from an American model.

Młodożeniec's 1973 poster *Amerykański zachód* (*The American Way*), produced for an exhibition of paintings that traveled from the Amon Carter Museum in Fort Worth, Texas, and was displayed at the National Museum in Warsaw, confronts us with an image that in its simplicity and directness encompasses the story of the West (plate 45). A huge cowboy hat lies astride the prairie-green expanse. At the top of the hat, two sheriff's badges hang like stars in the indigo blue of the sky. At bottom left, an image representing the American flag suggests the ultimate victory of Manifest Destiny in the West. To the right shine the pink and red rays of a sun. The sun has frequently been used as a symbol to portray the West, but not always optimistically. The sun always rises in the East, but it sets in the West.

While the pattern in the United States was one of expansion without much regard for the native population or the boundaries of neighboring countries, Poland's story was of diminishing space, increasing impoverishment, and eventually loss of independence. Whereas violence in America's expansion westward gave rise to mythical heroes and accorded even outlaws a prominent place, in Poland opposition to foreign rule brought humiliation and martyrdom to its patriots. Poland saw itself increasingly as the "Christ of Nations," victimized by rapacious neighbors. And as America became the home for a growing number of European immigrants, Poland saw its people leave in successive waves until its history came to be written in terms of emigrations.

While Poles might admire the rugged individualism associated with westward expansion, they could feel sympathy for those subjected to the process. They also could bear witness to the ravages of violence. Until the eighteenth century, Poland was a major power in Europe, its territory at times extending from the Baltic to the Black Sea. This was to change dramatically. The internal squabbles of the Polish aristocracy led to the election of foreign rulers as kings of Poland. In 1772, after the First Partition, Poles lost 30 percent of their land and more than 33 percent of their population to neighboring Russia, Prussia, and Austria. Like other oppressed nationalities, the Polish people looked more and more to newly independent America as a symbol of their own struggle.

In a last effort to strengthen their society, patriotic elements undertook to reform many of Poland's institutions and even modeled their great Constitution of May 3, 1791, in part on that of the United States. But in spite of these reforms, Poland succumbed to a Second Partition in 1793, and the Russian forces defeated the insurgent Poles. The Third Partition in 1795 signaled the end of the Polish state. In a world where national sovereignty was sacrosanct, this was an unprecedented humiliation. American writers and the press praised Poland's struggles. Each of the abortive uprisings against Russia, in 1830 and 1863, led to an outpouring of public sympathy and financial support for the Polish cause and resulted in an influx of refugees. Many of these Poles were scattered throughout the United

45. Jan Młodożeniec (b. 1929)

Amerykański zachód wystawa obrazów, 1973

Polish poster for an American exhibition of Western paintings

that traveled from the Amon Carter Museum, Fort Worth,

Texas, to the National Museum in Warsaw in 1974

Lithograph: 96 × 66 cm. Gift of Frank Fox

States, as far west as Ohio. The press was filled with accounts of Russian perfidy and Polish bravery.

Jacksonian America was swept by a wave of Polonophilia. In 1832, Józef Hordynski published his *History of the Late Polish Revolution, and the Events of the Campaign*, helping to stir interest in Poland's independence.[3] The Russian diplomats complained bitterly, only to have their chargé declared persona non grata and expelled. The Poles formed a committee that became the first Polish organization in America. Congress offered the newcomers a choice of land in either Illinois or Michigan. In 1834, President Andrew Jackson signed the bill into law, but due to strains within the exiled community, opposition by local inhabitants, and lack of funds, the land was eventually forfeited. Letters home to Poland from these exiled patriots reflected the reality of the immigrants' lot. Their experiences contrasted sharply with the romanticized versions portrayed in popular media. One wrote about his job at a tanner's: "I worked even though blisters grew on my hand . . . but now they tell me to crawl on roof tops and stretch the stinking hides from roof to roof and when I fell to the ground I became so pained that I cast it all aside and now I am like a madman without lodging and without food and if I knew that I would be of some use to the Motherland I would change this miserable existence." Another wrote, "We have nothing here to live for except as colonists committing an act of national suicide." Nonetheless, many remained.[4]

The California gold rush accelerated the arrival of many Europeans, including Poles. A Polish topographer, Felix Paul Wierzbicki, who had settled in San Francisco in 1848, the next year published *A Guide to the Gold Region*. Wierzbicki's *Guide* was the first book in English to be printed in California and the first book published in San Francisco. It went into a second expanded English edition that same year, and in 1850 was published in Germany. There was even a Tasmanian edition. Clearly, the work was much sought after by prospectors traveling to the gold fields.[5] Alexandre Holinski, a mapmaker of the California gold rush region, in 1853 published in Belgium a work titled *La Californie et les routes interoceaniques*,[6] and suggested that a canal be dug across the isthmus of Panama. Holinski and Wierzbicki were representative of a remarkable group of Polish topographers who played a major role in mapping new territories. Aside from these educated Polish refugees, and stimulated by a decline in agriculture, the pressures of industrialization, onerous taxes, and efforts at Germanization, more Polish farmers emigrated from the region of Silesia in 1855–56.

During the American Civil War, the Confederacy encouraged plans to settle Poles in Texas to fight on the side of the South. For that purpose, some 30,000 acres were set aside for these immigrants on the Trinity River in 1864. This area was to be called New Poland. The project did not get off the ground because of criticism by Polish emigrants in Europe.[7] On the other hand, a Democratic Society of Polish Emigres that condemned slavery and leaned to the more radical Republican Party organized a Polish Legion to fight

for the North. The Confederate "Polish Brigade" and the Union "Polish Legion" took part in important battles in the Virginia and Gettysburg campaigns.[8]

The story of one such migration from Upper Silesia to the United States has retained a special place in the history of Polish connections with the American West. Father Leopold Bonaventura Maria Moczygemba, a Franciscan monk recruited by the bishop of Galveston in 1852 to help settle Germans in remote regions of Texas, was so pleased with the results of his work that he urged his Polish compatriots to migrate to the New World. Attracted to America by the promise of land, in December 1854 Moczygemba led 159 families from Upper Silesia. These 800 farmers reached Galveston after a voyage of nine weeks and established Panna Maria (Virgin Mary), a settlement sixty miles southeast of San Antonio. Land was purchased at seven dollars an acre, to be repaid within twelve years. Additional acreage was acquired for a church and school. Fifteen hundred other emigrants eventually joined their countrymen at the colony. Panna Maria amounted to the first sizable Polish settlement in the United States. Its founding signaled the beginning of significant emigration of Polish farmers to the American South and West.

A witness to the landing of the Polish farmers in Galveston provided this description: "They wore the costumes of the old country. Many of the women had what at that time were regarded as very short skirts showing their limbs two or three inches above the ankle. Some had on wooden shoes and . . . wore broad-brimmed, low-crowned black felt hats, nothing like the hats worn in Texas." The Silesian Poles carried their plows, bedding, kitchen utensils, and a large crucifix from their former parish. They traveled inland behind ox carts whose drivers wore broad sombreros and striped blankets. As described by one writer, "Sheltered in rough-hewn pole cabins and sod houses, the Silesian immigrants withered in the dry Texas climate and faced the constant perils of grasshopper plague and hostile Indian attack."[9]

It proved a disappointing venture. This first permanent Polish settlement in the United States was plagued by drought and debt. As one writer put it, "They had come expecting a land of milk and honey and found a prairie full of rattlesnakes." There were many complaints. On May 13, 1851, the Polish newspaper *Goniec Polski* (*The Polish Messenger*) reflected on these complaints, undoubtedly with the intention of discouraging more departures of able-bodied men. "Nearly everybody is dreaming and chattering of America and a California abounding in gold while willingness to work ebbs ever more visibly. One is considering selling all his chattels to cover the costs of the pilgrimage, another is willing temporarily to sell his freedom in exchange for the price of the trip. . . . [A] fortnight ago two Poles set out from here and the loss of one of them, a capable cabinetmaker, is most regrettable." On September 7, 1854, another paper reported that 150 persons had departed for Texas, and by December 1855 another 700 had left Silesia for America.[10]

In 1856 a drought forced many of the Silesian farmers to leave Panna Maria. Some formed a settlement at St. Gertrude, Missouri, which they renamed Cracow. Since many were known to be Union sympathizers, the Silesians were not popular among their south-

ern neighbors. In fact, U.S. cavalry had to be summoned to protect the Polish settlers in Missouri after the Civil War. Eventually Moczygemba left Panna Maria. Father Bakanowski, who succeeded him, wrote about the many difficulties experienced by the remainder of the Silesian community. The church had bare walls and but one bed, so his assistant had to sleep on the floor. Bakanowski traveled to other communities with a dog to protect him against jackals that were drawn to the camp site by the smell of kiełbasa cooked over an open fire. Still, in spite of Indian raids and other problems, the community expanded. A "Polish corridor" was eventually created, and the number of Poles in Texas grew appreciably.

The 1860 census listed 7,200 Poles living in the United States, a figure that should have been closer to 30,000 since many were counted as nationals of other powers. By 1870, there were more Polish settlements in the Texas Panhandle, with names such as Bandera, St. Hedwig, Czestochowa, Kosciuszko, and Polonia. There was also a Polonia, Wisconsin in 1858, as well as such settlements as Pulaski, Kazimierz, Poniatowski, Cracow, and Sobieski. More and more Poles settled in Ohio, Indiana, Arkansas, Oklahoma, Illinois, and Missouri. Many others came to the United States after the second abortive uprising against the Russians in 1863. But the harsh reality of those experiences, the poverty and the ethnic segregation, whether on the Texas plains or in the California gold fields, typically stood in stark contrast to the romanticized plot lines of popular fiction and, later, Westerns.

The Polish writer Henryk Sienkiewicz spent two years in the United States and described his stay in his letters from America.[11] In these accounts, originally printed in a Warsaw newspaper and read widely in Poland, Sienkiewicz described scenes in the American West. He also used them to great effect in his books on Polish history, particularly when describing struggles with the Cossacks, whom he compared to American Indians. In a recent introduction to an English translation of *With Fire and Sword* (originally published 1884), Jerzy R. Krzyzanowski described the "two happy and exciting years" Sienkiewicz spent in the West, "traveling down the great rivers and across the continent in the time of wagon trains, stage coaches and Indian campaigns, hunting, fishing and camping in the Sierras. . . ." Krzyzanowski noted that Sienkiewicz's comments on the Ukrainian Steppes sounded very much like a description of the American West. "The young Polish writer wandering through the prairies, breathing the vastness of America and the variety of its many people, while George Armstrong Custer made his last stand at the Little Big Horn and the great Indian nations of the Plains receded into history."[12]

It says something about the power of imagination that Sienkiewicz, who was never in the legendary "wildlands" on the border of the seventeenth-century Polish-Lithuanian Commonwealth, was able to use his impressions of the American prairie to such good effect. In *With Fire and Sword*, he described a sea of grass, where a man might ride unseen for days, like a "diver drifting through an ocean." He used a boat journey down the Mississippi to describe a voyage down the Dnieper River. He recalled the sight of huge reptiles,

much more likely remembered from his travels in the West than ever seen in the Ukraine. And when Poles were finally overwhelmed by Tatars, the scene resembled Custer's Last Stand, with brave Poles substituted for the Seventh Cavalry. Indeed, the themes that occupied Sienkiewicz's work—themes of freedom, struggle over territories, and a fight for national independence—were very much a reflection of his experience in the United States. Utilizing the American West to look at Poland was an idea that also would emerge much later in Polish poster art of the Western.

The bloody campaign in Poland's borderlands was a mirror image of what was happening in the United States. Sienkiewicz, however, seems to have had more affinity with the outnumbered Indians than with the aggressive cowboys. This idea deserves closer examination. Poles, who often have viewed themselves as history's victims, might have been expected to side with the cowboys in their efforts to protect their land, property, and families from "savage" Indians. Yet the Polish people, unable to play the role of gun-toting cowboys in their own tragic history, tended to identify with the Indians, a minority trying to survive on ancestral lands in the face of aggression, and yearning for former glories. This idea is reflected in a number of Polish posters for Westerns: sympathy for and empathy with the underdog, the outgunned, the victim—whether it be the American Indian or the Gary Cooper character in *High Noon*—is a central theme running throughout this body of work.

Sienkiewicz's letters show his love for the American West, mixed with a sense of awe for that vast expanse. He bemoaned the coming of the railroads and the displacement of the Indians. "There is nothing more depressing than [railroad tracks] across the prairie," he wrote:

At the top of the telegraph poles were attached horizontal crossbars, giving the appearance of crucifixes. All around stretched a grey, endless plain covered with sweetbroom and occasional patches of snow, and the long row of crosses, sad and funereal, as far as the eye could see. They seemed to mark the path leading into the valley of death, or to represent monuments upon the graves of wanderers.

They are really monuments. They mark the graves of the original inhabitants of this land. Wherever such a cross appears, there people, forests, buffaloes will perish; there will perish the virginity of the soil. Today's vast silence will be transformed into the hubbub of men selling, buying, cheating, and being cheated. On the graves of the Indians a learned professor will discourse upon the rights of nations. Over the lair of the fox a lawyer will set up his office. Yonder where the wolf roamed, a priest will tend his flock. Alas! the chase of humanity after what seems to be happiness will be no more successful than the chase of a dog after his own tail.[13]

Sienkiewicz's reference to postmortem discourses on the rights of nations was more than a familiar echo of Poland's tragic past. His dark vision of an American western paradise lost to progress stood in stark contrast to the literature and art of Manifest Destiny. In designing works for Westerns, a number of Polish poster artists have returned to Sienkiewicz's vision, incorporating Christian symbols into images of death and destruction.

Sienkiewicz's account of his first meeting with Indians showed where his sympathies lay. "For me this was a real joy and surprise," he wrote in one of his letters. His party had come across a delegation of Sioux traveling east to meet with President Grant. "They sat quiet and motionless . . . like bronze statues. The surrounding crowd was obviously very hostile toward them. 'God damn you!' 'Pest on you!' and other typical American profanities were constantly hurled at them." Sienkiewicz compared the stoic Indians to the rowdy westerners:

The unruly conduct of the white men was in striking contrast to the stolidity of the red warriors. They looked at no one, wondered at nothing. . . . Indians possess the same violent passions common to all children of nature, but according to Indian standards, only a woman, or a man unworthy of the name, reveals what is happening within her soul. The true warrior is master of his emotions. While his soul seethes with an insane rage, he can look upon his victim with that impassive expression which makes one's blood curdle. On the other hand, when he has been captured by enemies and tied to the torture stake, he will not betray his pain by even the slightest twitch of his muscles. . . . Such is the Indian Code.[14]

"The Sioux," Sienkiewicz wrote, "are trying to preserve at least the appearance of that stoicism which constitutes a strange yet admirable trait of this half-savage race, a race which has produced . . . ideals which belong only to peoples of a high intellectual development." These were qualities that Poles could respect. When he learned of the defeat of General Custer by Chief Sitting Bull, Sienkiewicz was quick to praise the bravery of the Sioux.

On the other hand, Sienkiewicz was impressed by the potential for independence and individuality in America, especially when compared with the efforts at Germanization and Russification imposed on his countrymen at home. "Never does it even enter the heads of the Americans or their Government to attempt to Americanize anybody," he wrote admiringly. "If Germans establish a settlement, they call it Berlin, the French call theirs Paris, the Poles—Warsaw, the Russians—St. Petersburg. . . . A town could even be named Shanghai and to an American it would not matter." He discussed at length, and somewhat optimistically, the Polish settlements, including Panna Maria: "Although their condition is far from opulent . . . they are able to satisfy their needs and their earnings are sufficient to build churches, establish schools, and defray municipal expenditures." Nevertheless, Sienkiewicz eloquently expressed the sense of loss associated with exile:

Whether on the shores of the Great Lakes or the Pacific Ocean those who have been born in the fatherland will not forget it and will remain faithful to it. Settlers in Illinois and in Texas preserve lumps of Polish earth as if they were relics. These they place in the coffin under the head or over the heart of the deceased. . . . Today on the prairies of Nebraska and Arkansas many a Polish peasant pauses to ponder and frequently to weep as he strikes his scythe against the whetstone, for the sound reminds him of his native village. Or somewhere under the hot skies of Texas when the church organ resounds and the people begin to sing "Holy Father," their eyes fill with tears and their peasant thoughts wing their way back across the ocean like sea gulls and return to the thatched huts of their native Poland.[15]

This account of the lives of Polish immigrants differs substantially from that of another student of Polish migrations. The prominent Polish-American sociologist Florian Znaniecki, in a pioneering work written with William I. Thomas, *The Polish Peasant in Europe and America*, produced a valuable analysis of the attitudes of Polish immigrants.[16] First published in five volumes between 1918 and 1920, Znaniecki's work reproduced many bitter letters from Polish husbands, fathers, and sons who came to America to earn money for themselves and their families back home. Znaniecki makes clear in his account that the Polish immigrants remained more ethnically segregated from mainstream America than other groups. More than two million Poles arrived in the United States between 1880 and 1910. Many were young farmers who provided unskilled labor for packinghouses, textile mills, and coal mines. Poles were (and are) inveterate letter writers, and the Polish peasant wrote many long letters home. This correspondence formed the heart of Znaniecki's work, and the exchanges, these so-called bowing letters between young immigrants and the parents, wives, and children they left behind, alternate between hope and despair.

A husband wrote to his wife: "Here in America . . . thousands of people go about without work. . . . I have not worked for 7 months and now times are so bad that in America it gets worse and worse. A lot of people come from our country, and here . . . thousands walk about without work. But the people in our country imagine that when somebody comes to America he does nothing but make money." Another explained: "Being working people, oppressed with exploitation in their fatherland, harassed in their village by the uncertainty of tomorrow and hearing about this gold-flowing America of their dreams . . . they go there. But what befalls them? The same, even still harder labor, sometimes complete lack of work . . . and such people, being in such a condition, commit often unheard-of things. . . ." But in the final analysis, the emigrant could not persuade family members back home to remain in the Old World: "As the fish thirsts for fresh water so we thirst to be united with you, but not here, only in America." These letters make for sad reading. For every success story there were many of families never to be reunited, of hopes for a better future dashed against the harsh reality of American life. At a time when silent Westerns were beginning to circulate a romanticized view of America, and were being shown in Eastern Europe, Znaniecki's work revealed the realities of Polish immigrant life.

In the nineteenth century, America represented hope for multitudes in Russian Poland, and the expansion westward was read as a story of a free people occupying a free land. It was a deeply felt belief that attracted many Polish immigrants to seek opportunity in the West. Long before the films that purported to portray the history of the West, there was a considerable literature in translation that acquainted Poles and other people of central Europe with the open spaces of America. It was a utopian dream, spawned by a plethora of travel accounts since the time of Columbus and added to by a large body of romanticized popular fiction.

Works of art and travel literature provided an important source for the propagation

of this vision. In addition to those of Sienkiewicz, accounts by English, French, German, and Italian travelers were distributed widely throughout Europe.[17] Especially important were images of American Indians whose lives and misfortunes proved of considerable interest to Europeans. Starting with the nine Indians Columbus brought back to Spain after his first voyage, subsequent travelers and explorers carried Indians back as guides for future travel or as hostages.[18] Artists, poets, and novelists also used Indians as subjects for their works. As America conquered the "wilderness," Indians became either an abiding object of hostility or "noble savages," nature's children. While the success of westward expansion seemed to furnish proof of the superiority of Euro-American civilization, the Indians' bravery in the face of adversity elevated them (in the minds of many Europeans at least) to a status equal to or above that of their enemies.

Though Frederick Jackson Turner argued in 1893 that the frontier epoch had ended, pioneers were just beginning to explore the frontiers of the imaginary West. "The tale of the American tribe," is how the Goetzmanns described the mythical narrative of the West, astutely observing that it is no straightforward matter to differentiate fact from fiction when looking at representations of the region: "For the visual image-makers have contributed as much as the writers to the fundamental myth of the American experience—the story of the peopling of a vast new continent by emigrants from the old European world who were forever moving West." Novelist Larry McMurtry takes the argument an important step further: "For the lies about the West are more powerful than the truth about the West—so much more powerful that, in a sense, lies about the West are the truths about the West—the West, at least, of the imagination."[19]

Richard Slotkin, in *Gunfighter Nation*, writes, "The Myth of the Frontier is our oldest and most characteristic myth, expressed in a body of literature, folklore, ritual, historiography, and polemics produced over a period of three centuries." He continues: "According to this myth-historiography, the conquest of the wilderness and the subjugation or displacement of the Native Americans who originally inhabited it have been the means to our achievement of a national identity, a democratic polity, and ever-expanding economy, and a phenomenally dynamic and 'progressive' civilization." Slotkin uses the word "conflict" frequently to describe frontier expansion. The history of contact between Euro-Americans and indigenous populations indeed has been marked by great violence. But more important, America has portrayed itself as a "peculiarly violent nation" to the point where violence has acquired "mythic significance." After 1893, Slotkin notes, the frontier had become "a set of symbols that *constituted* an explanation of history. Its significance as a mythic space began to outweigh its importance as a real place. . . ." Such an explanation insisted that conflict was linked to fate and that aggression served destiny. Symbols of frontier violence became embedded in the mythology of the Old West, a mythology soon exported elsewhere. But while they might recognize and utilize Western symbols, people outside of America might not agree with the explanation, or subscribe to the myth.[20]

Mythical notions of the frontier lie at the very heart of America's identity. As Slotkin has argued, over time the narrative became reduced and abstracted until it emerged as a deeply encoded and resonant set of symbols, icons, keywords, and clichés. In this form, it entered memory and remains there today as what Gretchen Bataille and Charles Silet have termed "the central myth of the American Experience." The very word "frontier" can be drawn upon to drum up support for an idea or a course of action. In 1960, John F. Kennedy coined the term New Frontier to define the central theme of his presidential campaign. And who can forget Captain Kirk's immortal words, "Space: the final frontier," at the beginning of each episode of *Star Trek*? Over time, these symbols have become universally recognized. The Polish poster artist consistently uses this to powerful effect in illustrating Westerns. The myth of the West can be mobilized to explain the Vietnam War, or to sell cigarettes. Its symbols define the past, and can help make sense of the present and set a course for the future. As Slotkin relates, the frontier narrative "still colors the way we count our wealth and estimate our prospects, the way we deal with nature and with [nations]." So deeply has it been woven into the American psyche that "the Myth can still tell us what to look for when we look at the stars." The Western encapsulates America's view of itself. Utilizing Western subject matter allows the Polish poster artist to comment on America as a whole.[21]

Richard White describes the West as the most "imagined" section of the United States, arguing, "So powerful is the influence of this imagined West that its fictional creations and personas become symbols of the West, and real westerners model themselves after fictional characters."[22] Visual spectacles and imagery, especially such popular manifestations as dime novels, Western melodramas, Wild West shows, rodeo, advertising, fashion, and country and western music, have played a vital role in identifying and defining the West, creating the myth, and influencing perceptions of the region. Without question, however, the medium that embraced, fine-tuned, and disseminated the myth to a mass worldwide audience was the Western. How foreign audiences have responded to America's vision of itself makes for a truly fascinating yet largely unexplored story.

The creation of the Western myth first became important as the frontier receded into memory in the wake of industrialization and urbanization. It was no accident that the Wild West shows became popular entertainment in the 1880s.[23] Americans, no longer divided by Civil War loyalties, sought a national history and mythology. Lawmen and gunfighters, scouts and gold seekers—these were proof that the conquest of Indian Country was necessary for nation-building. In the years between the War of 1812 and the Civil War, writers and artists used the Indian to portray a distinct American nationalism, free of European models. It was the American answer to the Romanticism sweeping European arts and letters. American writings on the legendary exploits of Daniel Boone and Davy Crockett were published in Europe, the frontiersman saga appealing particularly to the German reading public. James Fenimore Cooper's Leatherstocking Tales, as well as the later novels of Zane Grey, were translated into many languages, including Polish. Works

of art inspired by Cooper's novels were exhibited in the Paris Salon. Some of the artists visited or lived among Indian tribes, and their works proved of great interest to a European public hungry for such exotic scenes.

Poland's own frontier lay to the east, its defining geographical feature being Białowieża, a heavily forested region bordering present-day Belarus. The forest had been the hunting ground of European royalty and dignitaries for centuries. The prey was the fierce *żubr*, Poland's equivalent of the American buffalo, and it too became practically extinct. The eastern borderlands have always been associated with the Lithuanian-born Polish poet Adam Mickiewicz, whose epics were inspired by his familiarity with the region. Mickiewicz was traveling in Italy prior to the 1830 Polish revolt against Russian occupation. While there, in 1829, he met Cooper, already famous in Europe, particularly for *The Last of the Mohicans* (1826). The two met again in Paris after the outbreak of the Polish rebellion. Cooper helped to organize a Committee for Poland while Mickiewicz wrote *Pan Tadeusz*, his paean to the Polish-Lithuanian borderlands. Simon Schama has noted that both the Leatherstocking Tales and *Pan Tadeusz* were written to "celebrate worlds their authors knew to be already extinct." Cooper and Mickiewicz both wished to bequeath their works to posterity as examples of "sylvan virtue"—"the hidden heart of national identity."[24]

The frontier was important to Poles as well as Americans, even as the frontiers of both nations began to disappear. To Poles, Białowieża and its vast expanses to the east constituted a mythic space analogous to the American West, where boys could become men and virtue could be tested. Geography determined that Poland's frontier would be forest rather than prairie or plain, and while the history of the American West was characterized by seemingly limitless expansion and possibilities, Polish territories shrank as the country lost its independence. Poles would continue to look to America as a land that, unlike theirs, was blessed by both geography and history, a land peopled by heroes. Westerns may have been entertainment to Americans, but to the Polish people they have presented a visual confirmation of the democratic ideal they were denied.

The works of George Catlin, hundreds of portraits and scenes produced as a result of his journeys up the Missouri River begun in 1832, became an invaluable record of Indian civilization at that time.[25] Catlin thought his art would save the Indian and buffalo from extinction, and was critical of those who traded liquor and guns to the Indians for buffalo hides. He recommended that an extensive national park be established to separate the races and allow the Indian to live in a state of nature. As "artist, scientist and showman," Catlin sought to plead his case before a public that paid little attention to him even as they bought his art. Catlin also exhibited his collection of Indian artifacts in New York in 1837, in a show dubbed by one writer "the first Wild West show and an authentic one." Eventually, Catlin took his show to England where he presented *tableaux vivants* on Indian life. These were eventually shown on the European continent, a precursor of Buffalo Bill's Wild West shows.[26]

The writings of the German Karl May also were translated into many languages and further inspired European interest in a romanticized American West. Born in 1842, May was sightless for a period as a child and developed a vivid imagination. Although he made only one visit to America, he was well acquainted with books on geography and wrote with authority about the West and Mexico. May's books have been published in Poland and read widely from the nineteenth century to this day. I found his books about Indians, such as *Winnetou*, *Old Surehand*, and *Old Shatterhand*, and works such as *W Kordylierach* (*In Cordilleras*), *Skarb w srebrnym jeziorze* (*The Treasure of Silver Lake*), and *Przez góry i prerie* (*Over Mountains and Prairie*), on my recent visit to Warsaw. One series under the title *Ród Rodrigandów* (*The Rodriguez Family*) has appeared in seventeen volumes. I was able to buy the last of these, *Zmierzch cesara* (*Twilight of the Emperor*), from a prominent display amid the stalls on Marszałkowska Street, near an immense sign advertising the Marlboro Man (plate 46).

Catlin died in 1872, the same year that William F. "Buffalo Bill" Cody began his career as a Western showman. Appearing on stage in dramas based on real and imaginary dime-novel accounts of his life, Buffalo Bill rapidly achieved what today would be called stardom. Together with James Butler "Wild Bill" Hickok and others, he formed the Buffalo Bill Combination, conducting performances that led him to believe that his own appearance, joined with that of Indians, would convey to a public hungry for heroes the flavor of the real West. By 1883, he was ready to bring his show into the arena.[27]

Buffalo Bill's enterprise was a representation of American history at its most inventive. "Wild West," the name he coined for his show, became for many a lodestar of their hopes and dreams. It was not an America with a frontier that was soon to end, but a land of unlimited possibilities. The aim of the show, as Cody saw it, was to educate people about American history with a new type of visual attraction. Through a series of "animated scenes and episodes" (as an 1886 program phrased it), the Wild West sought to show how civilization came to the American continent. The performance began with the Primeval Forest and ended with a display of marksmanship by Buffalo Bill and Annie Oakley. Although many of the scenes were more in keeping with the writings of Cooper than with historical events, an element of truth—as in Western movies—created an atmosphere of authenticity. From 1887 to 1892, Buffalo Bill took his show to Europe. An important addition was the Congress of Rough Riders, with horsemen from different countries, including Cossacks, performing. Buffalo Bill's Wild West shows influenced European perceptions of America for a generation.[28]

Other Wild West shows toured Europe in competition with Buffalo Bill. One, organized by Doc Carver, landed in Hamburg in June 1899. For the next two years, Carver's "Wild America" show performed all over Europe. Carver journeyed to Russia by way of Budapest and Warsaw. There were 100,000 Russian soldiers quartered in Warsaw at the time, including 20,000 Cossacks. The latter, widely known for their horse riding skills (and brutal attacks on demonstrating crowds), were awed by the skill of Carver's riders.

46. *Marlboro Man* billboard, Warsaw, September 1997

Photograph by Frank Fox

In Warsaw, a city tax was levied on the show to provide 10 percent of its receipts for the city poor. Fred C. Whitney, Carver's shrewd business manager, then raised the admission price to make up for the tax. The program for the 1890 Doc Carver show in Warsaw boldly displayed the "Wild America" title in English, Russian, and Polish. Carver's likeness on the cover presented the epitome of the frontier scout as performer.[29]

Buffalo Bill made it to Poland as well. In 1906, on the last leg of a European tour, Cody performed in Austrian Poland. The area was filled with Russian Jews who had fled persecution in Russia. This was not an audience to be interested in Cody's kind of entertainment. As he explained to a friend, "Well, I simply done no business and had worlds of trouble. I lost my socks but not my courage for I knew if the old show could live to get out of there she would right herself and she is doing it."[30] In fact, by this time, Buffalo Bill was aging and Wild West shows were in decline. His last European tours coincided with a period of great migration to the United States. The Wild West shows had served as a huge advertisement to those contemplating leaving their homelands. To many Europeans, the likes of Buffalo Bill and Doc Carver had offered an irresistible image of an imaginary West.

The advent of motion pictures truly internationalized the American West. Silent Westerns were shown in Poland after World War I, and Poles became familiar with the Singing Cowboys and other B-Western stars during the 1930s. The German *Ersatzwesterns* of the interwar years also were screened in Poland. In spite of the growing estrangement between the East and West after World War II, America continued to export Hollywood productions to Eastern Europe, typically a few years after their U.S. release. At first, few Western films were shown in Poland, but the numbers grew steadily during the late 1950s and peaked during 1960–85. Undoubtedly, demand stemmed from the abiding attachment to America that Poland retained, and from the presence there of many Poles who maintained contact with their families and friends. American-made movies were always the most popular, and Poles tell stories of long lines and even ticket scalping for new John Wayne features in the sixties and seventies. The Communist authorities, known for their anti-American propaganda, failed to realize the impact that Westerns would have on Polish youth, and considered them innocent entertainment. The Western's popularity is directly linked to the spread of television in Poland. *Bonanza* and Disney's *Zorro* became popular series in the 1960s, and classic movies like *Red River* appeared regularly on TV. Special clubs were created in colleges to debate the merits of American films such as *Stagecoach*. The magazine *Kino* (*Cinema*) frequently ran articles on Westerns, while the agency Wytwornia Filmów Dokumentalnych (Documentary Film Productions) promoted interest in the likes of director John Ford.[31]

Perhaps because of his ethnic background or the kind of roles Kirk Douglas played, his Westerns seem to have been in heavy demand in Poland. Douglas was not known as a prolific performer in Westerns, appearing in less than twenty features, yet at least six Polish posters—Adam Bowbelski's 1957 *Indiański wojownik* (*The Indian Fighter*, 1955) (see plate 100); Witold Janowski's 1966 *Ostatni zachód słońca* (*The Last Sunset*, 1961) (see plate 134);

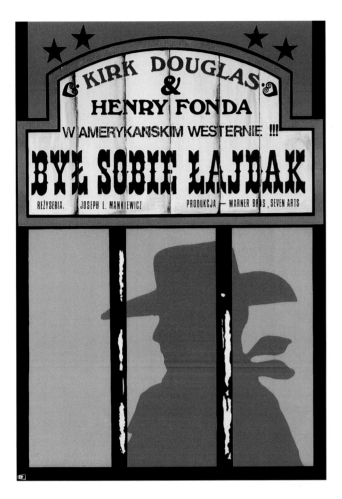

47. Jakub Erol (b. 1941)
Był sobie łajdak, 1972
Polish poster for the American film
There Was a Crooked Man (1970)
Lithograph: 81 × 58 cm

48. Jerzy Flisak (b. 1930)
Ostatni pociąg z Gun Hill, 1974
Polish poster for the American film
Last Train from Gun Hill (1959)
Lithograph: 82 × 58 cm

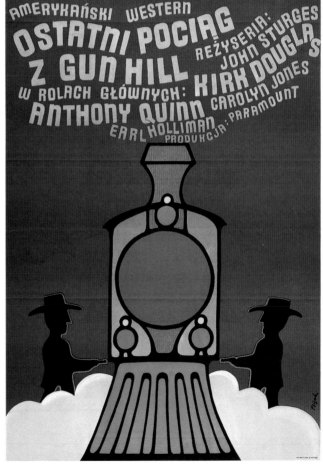

Andrzej Bertrandt's 1972 *Pojedynek rewolwerowców* (*A Gunfight*, 1971) (see plate 41); Jakub Erol's 1972 *Był sobie łajdak* (*There Was a Crooked Man*, 1970) (plate 47); Jerzy Flisak's 1974 *Ostatni pociąg z Gun Hill* (*Last Train from Gun Hill*, 1959) (plate 48); and Młodożeniec's 1976 *Oddział* (*Posse*, 1975) (see plate 81)—were commissioned for his films. Poles may have been drawn to Douglas's love of melodrama and "a performance style of barely contained emotional explosiveness and below-surface tension."[32] Even more likely, they would have empathized with the Douglas characters' love of freedom and hatred of restraint, as epitomized in his defining role in *Man Without a Star* (1955).

During the sixties, seventies, and eighties, Polish theaters also showed Westerns made in Eastern European nations such as Czechoslovakia, East Germany, Romania, and Poland itself. Western films produced in West Germany and occasionally Britain and France were screened, but the Poles had no appetite for Spaghetti Westerns and few were shown. Though they enjoyed satire, and Polish poster art of the genre could be challenging and offbeat, Poles typically preferred the Western itself to be more traditional.

Some excellent Polish posters were designed for these European Westerns. Two for German Democratic Republic productions, in keeping with the subject matter of the films, feature American Indians. Zbigniew Czarnecki's 1975 *Ulzana-wódz Apaczów* (*Ulzana*) presents a dark yet beautiful portrait of Yugoslav actor Gojko Mitic as the Apache leader. The painted face of Ulzana appears like a mask (plate 49). Andrzej Krzysztoforski's 1983 poster *Tropiciel* (*Der Scout*) also portrays an Indian leader. Though appearing somewhat humorous, with a prominent nose and chin shown in profile and virtually no mouth, the Indian wears a feathered headdress and war paint and has an angry expression (plate 50). Marian Stachurski's 1968 poster *Wilcze echa* for the Polish film of the same name, presents a subtly understated flight and pursuit image. Three miniaturized silhouette figures on horseback are pictured against a blood-orange sky. Two of the riders, wearing soldiers' caps and carrying guns, chase the third, who aims a gun back at them (plate 51). Andrzej Pągowski's 1981 work *Siedmiogrodzianie na dzikim zachodzie*, for a Romanian-produced Western, portrays a revolver with "oil" stamped on the cylinder. A pressure button has been added to the ejector rod beneath the barrel, and the hammer is angled to resemble a spout (plate 52). In the 1974 poster *Dzielny szeryf Lucky Luke*, by an unknown artist, for the 1971 French-Belgian animated production *Lucky Luke*, the cowboy's mouth has become a cigarette-holder (plate 53). Two posters for Eastern European-produced Western satires, though different in style, present the same message. Maciej Hibner's 1965 *Lemoniadowy Joe* for the Czech film *Limonádový Joe . . . konska opera* (*Lemonade Joe*, 1964), and Mieczysław Wasilewski's 1979 *Prorok, złoto i Siedmiogrodzianie* for the Romanian film *The Prophet, the Gold, and the Transylvanians* both show smiling cowboys, but have a darker meaning. Hibner's Lemonade Joe sports a 0% target on his torso, while Wasilewski's portrait is riddled with bullet holes. The cowboys' attitude might be devil-may-care, but they will not be smiling for long (plates 54, 55).

49. Zbigniew Czarnecki (b. 1948)

Ulzana-wódz Apaczów, 1975

Polish poster for the East German film *Ulzana*

Lithograph: 84 × 56 cm

50. Andrzej Krzysztoforski (b. 1943)

Tropiciel, 1983

Polish poster for the East German film *Der Scout*

Lithograph: 98 × 68 cm

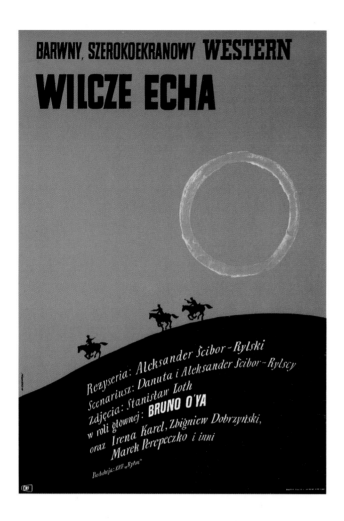

51. Marian Stachurski (1931–1980)
Wilcze echa, 1968
Polish poster for a Polish film
Lithograph: 84 × 58 cm

52. Andrzej Pągowski (b. 1953)
Siedmiogrodzianie na dzikim zachodzie, 1981
Polish poster for a Romanian film
Lithograph: 95 × 68 cm

53. **Dzielny szeryf Lucky Luke**, 1974

Polish poster for the French-Belgian co-production

Lucky Luke (1971)

Lithograph: 80 × 58 cm

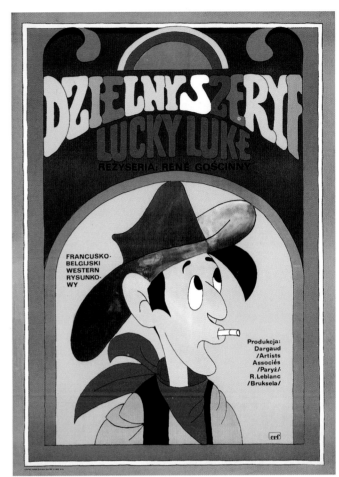

54. (*below*) Maciej Hibner (b. 1931)

Lemoniadowy Joe, 1965

Polish poster for the Czech film *Limonádový Joe* (1964),

also released as *Lemonade Joe* (1966)

Lithograph: 89 × 59 cm

55. (*right*) Mieczysław Wasilewski (b. 1942)

Prorok, złoto i Siedmiogrodzianie, 1979

Polish poster for the Romanian film

The Prophet, The Gold, and the Transylvanians

Lithograph: 83 × 58 cm

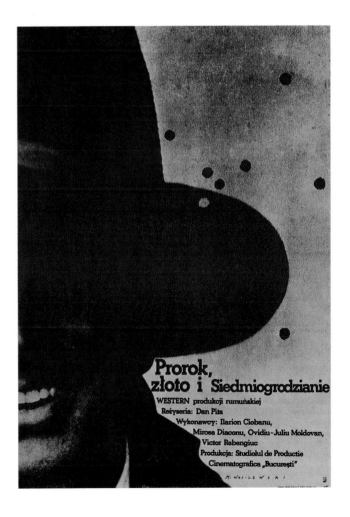

No account of Poland's relationship with the American West would be complete without the extraordinary story of one man's efforts to create a Polish Western. The documentary filmmaker Tomasz Magierski has referred to this genre as Kiełbasa Westerns. The work of Jósef Kłyk, an amateur filmmaker from Polish Upper Silesia, offers evidence of how abiding and strong are the ties that bind the Polish people to an imaginary American frontier. More important, his films point to the uses one society may make of the history of another.

Kłyk has been making Westerns for twenty years, and so far has directed fifty, receiving awards for his amateur productions. It has been his dream to connect the story of Upper Silesia, when it was still under German rule, with nineteenth-century America. In the village of Bojszowo, a place he calls his "little Hollywood," Kłyk and a small crew produce Westerns with a Russian 16 mm camera. Each film is a primer on the symbols and icons that have been used to define the American West. With a Polish martial tune in the background, *Człowiek znikąd* (*The Man from Nowhere*) begins with a tight shot of a stack of rifles being passed out to willing hands as an ancient cannon is rolled out from under a plastic cover—the scene eerily reminiscent of footage from the Warsaw Uprising of 1944. To the sound of revolver shots, the screen announces: "Kłyk Western, & Co." In a voice-over commentary as various props are displayed and characters introduce themselves, Kłyk tells of the Panna Maria settlement of 1854, when the occupants of an entire village under the leadership of Reverend Moczygemba tried to escape a ten-year period of hunger and disease by selling all their possessions and moving to Texas. As his camera pans the cemetery abandoned by the emigrants, Kłyk recalls how his fellow Silesians left for Texas with only the symbols of their faith: the church crucifix, a bell, and a container of holy water. The idea was to establish a "Poland in America."

We next see Kłyk in his workshop as he prepares his day's shoot. Surrounded by Western memorabilia, he introduces the viewer to members of his cast. Outdoors, the painted prop signs in the village suggest the impact Buffalo Bill has exerted on the imagination of Europeans. One reads: "Farewell Appearance of Buffalo Bill." Another proclaims: "The Farewell Shot. Positively the Last Appearance of Col. W. F. Cody in the Saddle. Buffalo Bill with the Congress of Rough Riders." Without funding or sponsors, Kłyk and his friends do the shooting on a nearby farm. His entire family is involved, some of them dressed as Indians. "My life would have been incomplete without this film," he confesses. "All my free time is devoted to it." For Kłyk, the film represents freedom, the open prairie he never saw. "America for me is a dream," he insists.

Kłyk enumerated some of the difficulties he faced. "The film was shot on two locations. The exteriors were done in a small village near my home. The interiors were done in my basement. The important thing was to try to shoot the film in the morning before the actors got too drunk. I wanted to make the pistol duels as spectacular as possible. Wounds were simulated by having condoms filled with blood and detonated by batteries with bits of dynamite tied around the neck. Such materials are easily available in this mining commu-

nity. The actors were taught how to shoot and fall. To emphasize the actors' reaction we decided not to use protective vests. So their pained expressions are real. The shots burned their skins. But the blood from the condom cooled them," Kłyk adds without cracking a smile. As the crowd gathers, Kłyk goes over his final preparations. He explains to the actors how they are to use their guns and shows them how to twirl a revolver in the traditional Western style. It is Sunday after Mass, so the filmmaking will have the ecclesiastical blessing. Costumes are tried on, Indian headgear adjusted, faces painted, and mustaches glued on. This may be a far cry from John Ford's *Stagecoach*, but now at last Kłyk is ready to shoot his Western.

The Man from Nowhere is the story of a Pole who emigrates to Panna Maria and becomes a skillful cowboy. He battles almost everybody—cowboys, Indians, and after the Civil War, the Ku Klux Klan. (Kłyk not only directs and provides voice-over commentary but also plays the lead role.) The "man from nowhere" returns from America to Upper Silesia, where a struggle for secession from Germany is taking place. He hides in the woods as the fighting starts and dreams that he is back in Texas. The dream sequence includes just about every cliché used in Westerns. Scenes constantly shift from America to Silesia. We know we are in America when we see a "U.S. 58th Regiment" wagon with two drivers wearing Union hats. The soldiers talk about Panna Maria and the Silesians who have arrived from there. The scene then shifts to Silesia, where Kłyk is working as a blacksmith. German soldiers with peaked helmets, typical of the Wilhelmine period, enter. There is a struggle and Kłyk is at first overpowered, but he eventually kills his captors, goes to Hamburg, and sails for the New World and Texas. Throughout this scene an accordion is heard playing over and over *The Battle Hymn of the Republic*. The story continues in a small Texas frontier town. In a scene more typical of a Polish village than a settlement in Texas, Kłyk meets a Jewish storekeeper and starts working for him. In another sequence there is a shootout, while the accordion plays the theme from *High Noon*. In a scene obviously patterned on the Gary Cooper film, there follows a camera shot of a bandit through the legs of a sheriff who recognizes the wanted man and shoots him. Kłyk in voice-over narration says, "Never reach for your gun unless you can be sure you are first. This is the law of the West, kill or be killed." As the music switches to *Oh! Susanna* the camera zooms in on a "Wanted" poster for Liberty Valance. The sheriff enters the saloon, spots the wanted man, kills him, and removes the poster from the wall. Use of the music from *High Noon* and a poster of a character drawn from the classic John Ford, John Wayne, and James Stewart film, *The Man Who Shot Liberty Valance*, give a fascinating insight into this Polish Western filmmaker's lexicon of imagery.

In another Kłyk film, Buffalo Bill makes his appearance, standing under a sign that advertises his show. He then walks inside the saloon and poses under his own poster. Kłyk's is an aging Buffalo Bill. The Polish poster artist Jakub Erol captures a similar idea in his 1978 poster for the 1976 film *Buffalo Bill and the Indians, or Sitting Bull's History Lesson* (plate 56). The face of Paul Newman bears a close resemblance to Buffalo Bill, but the

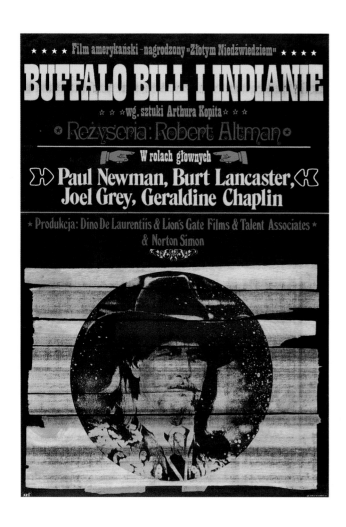

56. Jakub Erol (b. 1941)
Buffalo Bill i Indianie, 1978
Polish poster for the American film
Buffalo Bill and the Indians, or
Sitting Bull's History Lesson (1976)
Lithograph: 98 × 68 cm

57. Jan Sawka (b. 1946)
Buffalo Bill, 1975
Polish poster for the American play *Indians* (1969)
Lithograph: 98 × 68 cm

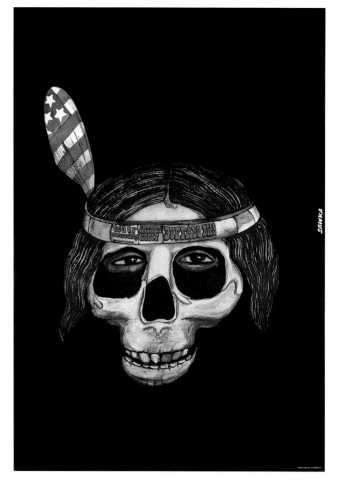

likeness is glued to old and deteriorating wooden slats. Although the myth is still with us, it has become a victim of time. Another poster of Buffalo Bill by Jan Sawka, designed in 1975 for Arthur Kopit's stage play *Indians* on which *Buffalo Bill and the Indians* was based, is in keeping with the changing views of America's treatment of Indians (plate 57). Here Buffalo Bill is portrayed by an image of a human skull. The skull's stars-and-stripes hippie headband lampoons patriotism, and typifies the Vietnam protest era.

Kłyk's Kiełbasa Westerns highlight the behavior that represents to the Polish audience the freedom-loving Westerner, and they show what in the eyes of Poles should be the spirit of men away from home. Kłyk's films portray a life of conflict, of defiance of authority, of acquiring skills that ensure survival. His character learns how to use a gun to protect himself and to enforce a rough code of justice. He must quickly distinguish friend and foe and reward loyalty. He must be prepared to win or lose all with a deck of cards. It is even important to know how to slide the beer mug to the end of the counter. The gambler instinct, the sense of danger, all these are made to reflect not just an American Western scene but what are assumed to be universal codes of manhood. A Western scene, perhaps, but applicable also to Poles.

There is something unique about the Polish poster. It is the product of a history that more than any other seems to fit the compressed nature of a poster's narrow rectangular space—the history of a nation hammered by adversity into compactness but still home to an extraordinary variety of complex symbols. This quality gives the poster simultaneously its Polishness and its universality.

In the nineteenth century, Polish graphic art was strong in the applied arts, folk art, and architecture. Typography became an important part of the work, and played a central role in the development of poster art. The first International Exposition of the Poster took place in Kraków in 1898 as prominent artists turned their attention to this art form. The Society for Polish Commercial Art was established in 1901. Lithographers asserted that a new type of image was being created, one that was to be read as well as seen. As Elena Millie has suggested, "Instead of adding text to the bottom, or top of the image in the traditional fashion, artists . . . made typography an integral part of the artwork."[33]

From the late nineteenth century until Poland achieved independence in 1918, the Polish poster included folk themes and helped foster a national identity. Polish artists of that period were influenced by ornamental and abstract developments in poster design taking place in Western Europe. None was more influential than Jules Chéret, whose pioneering work in lithography, particularly the use of color, was widely imitated. Polish artists such as Józef Mehoffer, Wojciech Weiss, Teodor Axentowicz, and Karol Frycz were especially adept at this new style of incorporating abstract and ornamental features into their work. In 1897 they formed a Society of Polish Artists (often referred to as *Sztuka*, "Art") which led to the first International Exposition of the Poster. Soon other organizations for Polish poster artists were formed.

The establishment of a Polish state in 1918 changed the direction of the graphic arts. The center shifted from Kraków to Warsaw, and the character of the Polish poster now was more in tune with the national demands of the new state. These trends are clearly seen in the vivid and even brutal posters designed during the Russo-Polish war in 1920 and the struggle to retain Upper Silesia within the new Poland. The posters showed a power and sharpness not present earlier and included elements of cubism, photo montage, and constructivism new to Polish graphic arts.

The interwar years of 1918–39 were marked by outstanding personalities in the field of the commercial poster. The artist most honored for his work during that period is Tadeusz Gronowski, who together with the well-known French designer A. M. Cassandre made airbrush work and Art Deco styles popular. Polish travel posters, particularly those sponsored by the national rail system, became colorful additions to the work of graphic artists; Stefan Norblin's posters are outstanding examples of this stylized art. The period was also notable for the impact exerted by the Warsaw Polytechnical Institute on poster designers. The number of exceptional poster artists who were also architects has remained high to this day.

The 1930s witnessed an increasing number of advertising posters and the formation in 1933 of a professional organization called KAGR (Graphic Artists Advertising Circle), founded by Gronowski and Edmund Bartłomiejczyk, that eventually included most of the well-known graphic artists. The worldwide economic depression that struck Poland by 1935 led to increased use of commercial design to foster economic growth. Publications such as *Reklama* (*Advertising*) encouraged publicity and competition among the poster artists. The Academy of Fine Arts in Warsaw finally joined the ranks of prestigious art academies in offering courses in graphic art.

Few countries have ever suffered the horrendous damage inflicted on Poland during World War II. Both invaders, Nazi Germany and Soviet Russia, sought to destroy Poland's elites. The only posters seen in Poland in that period were those of the occupiers, decreeing death and punishing an enslaved people. But the war period revived in the surviving generation a spirit of rebelliousness and inventiveness that was characteristic of the Polish people during the earlier period of their national existence. Poles defied the Germans by chalking on their walls "PW," which stood for *Polska walczy*, or "Poland Fights On." These symbols took the place of posters and trained an entire generation to express political freedom in minimal visual terms. Future Polish posters would be characterized by the irreverence and daring that was the signature of underground activity. The conclusion of the war did not end the oppression. Communist authorities banned such images as the crowned eagle (a symbol of Poland's past glory), and portraits of Marshal Piłsudski, the beloved national leader who died in 1935.[34]

After the war, some surviving artists began again to gather students and organize departments of art. Such accomplished artists as Tadeusz Trepkowski, Eryk Lipiński, and Józef Mroszczak were joined by those who survived the occupation, Gronowski and

Henryk Tomaszewski. An organization of artists called WAG (Wydawnictwo Artystyczno-Graficzne) was founded in 1950 and published *Projekt*, a periodical devoted to printing and design that continues to this day. *Projekt* has awarded prizes to worthy candidates and encouraged competition among poster designers.

How did it happen that, after World War II, posters could thrive in Poland under communism? Anna Husarska provides an excellent summation:

It was the result of a particularly felicitous combination of factors. First, the totalitarian state, with unlimited funds at its disposal, turned out to be a good patron. Second, given the general shortages of everything from toilet paper to washing machines, posters weren't really about advertising; they were art for art's sake. Third, the primitive state of printing techniques precluded any easy, conventional use of photographs, so the artists were obliged to be more creative. The isolation from the artistic currents in the West was an advantage, too: Polish artists had to follow their own, original path. And because in Poland there was no art market to speak of (art dealers were considered "rotten bourgeois"), poster-making offered one of the few opportunities for artists and designers to practice their profession.[35]

The climate may have proven advantageous to creativity and productivity, but the success of the Polish poster school also resulted from the extraordinary talents of the artists.

The Polish poster of that period has been capably analyzed by Szymon Bojko, one of the foremost authorities of the genre. The author, who was also on the editorial board of *Projekt*, has discussed the two chief directions taken in the design of the Polish poster: the emotional and the intellectual. The former became a "painter's poster," a sensual approach characterized by emphasis on color and texture. The second relied on a light, ironical touch, on graphic jokes "produced with charm and finesse." Bojko stressed the creative use of typography. Sometimes the lettering was borrowed from past forms, as in the example of Starowieyski. Other artists, in the words of Bojko, "became fascinated by the flamboyant style of the Wild West saloons taken from films about the conquest of the Wild West."[36]

In addition to Tomaszewski and Lipiński, artists whose style was not only individualistic but also filled with humor and spontaneity, there soon followed a group of similar free spirits. Waldemar Świerzy, Starowieyski, Młodożeniec, Roman Cieślewicz, Hubert Hilscher, and Jan Lenica shared with their mentors that spirit of whimsicality and unpredictability that became the hallmark of the Polish poster. Tomaszewski and Mroszczak became teachers in the Warsaw Academy of Fine Arts. Significantly, a striking number of artists who designed posters for Westerns, including Andrzej Onegin Dąbrowski, Jakub Erol, Marek Freudenreich, Maria "Mucha" Ihnatowicz, Jolanta Karczewska, Andrzej Krajewski, Lech Majewski, Jacek Neugebauer, and Wojciech Wenzel, had been students of Tomaszewski.

Poster artists led a bifurcated existence, often conforming to the demands of Communist officialdom while doing their best to bite the hand that both fed and restrained

them. The confrontations, which involved primarily a more assertive workers' move-
ment that started in earnest in the 1960s, came to a head in the next decade. The 1970s
ushered in a political phase for the Polish poster as unrest mounted, and by the end of the
decade a strike in the Lenin shipyards introduced to the world Solidarity, a movement
that found an echo in the rest of Eastern Europe. Poster artists soon came to the forefront
of the struggle when Jerzy Janiszewski designed the famous Solidarity logo. The logo
became widely used all over the world as a symbol of freedom. The shipyard in Poland
where the strike took place was festooned with signs and posters, most of them hand-
made, and soon a veritable industry of poster-making developed as the streets of Poland
came to resemble art galleries. Artists who had emigrated also took part. Polish communi-
ties in Paris, London, and New York printed their own versions of the Solidarity poster.
In New York, Rafał Olbiński designed a memorable image for Solidarity in his poster for
Andrzej Wajda's film, *Man of Iron*. In this image, a cement band encasing a worker's head
has burst, graphically illustrating the power of the individual. Thoughts always had been
free; now they exploded into action. Solidarity's adoption of the image from *High Noon*
was a logical extension: the central theme of this classic Western represents the universal
dream of the individual conquering overwhelming odds.

The film poster has enjoyed an interesting history within the evolution of Polish
graphics, but it had a late start, and for some time was not considered as prestigious as
posters designed for the theater or other arts. Few have commented on the history of the
Polish film poster better than Edmund P. Lewandowski. In his essay "Like a Fish Needs
a Bicycle," Lewandowski quotes Jan Lenica, who compared the Polish poster to a Trojan
horse. The idea that the poster was "smuggled" onto the street, where it became some-
thing no one expected, can be applied to Polish posters in general, but it was particularly
true of the film poster. Nobody expected the Polish film poster to be anything other than
advertising, as in other countries. After all, it was the film, not the poster, that was sup-
posed to be the focus. But the Polish film poster became an end in itself. It transformed
the increasingly oppressive postwar government-mandated style by "smuggling" into
it artistic expressions that were officially frowned upon. Lewandowski suggests that the
poster could be more than the movie it advertised. It not only interpreted the film but
made additional "statements" that could only be conveyed by an artist.[37]

In this sense, the Polish film poster became a form of subversive intellectual street art
easily accessible to the masses. Appearing to be a harmless advertisement, it was art with a
message in the disguise of ephemera. Produced in multiples, the posters were meant to be
pasted to kiosks, walls, benches, or billboards, and then torn down or glued over with oth-
ers (plate 58). A poster has a short lifespan, and like an exotic flower it must display itself
dramatically to attract maximum attention. The message must come across quickly and
effectively or be lost. Posters literally appeared overnight and brightened up the streets.
Poles would look forward to seeing the most recent crop while walking or cycling to work,
or waiting for buses or trains. It also became fashionable to hang them in kitchens and

58. **Rozklejacze plakatów** (The Poster Gluers). "You can meet them in every city and the work is not easy. They carry a heavy bucket of glue weighing 10 kg. and a bag full of rolled up posters weighing approximately 20 kg. They must paste posters on fences, walls, kiosks, and vitrines along a route that is often many kilometers long. Posters must appear on a designated day, not before or after, and the gluers sometimes work nights to meet these deadlines. The poster gluers also take small credit for making the Polish poster well known around the world." From PAP (Polish Press Agency).
Photograph by J. Morek, copyright PAI/EXPO

living rooms, "although at the time the only way to obtain a poster was to catch the man with the glue bucket just as he was about to paste one on a fence and offer him a few zlotys or half a litre of vodka."[38] Mass produced and mass consumed, Polish film posters would be seen by many more people than would see the movies themselves. The poster artist's visual interpretation of Westerns, often produced without reference to the films themselves, and in pursuit of another agenda, exerted profound influence on Polish popular perceptions of America.

Film Polski, the Polish film agency, had much to do with the growing popularity of the film poster. Under Aleksander Ford, this government agency granted considerable freedom to the designers of film posters, freedom not given to other poster artists in the postwar period. Movie directors were not enthusiastic about using "artistic" posters to advertise their films. But the agreement of three prominent artists, Lipiński, Tomaszewski, and Trepkowski, in 1946, to collaborate with Film Polski in designing film posters ensured the art form's ongoing success.[39]

Tomaszewski and Lipiński were the first to produce posters for Westerns. Tomaszewski's *Zwycięzcy stepów* (1947) illustrated the 1946 film produced by British-Pathé, *The Overlanders* (see plate 98). Set in World War II Australia, it was based on a true story of cattlemen driving their herds south to avoid Japanese invaders. In a nod to Sienkiewicz, Tomaszewski's title translates as "Conquerors of the Steppes." The artist appeals to his audience by catering to its point of reference. The Australian Outback, in this movie located within the genre of the Western, becomes in the poster the Steppes of present-day Kazakstan, the Polish equivalent. This striking image features a mounted cowboy in full gear astride a beautiful pinto. Tomaszewski's work was highly influential with his students and other artists, as can be seen in such later works as Adam Bowbelski's 1957 *Indiański wojownik* (*The Indian Fighter*, 1955) (see plate 100).

Although he had said that "respected graphic artists do not design film posters," Lipiński and others soon turned to that medium as the ideal vehicle for their talents (plate 59). Postwar Poland was devastated, the population in a state of shock. Viewing films, particularly technically superior American productions, was a psychological release for people and a rare opportunity for the graphic artist. Soon there was a flood of excellent film posters. In 1947, Lipiński designed *Znak Zorro* (*The Mark of Zorro*, 1940) (plate 60). Like Tomaszewski's, the work proved highly influential. Lipiński's Zorro appears as a galloping horseman, with cape flying, but the aspect makes him appear miniaturized, like a vampire. He is seen from a bricked fort window, reminiscent of a prison—or a tombstone. The character's signature Z crosses the title. The theme of flight and pursuit, suggestions of metamorphosis, incarceration, or death accompanying acts of violence, and dramatic typographical elements incorporated into the artwork, became standard fare for Polish poster artists illustrating Westerns.

Polish officials tried to impose the rules of socialist realism in order to banish American influence from the arts. Extra copies of posters advertising American films were not

59. Eryk Lipiński (1908–1991) in his studio

Photograph by L. Łożynski, copyright PAI/EXPO

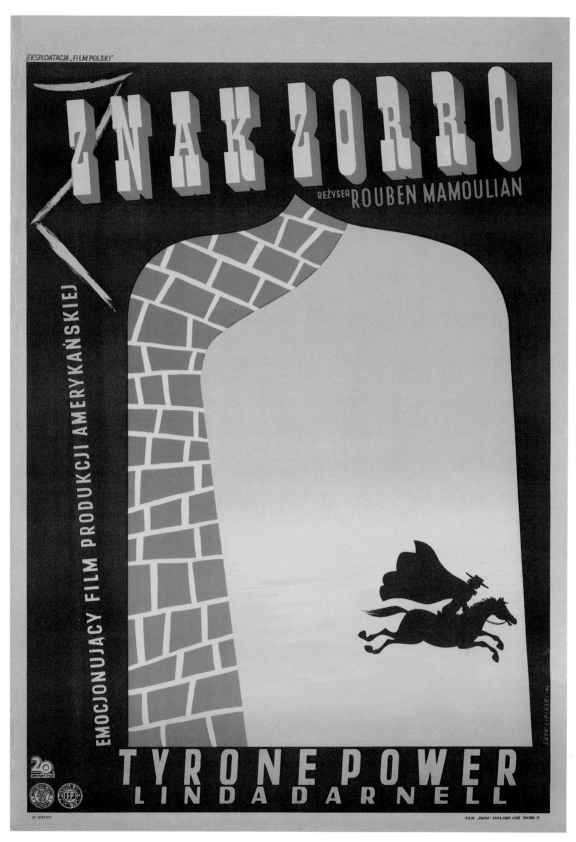

60. Eryk Lipiński (1908–1991)

Znak Zorro, 1947

Polish poster for the American film

The Mark of Zorro (1940)

Lithograph: 86 × 61 cm

safe from censors, making such works rare and thus more valuable for collectors nowadays. Capitalism and cosmopolitanism were seen as evil influences. Soviet norms were held up as models in the arts. Propaganda posters were the order of the day, with "blatant gestures, redness of slogans, dazzling brightness of colour, incredible amount of exclamation and question marks, [and] a monotonous style."[40] Posters had to be for or against something.

But there was still a margin of safety for the creativity of the Polish film poster designer. In the early 1950s, the newly established Centralna Wynajma Filmów (CWF), or the Central Film Leasing agency, took over film distribution from Film Polski. The CWF did not oppose artistic posters. Of course the artist still had to obtain the censor's stamp of approval, but more important, designs first were submitted to a board composed of the artists Tomaszcwski, Lipiński, Wojciech Fangor, and Mroszczak. A new group of film poster artists, Lenica, Fangor, Julian Pałka, Świerzy, Młodożeniec, Cieślewicz, and Starowieyski, began to emerge. The work of these artists infused the film poster with imagination and interest. Now the Polish film poster could be viewed safely as an art form. These posters featured humor and color, and character was emphasized. As Zdzisław Schubert has suggested, the Polish poster became "a satirical depiction with a note of sarcasm."[41] Elements such as avant-garde and surrealism, not permitted in other art forms, could be explored in the design of film posters. Indeed, the stultifying demands of socialist realism challenged artists to experiment with new forms.

It was Tomaszewski who expressed the spirit of the early and heady years of the film poster. He praised the competition that existed among the artists and drew attention to their new style, which he called an "innovative, unconventional approach to the subject." Like the films they portrayed, the posters were designed to be shortened graphic forms that gave the impression of clips. What eventually came to be called the "Polish poster style" began with film posters. Without too many rules governing their product, the artists created a new form of poster, blending different ideas, using camera angles, imitating the full shot and close-up. There are several examples of this style in posters for Westerns. Fangor's 1957 *Ostatnia walka Apacza* (*Apache*, 1954) features a red and green outline of an Indian profile with a feathered headdress and four black and white still photographs from the film inside the profile (see plate 101). In Stanisław Zamecznik's 1963 *Dwa oblicza zemsty* (*One-Eyed Jacks*, 1961) the image of cowboys with guns drawn resembles a photographic negative (see plate 110). Maria Syska's 1965 *Osiodłać wiatr* (*Saddle the Wind*, 1958) uses a technique similar to stop-action photography to provide a "moving" image for a galloping horse (see plate 112). Jacek Neugebauer instills a similar sense of movement into his 1974 poster *Jeremiah Johnson* for the 1972 American film of the same title (plate 61). Here, a slow-motion effect heightens the violence of a gunfight. Jerzy Flisak's 1978 *Inny mężczyzna, inna szansa* (*Another Man, Another Chance*, 1977) cleverly shows a cowboy in a reverse image inside a turn-of-the-century camera (plate 62). And in Jolanta Karczewska's 1965 *Złoto Alaski* (*North to Alaska*, 1960) the faces of John Wayne and

61. Jacek Neugebauer (b. 1934)

Jeremiah Johnson, 1974

Polish poster for the American film

Jeremiah Johnson (1972)

Lithograph: 84 × 59 cm

62. (*above*) Jerzy Flisak (b. 1930)

Inny mężczyzna, inna szansa, 1978

Polish poster for the French-American co-production

Another Man, Another Chance (1977)

Lithograph: 84 × 59 cm

63. (*left*) Jolanta Karczewska (b. 1933)

Złoto Alaski, 1965

Polish poster for the American film

North to Alaska (1960)

Lithograph: 82 × 58 cm

Stewart Granger are highlighted with photographic offset dots, while the artist introduces a suggestion of both history and fiction by illustrating at the top of the poster a man in period clothing using an old-fashioned camera on a tripod (plate 63).

At first, Polish film posters were appreciated more abroad than at home. As Tomaszewski has said in his self-deprecating style, the posters were considered only good enough to wrap herrings in. In truth, the film poster was more like an escape valve for the artist. The poster artist was one of the few whose work was not screened for a social message. The film poster seemed eminently suited to the Polish taste. It was often melancholy, and at times even grotesque. Wojciech Wenzel's 1959 *Jeździec znikąd* (*Shane*, 1953) provides a good example of this, as do Maciej Hibner's 1966 *Czarny dzień w Black Rock* (*Bad Day at Black Rock*, 1955), Jacek Neugebauer's 1967 *Major Dundee* for the 1965 film of the same title, and Marek Freudenreich's 1975 *Mściciel* (*High Plains Drifter*, 1973) (see frontispiece, plates 125, 64, 124). In these four posters, the featured characters appear dark, sinister, and disturbing. They reek of death.

Few poster designers have been more influential than Lenica. In 1970 he wrote, "The visual image has always been a universal means of communication and significance has grown hand-in-hand with the rapid development of the means of communication. Image has always had one advantage over words: it has been unequivocal. Words are usually ambiguous . . . even in the Bible there is a reference to God confusing men's tongues, but there is no mention of Him interfering with their eyesight."[42] According to Lenica, film took over from literature the function of storytelling, providing the ideal medium by combining movement and time. The greatest contributions to film were made by surrealists: they could reveal the subconscious and not just reproduce the theater. By extension, film poster art also could portray the subconscious.

Lenica suggested that the essence of the Polish poster lay in the equal application of the principles of defense and attack. The poster had to be defended from the very environment in which it was placed. It had to confront an architectural setting not necessarily meant for it. The poster had to struggle against the attitudes of a public that might be indifferent or even hostile. According to Lenica, the only means available to the poster artist lay in the capacity to surprise the viewer. Resemblance to other posters destroyed that power. The Polish poster, unlike propaganda or commercial posters, relies on the power of the creator's intellect rather than on conveying someone else's ideas.[43]

That power to attack, confront, and surprise the viewer can be seen strikingly in three examples drawn from the Western posters. In Maciej Żbikowski's 1971 *Był tu Willie Boy* (*Tell Them Willie Boy Is Here*, 1969) and Kazimierz Królikowski's 1967 poster *Rzeka bez powrotu* (*River of No Return*, 1954) the viewer finds himself facing the barrel of a shotgun at precisely the moment the trigger is about to be pulled (plates 65, 66). By his hat, the killer is identified as a cowboy, but because he is anonymous and illusive—a silhouette in the first, a cutout in the second—the act of violence assumes universal meaning. Maciej Hibner's 1968 *Strzały o zmierzchu* (*Ride the High Country*, 1962) is also loaded with

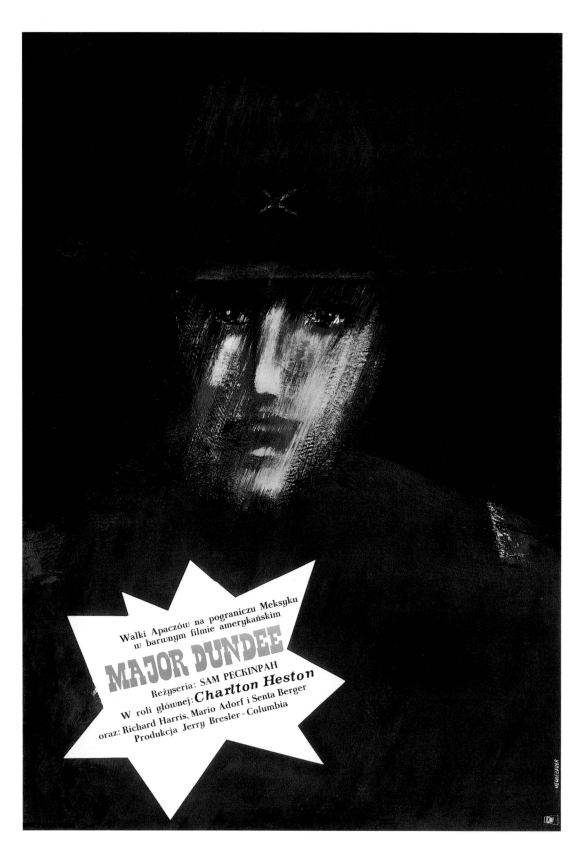

64. Jacek Neugebauer (b. 1934)

Major Dundee, 1967

Polish poster for the American film

Major Dundee (1965)

Lithograph: 83 × 58 cm

65. Maciej Żbikowski (b. 1933)
Był tu Willie Boy, 1971
Polish poster for the American film
Tell Them Willie Boy Is Here (1969)
Lithograph: 82 × 58 cm

66. Kazimierz Królikowski (1921–1994)
Rzeka bez powrotu, 1967
Polish poster for the American film
River of No Return (1954)
Lithograph: 83 × 59 cm

dramatic tension (plate 67). Here, we find ourselves facing another assassin. The gunfighter, arms by his side in classic preparation, at any second is about to burst through the saloon doors and blast away. Through direct engagement, the artist draws the viewer powerfully into the image.

I used to wonder why one of my relatives who had escaped the Nazi inferno was so addicted to watching Westerns. Night after night, exhausted after the day's exertions, he would sit in front of the TV and watch reruns featuring Gene Autry, the Lone Ranger, and Roy Rogers. Indeed, to this day, he still refers to himself as a "lone ranger." I am sure that to him, especially because of his experiences in Europe, the Western represented America, a place where the act of a courageous individual could make a difference, a society that considered justice a cherished concept, and where evil acts would not go unpunished.

Since the days of early silent film, through Westerns America has exported a vision of itself abroad. It was a triumphal narrative, a drama played out against an awe-inspiring landscape, a story of good overcoming evil. People everywhere could identify with the Western hero and his struggle against both the forces of nature and the enemies of law and order. It was history come to life, each film replicating with apparent authenticity the saga of the West, a romantic view of the past ever more important as the frontier receded further into memory. The Western presented an America that, compared to Europe, was practically without a history, where the past had more to do with sentiment and nostalgia than an immutable historical record. Most important, the Western strengthened a universal yearning for simpler times, when issues were less complex and an individual could influence the outcome. It was, to be sure, a one-sided story, an epic in which the hero was free to use physical power to overcome the enemy. Few expressed concern with the underlying premise that most problems could be solved, and evil eradicated, by using deadly force. But in Poland, poster artists challenged this assumption.

The Polish poster artists have produced a body of work that offers an unusual interpretation of the Western. In contrast to posters produced in other countries, their designs managed to create images which, while retaining the character of mass art, nevertheless took an intellectual approach and appealed to a population whose sophistication and discrimination had been born of a horrendous wartime experience. In the postwar period, the Polish mind was honed to razor sharpness through a crude state propaganda that sought to eliminate individual taste and opinion. The poster artist had to walk an ideological tightrope, maintaining artistic integrity while preserving a livelihood. Through the use of imaginative subject matter, bold imagery, and dark humor, Polish poster artists presented to the public a view of the Western that broadened and sharpened an understanding of the issues underpinning the film and the characters in it. The body of work they have produced provides a fascinating Eastern European commentary on the myth of the American West.

In Poland, symbolism has provided an important weapon for the artist in a society where words have been suspect, and where certain icons and even colors form a code

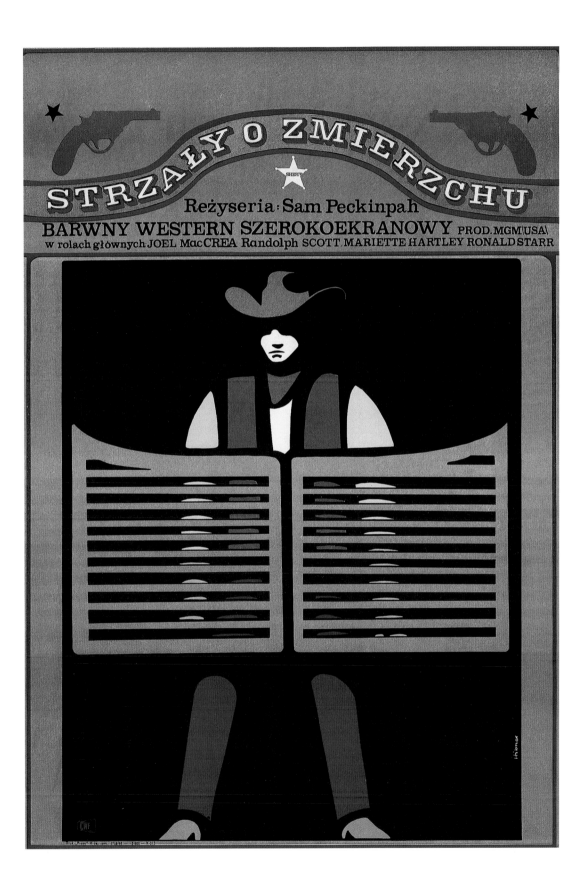

67. Maciej Hibner (b. 1931)

Strzały o zmierzchu, 1968

Polish poster for the American film

Ride the High Country (1962)

Lithograph: 83 × 58 cm

68. Jan Młodożeniec (b. 1929)

Niebieski żołnierz, 1972

Polish poster for the American film

Soldier Blue (1970)

Lithograph: 85 × 58 cm

understood by all. Classic icons of the West are often used to set the scene in a Western poster. Interestingly, however, pictorial reminders of wartime Poland have also been included. Młodożeniec's 1972 poster *Niebieski żołnierz* (*Soldier Blue*) illustrated a violent Western about the Sand Creek Massacre of 1864 (plate 68). But it also incorporates World War II imagery. The soldier's footwear bears an iron cross and is reminiscent of Nazi jackboots, which stride threateningly. A large, tear-shaped drop of blood falls from the soldier's rifle stock, providing a moving elegy for all those lost in war. The image is all the more powerful because the soldier is faceless. His act of violence becomes timeless, universal. Wiktor Górka's poster for *Cat Ballou* portrays in outline a cowgirl holding a gun that, upon closer inspection, resembles a German Luger (plate 69). In the movie, a comedy, the daughter turns outlaw heroine to protect her father from a vicious gunman. The 1965 American film and its 1967 Polish poster both recognize that women were gaining ground in their respective societies. Six years later, Górka produced another strong portrait of a cowgirl. In his 1973 poster *Królowe dzikiego zachodu* (*The Legend of Frenchie King,* 1971), he captures both the glamor of the leading ladies, Brigitte Bardot and Claudia Cardinale, and the comedy in the plot (plate 70). A masked protagonist aims a six-shooter toward the viewer, but this gunfighter has long chestnut hair and wears eye shadow and nail polish. Prior to *Cat Ballou*, strong roles for women had been largely absent in Westerns, and few portraits of females as central characters had appeared in Polish Western film posters. The Western is dynamic, ever adjusting to the interests, concerns, and sensitivities of its audience. The same can be said of the Polish poster.

These visually simple yet complex posters raise important issues. Creative images reflect the perspective of those who produce them: their likes and dislikes, their preferences and prejudices, their personal history. Clearly, Polish poster artists used Western subject matter to comment not only on America but also on Poland, and on their own experience. They also offer a view of America by intelligent, creative, and talented residents of an Eastern bloc country at the height of the Cold War. Central emphases that emerge from this body of work—flight and pursuit, threat and confrontation, guns and killers, authority and defiance—reflect this. Death, mutilation, destruction, incarceration, and dysfunction are recurring themes in what often amounts to an apocalyptic vision. Closely related ideas, such as anonymity, metamorphosis, and transcendence, permeate the works. At times, the posters assume the viewpoint of those subjected to violence, a concept familiar to viewers in Poland. They demand both sympathy and empathy from the audience.

"One of the reasons the western has maintained its hold on our imagination," Larry McMurtry once observed, "is because it offers an acceptable orientation to violence."[44] But for Poles, it seems, violence is never acceptable. In Polish poster art of the Western, it always is a negative force. That violent actions have consequences, an idea visually most powerful in a country where wartime destruction is still visible, and indeed is preserved as a reminder, is one of the strongest messages to come out of the posters. Westerns remind

69. Wiktor Górka (b. 1922)

Kasia Ballou, 1967

Polish poster for the American film *Cat Ballou* (1965)

Lithograph: 85 × 59 cm

70. Wiktor Górka (b. 1922)

Królowe dzikiego zachodu, 1973

Polish poster for the Italian-French-Spanish-British

co-production *The Legend of Frenchie King* (1971)

Lithograph: 82 × 57 cm

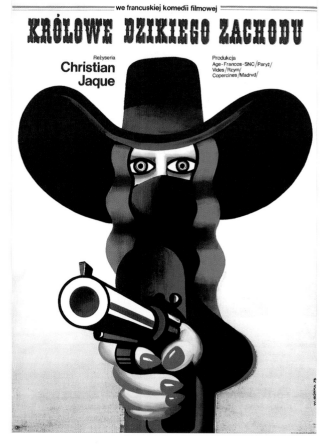

Poles of their historical helplessness against enemies, yet serve as a release from the numbness that accompanies defenselessness. Poles root for the power of the individual vested in Gary Cooper or John Wayne, yet they can also empathize with their fallen opponents. This conflict surfaces clearly within the Polish posters, yet seldom, if ever, within the movies they portray.

Stachurski's 1958 poster *Rekord Annie* (*Annie Get Your Gun*, 1950) furnishes an excellent example of the surprise, powers of suggestion, and complexities inherent in Polish poster art of the Western (plate 71). In contrast to the innocence of the musical it illustrates, Stachurski's poster contains a dark, powerful, and disturbing message. Using a folk art style, the poster plays off the musical elements of the movie. A Madonna-like Annie Oakley is at center, radiant as if standing in a beam of celestial light, her hat resembling a halo. She wears the trappings of cowgirl costuming, but with the addition of a baby's bib sporting the motif AO (for Annie Oakley). This reference to childhood suggests that the heroine considers the rifle she carries a toy. Annie is a Wild West performer, a showgirl, but guns kill. Even as she accepts the acclaim of the audience, the gun points menacingly (perhaps accidentally) at the head of an unsuspecting Indian.

Clearly, something is very wrong with this picture. Produced at the height of the Cold War, *Rekord Annie* portrays a world gone awry. The poster resembles a gaudy carnival ride gone out of control, to the accompaniment of distorted hurdy-gurdy music. The tone is discordant, the message dysfunction. The scene is constructed to resemble a record disc, yet it turns in an anticlockwise direction. The rifle becomes the arm of the turntable, but with strong sexual undertones, hinting at the tension between Annie's femininity and a traditionally masculine West. The ethereal Indian literally is raised to a higher plain but is oblivious to danger and grasps the instrument of his own destruction. In a reference not only to broken treaties but also to the failure of appeasement in Europe, the Indian mistakes the rifle for a peace pipe. Symbolically, his life cycle is thrown out of balance by technology, represented by the counterclockwise movement of the disc. Juxtaposed against him, lying on the floor, is the Frank Butler character, more earthy, pretending to be fixing his hat while slyly trying to look up Annie's skirt. The colors and angles of the cravat of the Pawnee Bill character at left suggest a disjointed American flag, while the Buffalo Bill character at right suicidally sports target motifs on the upper arms of his buckskin jacket. The whole is played out in imaginative space. Displaying excellent draftsmanship, Stachurski's tightly drawn angles complement and heighten the strongly anticyclical construction of his central message.

The figures in *Rekord Annie* resemble puppets, or cutouts, placed in the foreground, middleground, and background of the poster. Stachurski used this same spatial technique again to good effect a year later in his important poster for *High Noon* (see plate 103). In 1965 he returned to a folk art style in *Jeden przeciw wszystkim* (*The Sheepman*, 1958) (plate 72). Again, Stachurski creates a fairground effect, the horsemen shooting at their adversaries from merry-go-round mounts. The poster is reminiscent of a scene from the

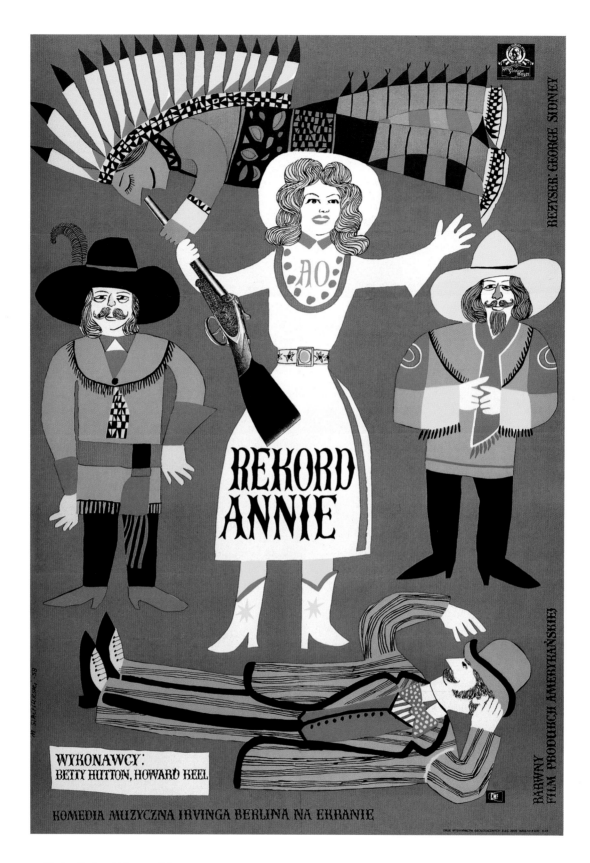

71. Marian Stachurski (1931–1980)

Rekord Annie, 1958

Polish poster for the American film

Annie Get Your Gun (1950)

Lithograph: 85 × 59 cm

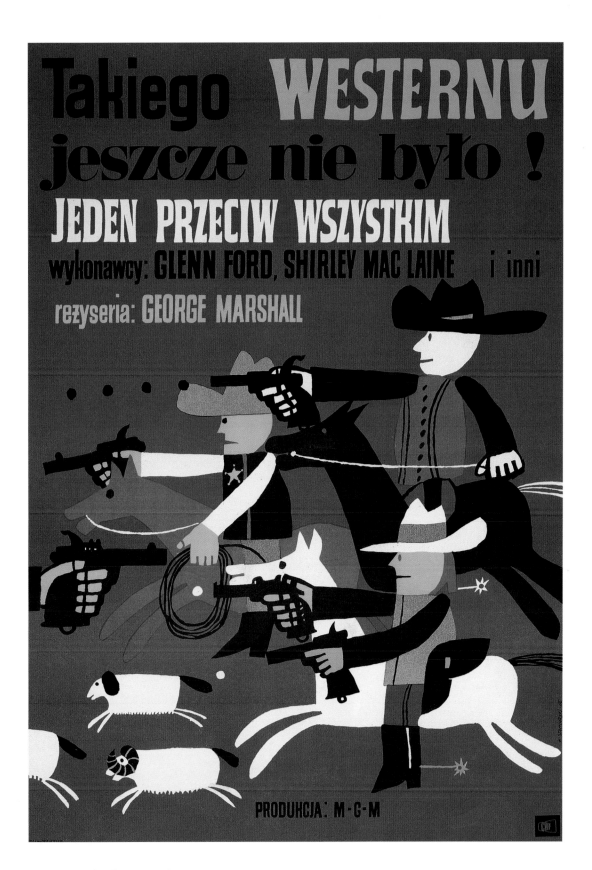

72. Marian Stachurski (1931–1980)
Jeden przeciw wszystkim, 1965
Polish poster for the American film
The Sheepman (1958)
Lithograph: 84 × 59 cm

1964 film *Mary Poppins*, in which Julie Andrews, Dick Van Dyke, and the children glee-fully bound over a fantasy English landscape on detached carnival horses. But the ride in Stachurski's poster seems about to end less happily. The horsemen blindly pursue their quarry, oblivious to the danger staring them in the face. In the foreground, a six-gun points straight at them from point blank range, and a finger is on the trigger.

In 1983, Andrzej Pągowski designed two posters for the 1969 movie *Butch Cassidy and the Sundance Kid*, starring Paul Newman and Robert Redford. One is a playful representation of a comic strip, the violence seemingly as imaginary as the word "Bang," signifying that someone may be shot. Yet even here, in a small circular inset, the two "heroes" appear as bloody corpses (plate 73). In his other poster Pągowski goes beyond the film's final sequence to represent the end that would befall Butch and Sundance (plate 74). In stark contrast to the simple black on white outlines delineating the two subjects, the red blood splotches left by the exploding bullets tell the price they will pay for defying conventions. Świerzy, one of the best known and most widely respected of all Polish poster artists, also designed a poster for this movie (see plate 156). Świerzy adopts an approach similar to Pągowski's second poster, but instead uses rich sepia tones, reminiscent of an old photograph, to link history to the movie's fiction. The image is more bloodied, but disturbingly this time Butch and Sundance are smiling, in defiance of authority and unaware of their impending fate.

I remember that when I purchased my first Polish posters in 1983, I was struck by these Pągowski and Świerzy images. The young man who sold them to me had just come to America, and he related a mysterious story about them. He told me that the Polish authorities had considered these posters particularly subversive: Butch and Sundance seemed to represent Robin Hoods gunned down by the authorities. The posters were smuggled out of the country in a fisherman's case, and the blood spatters had to be added abroad, perhaps in Italy. The story seemed believable, but I have never confirmed it with the artists.

Świerzy has designed other outstanding Western posters. His 1961 work *Vera Cruz* offers an early example of a style that would become his signature (plate 75). The face of the actor is smudged and blurred in an effect that preserves the likeness and character of the protagonist while emphasizing the transient nature of life in the West. In 1978, Świerzy created two posters for Westerns that presented a similar theme. *Across the Great Divide*, 1977, is a scenic Western in which two orphans journey to Oregon in 1876 to claim inherited land. Świerzy's colorful poster *Przez góry skaliste* features a girl's head in the sky, looking down upon a rocky landscape (plate 76). She is surrounded by clouds, and has become one with the elements. To make sure the viewer does not miss the point, the word "Western" at the top is underlined. Świerzy's *Przełomy Missouri* (*The Missouri Breaks*, 1976) displays a further evolution of his style (plate 77). A cowboy's head seems to grow right out of the prairie. The protagonist may still be alive, but clearly his cause is lost: he is pushing up daisies. Prairie grass mixes with his hair and forces its way out of the crown of his hat,

73. Andrzej Pągowski (b. 1953)
Butch Cassidy i Sundance Kid, 1983
Polish poster for the American film
Butch Cassidy and the Sundance Kid (1969)
Lithograph: 96 × 68 cm

74. Andrzej Pągowski (b. 1953)
Butch Cassidy i Sundance Kid, 1983
Polish poster for the American film
Butch Cassidy and the Sundance Kid (1969)
Lithograph: 68 × 95 cm

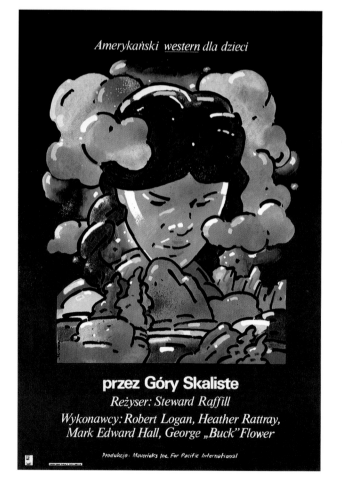

75. Waldemar Świerzy (b. 1931)

Vera Cruz, 1961

Polish poster for the American film

Vera Cruz (1954)

Lithograph: 85 × 58 cm

76. Waldemar Świerzy (b. 1931)

Przez góry skaliste, 1978

Polish poster for the American film

Across the Great Divide (1977)

Lithograph: 95 × 66 cm

while red blood splotches, in striking contrast to the indigo blue of the rest of the image, suggest pain and death. The cowboy is turning into earth. The eyes of the doomed man are the most arresting feature of this poster. They seem to have seen the light, but too late.

It is difficult to choose a favorite from among the many works of Jan Młodożeniec, since his style lends itself so well to both the simplicity and complexity that defines the Polish Western film poster. His 1975 *Sędzia z Teksasu* (*The Life and Times of Judge Roy Bean*, 1972) furnishes an excellent example (plate 78). The self-destructive lawman, portrayed as a yellow silhouette wearing a gun belt, his body already full of bullet holes even as he reaches for his guns, presents an image of a shootist for whom violence has become the standard way of administering justice. Młodożeniec humorously captures the absurdity and insanity of a shootout. The gunfighter, an icon of the mythical Old West, has been reduced to a slice of Swiss cheese.

The 1973 movie *Oklahoma Crude*, set in 1913, is the story of a drifting oilman who stops to help a woman set up her rig. In Młodożeniec's 1975 *Taka była Oklahoma*, the brave and assertive figure of a woman in a long dress dominates, as a large glob of oil oozes from her rifle barrel (plate 79). The glob reminds us of the drop of blood in Młodożeniec's earlier poster for *Soldier Blue* (see plate 68). The woman faces east, symbolically for emigrant Poles, perhaps looking toward home. She is flanked by two figures, her helper and her adversary. The adversary sports a bowler hat and smokes a cigar, both associated with the exploiter. Significantly in terms of both the Western and the history of Poland, the enemy is portrayed to the right of the poster, suggesting residence in the East. Her ally is at left: help and salvation lie to the West.

Młodożeniec's brilliant use of color makes his 1976 *Świat dzikiego zachodu* (*Westworld*, 1973) a truly memorable poster (plate 80). The film is the futuristic story of a holiday resort which recreates the past. Despite the suggestion that "nothing can possibly go wrong," a robot bandit goes berserk and attacks two visitors. In Młodożeniec's work, the dark, threatening figure of the robot killer, activated by wires and triggering warning lights, is juxtaposed against its blonde, lighter colored, scantily clad female partner. Though both are plugged in, they gaze in opposite directions. This suggests sexual tension, but it also addresses the conflict inherent in creating a future which attempts to recreate the past.

The 1976 poster *Oddział* for the 1975 film *Posse*, directed by and starring Kirk Douglas, is another excellent example of a Młodożeniec design in which an almost abstract layout tells a complex story through a few clearly understood symbols (plate 81). The head of the marshal is a stack of greenbacks, the spare lines of his expression suggesting that he knows his time has come. His adversary is represented only as a smoking gun aimed the marshal's way, the revolver and its smoke the same blue color as the lawman's badge. In a spin on the Western mortality tale, Młodożeniec suggests that even good guys who live by the gun shall die by the gun.

Jerzy Flisak has been a prolific designer of posters for Westerns (figure 6). His 1973 poster *El Dorado* for the 1967 film of the same title is an excellent example of an

77. Waldemar Świerzy (b. 1931)

Przełomy Missouri, 1978

Polish poster for the American film

The Missouri Breaks (1976)

Lithograph: 97 × 68 cm

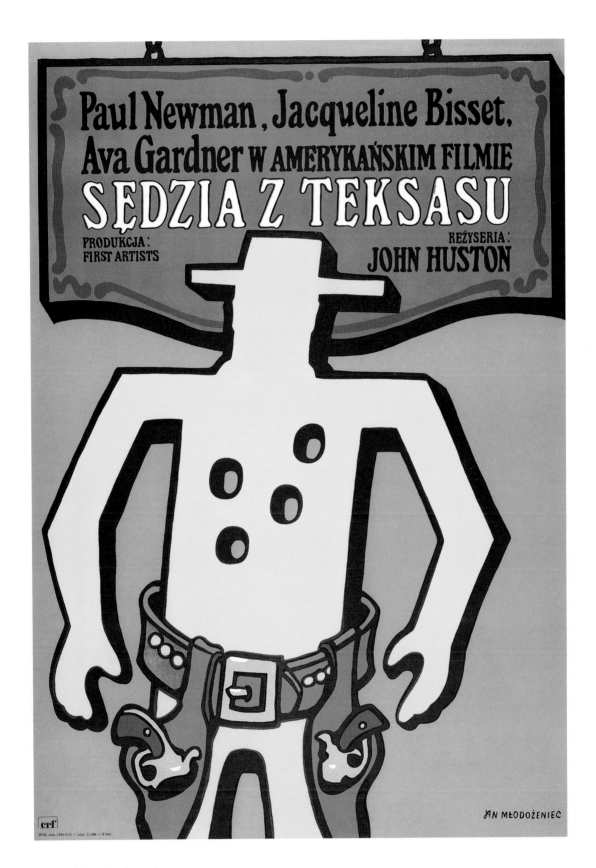

78. Jan Młodożeniec (b. 1929)

Sędzia z Teksasu, 1975

Polish poster for the American film

The Life and Times of Judge Roy Bean (1972)

Lithograph: 84 × 58 cm

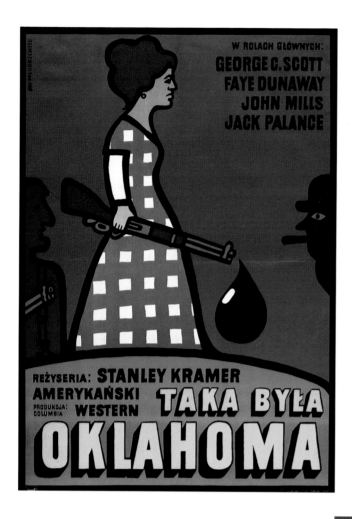

79. Jan Młodożeniec (b. 1929)
Taka była Oklahoma, 1975
Polish poster for the American film
Oklahoma Crude (1973)
Lithograph: 84 × 59 cm

80. Jan Młodożeniec (b. 1929)
Świat dzikiego zachodu, 1976
Polish poster for the American film
Westworld (1973)
Lithograph: 84 × 58 cm

uncompromising, straightforward style, which at the same time conveys the story line, its drama and humor, with amazing economy (plate 82). In the movie, a gunfighter and a drunken sheriff confront an evil cattle baron. Flisak's poster portrays an oversized cowboy whose hat is crowned with a whiskey bottle and who cradles a crutch as if it were a rifle. There is wonderful pictorial balance in this insane image. The cowboy may be old, wounded and inebriated, but he is still dangerous. He makes a commanding figure, and still packs a gun and belt full of bullets.

Flisak's 1972 poster *Ballada o Cable'u Hogue'u* (*The Ballad of Cable Hogue*, 1970) presents another powerful image (plate 83). An episode central to the film's story line revolves around a fight for a water hole in the desert. Flisak's poster features a figure whose head is full of water. The nose is a leaky spigot, the hair a pump handle. Again, playfully yet meaningfully, Flisak comments on the premises underpinning violent action. The protagonist ultimately metamorphoses and becomes one with the object of his obsession. Yet even in this altered state he cannot transcend violence. The expression of recognition intimates that he has learned his lesson too late, and with deadly consequences. His life literally ebbs away.

Other Flisak posters worthy of special consideration include his 1963 *Pechowiec na prerii* (*Alias Jesse James*, 1959), his 1964 *Siedem narzeczonych dla siedmiu barci* (*Seven Brides for Seven Brothers*, 1954), and his 1974 *Kiedy legendy umierają* (*When the Legends Die*, 1972). In the humorous Bob Hope vehicle *Alias Jesse James*, an insurance agent is sent west to protect Jesse James after the company discovers it has a policy on the outlaw. The agent is mistaken for a gunfighter. In *Pechowiec na prerii*, Flisak picks up on the humor in the film by furnishing the bowler-hatted and tie-wearing easterner with a Western bandit's mask and a derringer stored behind the ear (plate 84). Reminiscent of Stachurski's *Rekord Annie* (see plate 71), Flisak's poster for *Seven Brides for Seven Brothers* illustrates the musical elements by creating a record disc design (plate 85). At the apex, a red heart-lipped blonde woman closes her eyes and blushes. Around her, cowboy boots turn in an anticlockwise direction, suggesting her head is in a spin. Western motifs and typographical elements at the bottom of the poster add to its attractiveness. *When the Legends Die*, the story of an aging rodeo circuit rider, gave rise to one of Flisak's finest works (plate 86). The conflict between the old ways and the new is symbolized in the form of a designer show saddle. When the legend dies, the saddle sprouts the wings of a dove and flies off into the wild blue yonder. Flisak's work remains with us as a beautiful elegy to the passing of the golden era of those two great legends, the American Western and Polish poster school.

Wiktor Górka's work testifies to the skill of the poster artist not only in advertising the film but also in augmenting it with an additional message and even shifting the emphasis for the viewer. His 1969 poster *Szalony koń* (*The Rounders*, 1965) portrays the wild, untamed head of a horse in red, the animal about to rear. Below is a blue and black image of the head and shoulders of a wrangler looking to break the horse (plate 87). The film centers on two cowboys who wished to settle down but could not get around to it.

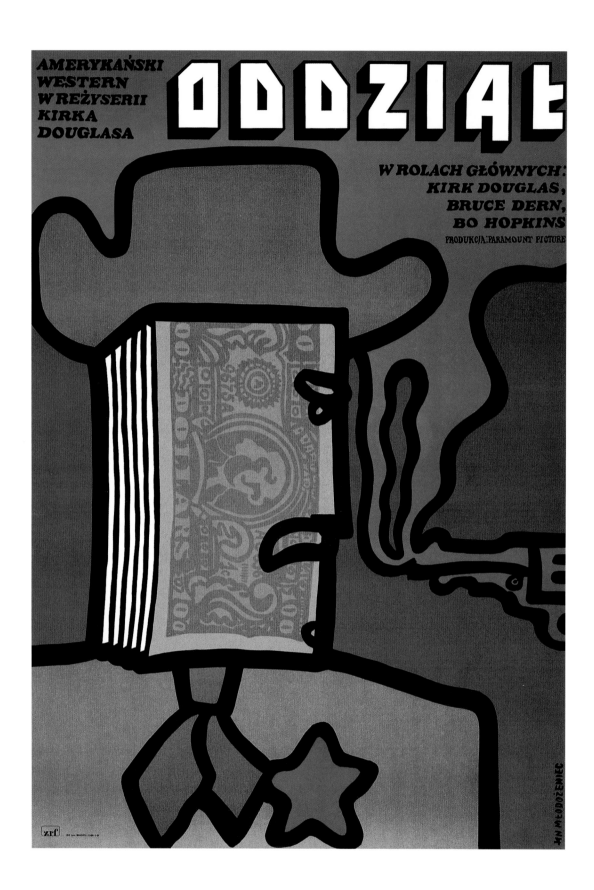

81. Jan Młodożeniec (b. 1929)

Oddział, 1976

Polish poster for the American film *Posse* (1975)

Lithograph: 85 × 59 cm

Fig. 6. Jerzy Flisak (b. 1930) sketching, 1969

Photograph by J. Kosidowski, copyright PAI/EXPO

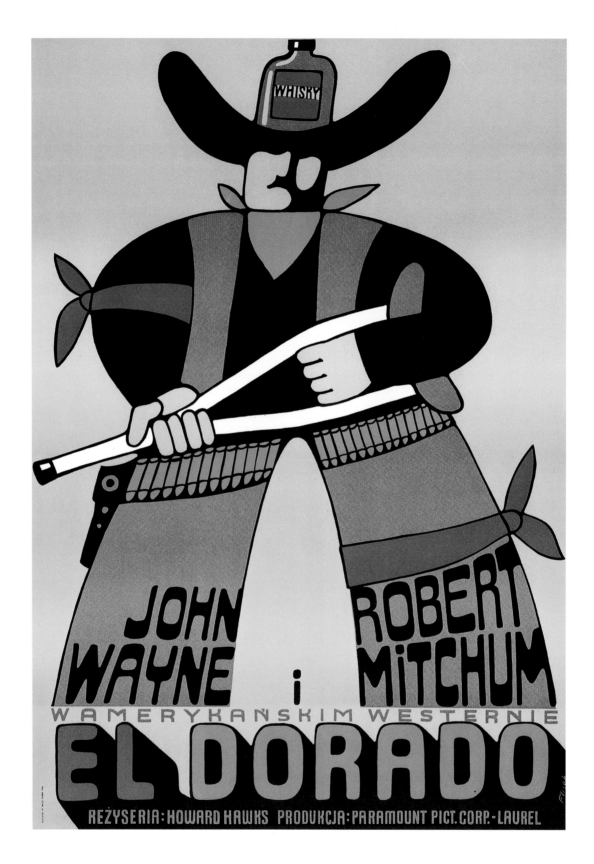

82. Jerzy Flisak (b. 1930)

El Dorado, 1973

Polish poster for the American film

El Dorado (1967)

Lithograph: 84 × 59 cm

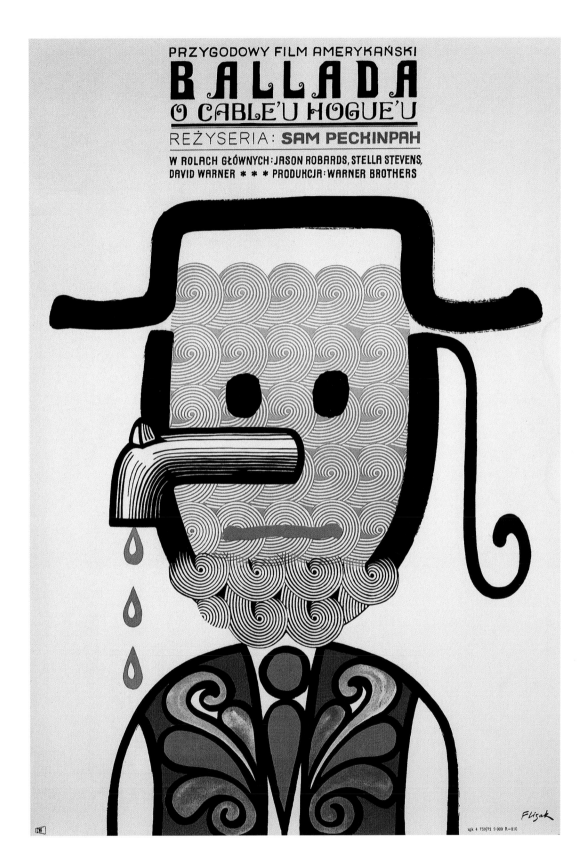

83. Jerzy Flisak (b. 1930)

Ballada o Cable'u Hogue'u, 1972

Polish poster for the American film

The Ballad of Cable Hogue (1970)

Lithograph: 84 × 58 cm

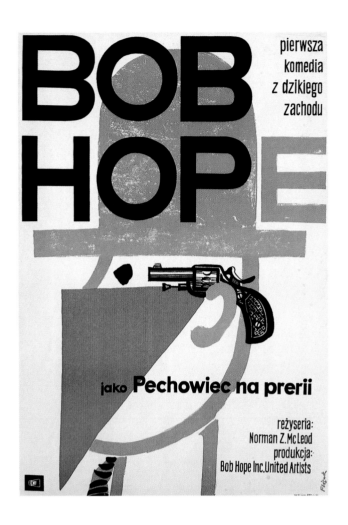

84. Jerzy Flisak (b. 1930)

Pechowiec na prerii, 1963

Polish poster for the American film

Alias Jesse James (1959)

Lithograph: 59 × 41 cm

85. Jerzy Flisak (b. 1930)

Siedem narzeczonych dla siedmiu braci, 1964

Polish poster for the American film

Seven Brides for Seven Brothers (1954)

Lithograph: 85 × 58 cm

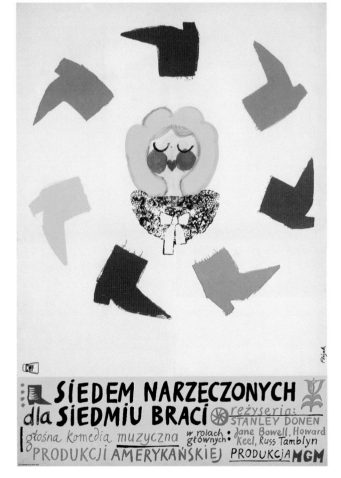

It is a relatively unremarkable plot, but the poster is a different story. Górka contrasts the wild horse with its environment and its captor and makes the animal the dramatic focus of his work. In Polish, Górka's title means "Crazy Horse."

During the early 1970s, Bertrandt created two beautifully designed humorous cartoon posters for Westerns directed by Konrad Petzold and produced in the German Democratic Republic. *Białe wilki*, 1970, shows cowboys and Indians playing out a fight scene among props, under spotlights, and before the cameraman (plate 88). The two Indians look on sardonically, but the cowboys clearly know how to act. Bertrandt's work illustrates how Westerns present not historical facts, but fiction. In *Błąd szeryfa*, 1972, a figure crawls down the barrel of an enormous gun (plate 89). The poster plays off opposites. Though the gun is a recognized phallic symbol, the theme is back to the womb. Unlike the circus human cannonball the image recalls, the character enters the gun headfirst. The viewer can see only the bottom half of the figure, but we know from his boots, spurs, and holstered gun that he is a cowboy. With biting humor, the artist has the cowboy unknowingly seeking refuge within the object of his own destruction. In this deceptively simple work, Bertrandt recalls the failure of European appeasement and other poor choices made in alliances. Through a Western motif, the poster invokes universal issues of innocence and betrayal.

American Indians typically have been treated sympathetically in Polish posters for Westerns. The tone was set early by Bowbelski in his 1957 work *Indiański wojownik* (*The Indian Fighter*, 1955) in which an imposing Indian leader aggressively gallops westward brandishing a lance above his head (see plate 100). That same year, Cieślewicz produced *Złamana strzała* (*Broken Arrow*, 1950) portraying the strong face of a young Native American woman from a film that tried to present an Indian perspective (see plate 99). In Flisak's 1965 poster *W kraju Komanczów* (*The Comancheros*, 1961) an Indian mask and headdress fuse and become a beautiful bird, flying westward (see plate 130). Hibner's *Ostatni Mohikanin* (*Last Tomahawk*), 1966, based on the German-made film *Letzte Mohikaner* (*Last of the Mohicans*, 1965), features the majestic figure of an Indian leader (see plate 153). Elżbieta Procka-Socha's 1978 poster *Powrót człowieka zwanego Koniem* (*The Return of a Man Called Horse*, 1976) displays an image of a Pacific Northwest Coast Indian mask. Surrounding it, however, is long white hair and a beard. These additional elements make the poster seem more theatrical, but they also suggest the interaction between Europeans and Native Americans (plate 90).

Stachurski's 1970 poster for the 1968 British-made Western *Shalako* presents, perhaps, the most outstanding example of such Indian imagery (plate 91). Here, the Brigitte Bardot character appears at center, sporting an iron cross insignia, and aiming a rifle. The ghostly gray-white of her skin contrasts starkly with her black clothing, giving her the appearance of a grim reaper. Two Indians wearing face paint, one bearing a tomahawk, flank her, but these characters have proud postures and are portrayed in warm and vibrant

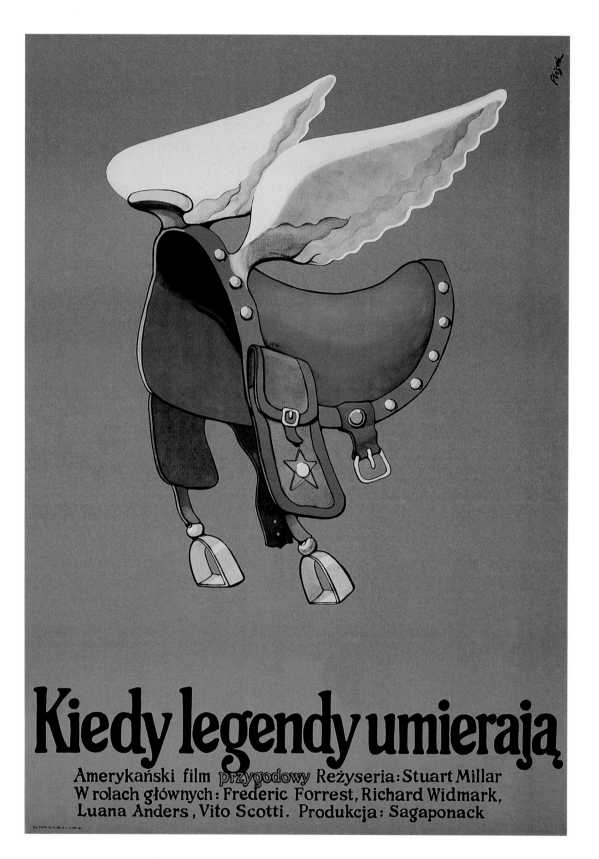

86. Jerzy Flisak (b. 1930)

Kiedy legendy umierają, 1974

Polish poster for the American film

When the Legends Die (1972)

Lithograph: 84 × 59 cm

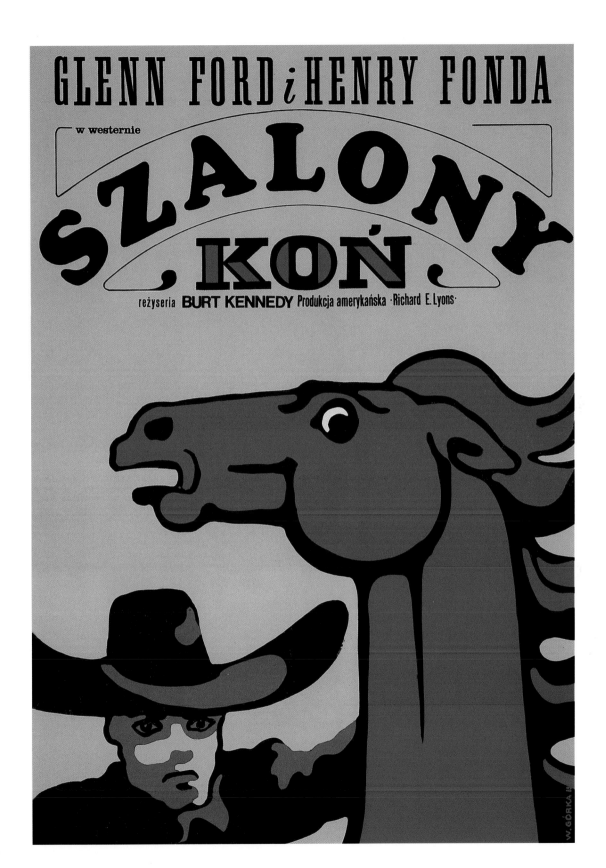

87. Wiktor Górka (b. 1922)

Szalony koń, 1969

Polish poster for the American film

The Rounders (1965)

Lithograph: 82 × 58 cm

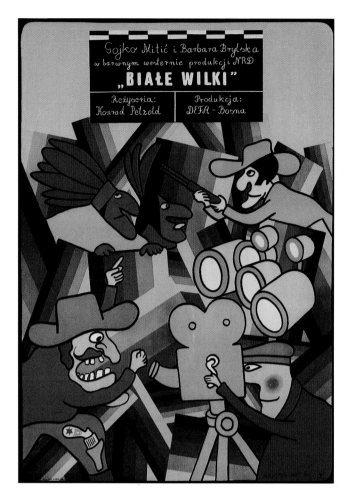

88. Andrzej Bertrandt (b. 1938)

Białe wilki, 1970

Polish poster for the East German film

Weisse Wolfe

Lithograph: 82 × 58 cm

89. Andrzej Bertrandt (b. 1938)

Błąd szeryfa, 1972

Polish poster for the East German film

Todlicher Irrtum

Lithograph: 82 × 58 cm

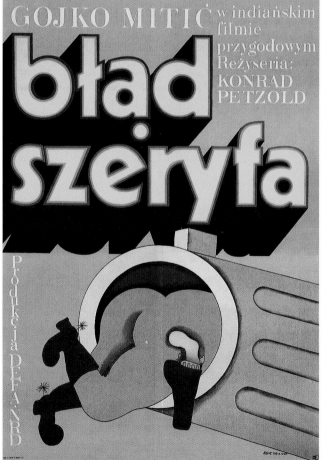

color. Stachurski here contrasts the life-and-death cycle of American Indian existence with the clinical, detached, and self-serving violence meted out by Euro-Americans in the American West and, later, by Nazis in Poland.

Humor, whether light or dark, has been put to good use by Polish poster artists. Yet often, more serious subject matter is employed to get the message across. Marian Terechowicz's 1984 poster *Na granicy* (*The Border*, 1982) and his 1982 poster for the 1980 film *Tom Horn* furnish powerful examples of this (plates 92, 93). In *The Border*, a Los Angeles policeman on patrol in El Paso becomes involved in corruption, violence, and double-dealing, while in *Tom Horn*, an ex-cavalry scout turned detective is framed for murder and executed. In the former, the artist portrays the cowboy as a skull in a cowboy hat, a red rose between its teeth; in the latter, prison bars in a jail window replace the eyes, the sun setting behind them in a sad farewell to life.

Other artists have employed biblical imagery, reflecting Poland's Roman Catholic heritage and majority. Hanna Bodnar-Kaczynska's 1975 *Człowiek w dziczy* (*Man in the Wilderness*, 1971) draws directly upon the film title in portraying a Christ-like mountain man (plate 94). Other artists have referred to the Bible in portraying the death and destruction that is sure to accompany violence. In Stanisław Zamecznik's 1967 poster *Ringo Kid* (for the 1966 *Stagecoach*, a remake of John Ford's 1939 classic movie), a coach appears red hot as if driven from the inferno. The horseless carriage, carrying a faceless passenger, is reminiscent of a death cart (see plate 105). A dueling cowboy seems to be facing a Polish-Western version of the horsemen of the apocalypse in Z. Bobrowski's 1970 poster *Powrót rewolwerówca* (*Return of the Gunfighter*, 1967) (plate 95). In Ihnatowicz's 1977 poster *Mistrz rewolweru* (*The Master Gunfighter*, 1975), the lone gunman reaching for his revolver appears at the very gates of hell (see plate 144). Has he returned briefly to fulfill a satanic calling, or is he about to be dispatched to a fiery fate? Chillingly, in his 1966 poster *Z piekła do Texasu* for the 1958 flight-and-pursuit desert movie *From Hell to Texas*, Dąbrowski employs a silhouette shaped like the head of the Devil (plate 96). The only features appearing on this satanic face are a bare footprint for the nose and a single bone for the mouth. The combatant is left eyeless in Gaza. For these and other Polish poster artists, the Western had gone to hell.

In a land awash with memories and bereft of the cherished objects of childhood, the Polish poster artist anchors himself in his work. At times it seems his very appearance is mirrored in the poster. Tomaszewski's slender and precise poster lines are very much like those of his face: intense and expressive. Młodożeniec, with his strong, stoic peasant face, unmistakably embodies the folklike style of his posters. When I met Świerzy, Górka, and Flisak in 1997, I was struck by another quality of the Polish artist. It was not only their uncompromising seriousness as craftsmen and their wide-ranging intellects but also that childlike wonder at the world around them. It reminded me that, like myself, they were children when the war broke out (except for Górka, who was older and was deported to

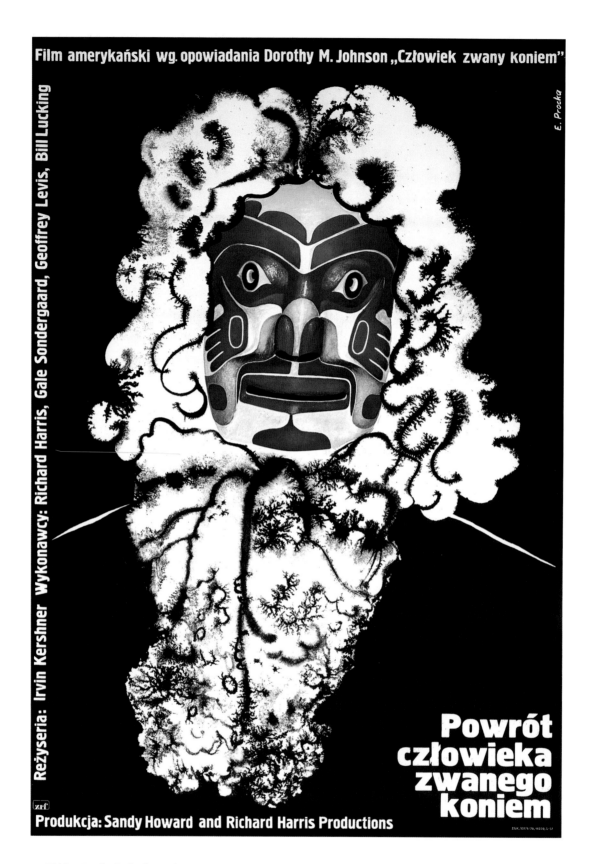

Film amerykański wg. opowiadania Dorothy M. Johnson „Człowiek zwany koniem"

Reżyseria: Irvin Kershner Wykonawcy: Richard Harris, Gale Sondergaard, Geoffrey Lewis, Bill Lucking

E. Procka

Powrót człowieka zwanego koniem

Produkcja: Sandy Howard and Richard Harris Productions

90. Elżbieta Procka-Socha (b. 1947)

Powrót człowieka zwanego Koniem, 1978

Polish poster for the American film

The Return of a Man Called Horse (1976)

Lithograph: 96 × 67 cm

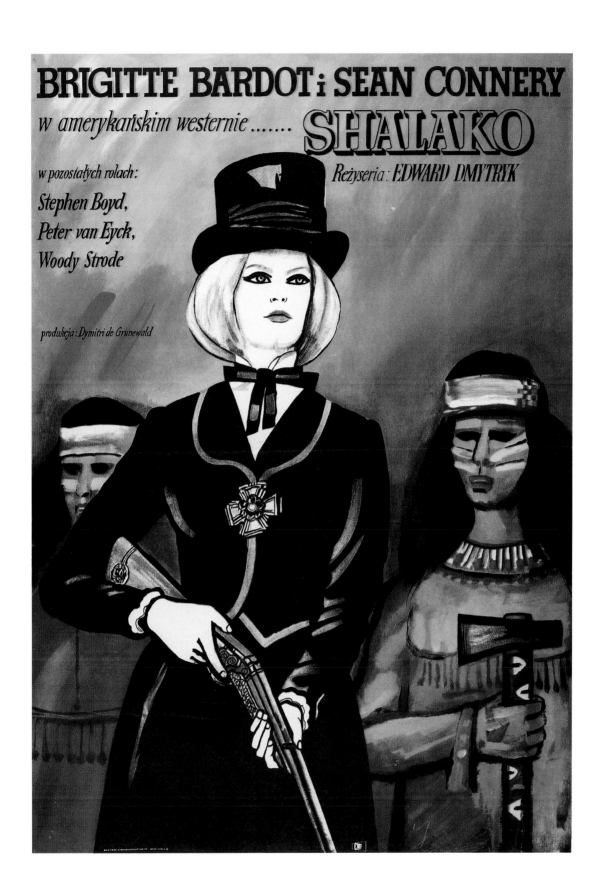

91. Marian Stachurski (1931–1980)

Shalako, 1970

Polish poster for the British film *Shalako* (1968)

Lithograph: 82 × 57 cm

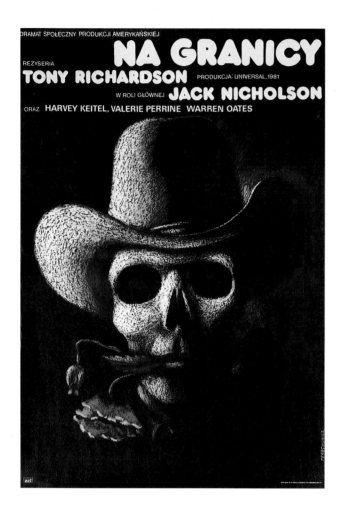

92. Marian Terechowicz (b. 1933)
Na granicy, 1984
Polish poster for the American film
The Border (1982)
Lithograph: 97 × 67 cm

93. Marian Terechowicz (b. 1933)
Tom Horn, 1982
Polish poster for the American film
Tom Horn (1980)
Lithograph: 97 × 67 cm

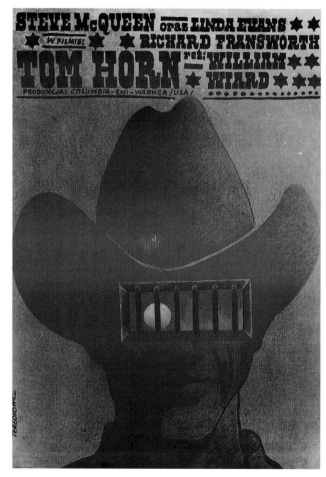

94. Hanna Bodnar-Kaczynska (b. 1929)

Człowiek w dziczy, 1975

Polish poster for the American film

Man in the Wilderness (1971)

Lithograph: 81 × 59 cm

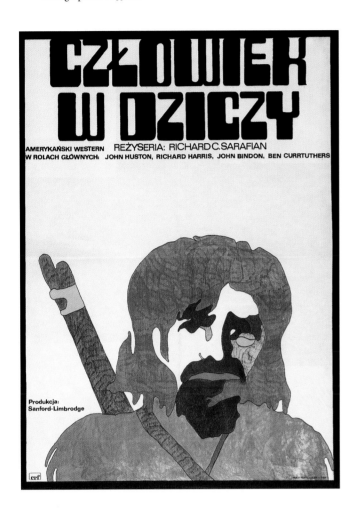

95. (*upper right*) Z. Bobrowski (b. 1932)

Powrót rewolwerówca, 1970

Polish poster for the American film

Return of the Gunfighter (1967)

Lithograph: 81 × 58 cm

96. (*right*) Andrzej Onegin Dąbrowski (1934–1986)

Z piekła do Texasu, 1966

Polish poster for the American film

From Hell to Texas (1958)

Lithograph: 81 × 57 cm

a labor camp in Germany). Like myself, they must have spent days on end in movie theaters before the curtain of war descended on their country. Ever since that time, I have remembered the Westerns of Tom Mix and Ken Maynard. I am sure they too must have absorbed similar images of the American West.

When I attended the final ceremonies of the Biennale at the Wilanów Palace in 1986 and saw the sumptuousness of the reception in a country where few goods were available for the populace, I realized that the Polish poster artist lived in a society where a sense of injustice is always present. As I stood near the modestly dressed young artists, a table-width away from the immaculately clad officials, it struck me that this tableau of contrasts was the source of the artist's sense of irony. Poland's had been a society of macabre happenings, of memories repressed and bodies imprisoned. Poster art has been a way of settling the score. It was combat on a sheet of paper.

The West has continued to fascinate the people of Poland. Its symbols remain recognized and admired. When the Warsaw company Chevalier commissioned Grzegorz Marszałek in 1984 to design a poster for its riding equipment, the artist naturally turned to the great popularizer of dramatic horse and rider imagery for inspiration. Marszałek produced a powerful rendition of a nineteenth-century U.S. Army Indian scout astride his faithful mount at a full gallop, with bullets ricocheting from the borders of the poster. An image straight out of a classic Western, this Chevalier ad had great selling power (plate 97). Poland's entry into NATO makes possible closer future associations with the West in political as well as cultural areas. Poles have always argued that their country was a bulwark against the enemies of the West, whether it be Turks at the gates of Vienna repulsed through the efforts of a Polish king in the seventeenth century, or the valiant defense of Poland against Russian communism in 1920. The destruction of Poland and millions of its people in wartime and the abandonment of the country to Russia as a result of agreements made at Yalta put an end to a nation's hopes and expectations. But the emotional ties remained strong, and the West has retained its promise of a better life even through the filtered and censored films and television images of the postwar period. Polish women remember that in girlhood they gazed at ten-inch black and white Russian TV sets during the 1960s, when the screens flickered with the image of Little Joe in *Bonanza*, and that they fell in love with him. And Polish men will tell you that they learned from John Wayne the meaning of dignity, and the importance of standing up for what is right.

When I visited Warsaw in 1997, I saw in a bookstore *Poszukiwanie Ameryki (In Search of America)*, by Małgorzata Niezabitowska and Tomasz Tomaszewski, a title that featured beautiful photographs of America reproduced earlier in *National Geographic*. It included stunning photographs of the West. Of the 30,000 images taken by the Polish photographer, by far the most impressive were of Monument Valley, Yosemite, the Four Corners area, and Pitchfork Ranch, Wyoming.[45] There are other reminders in Warsaw of

97. Grzegorz Marszałek (b. 1946)

Polish poster advertising Chevalier riding equipment, 1984

Lithograph: 98 × 67 cm

how the Polish people remain attached to the symbols and stories of the American West. I saw an ad in a newspaper for sled dog races sponsored by the Polish Association of North American Indian Friends. This was the fourth international meeting, with thirty Polish and foreign participants. Clearly, country and western music also has become an important element in Polish youth culture. Tomasz Szwed and others hold festivals each year in the Mazury District, and in the summer of 1998 Cornel Patsuda staged the seventh Polish international "Picnic Country" music festival. In Warsaw and other cities, bookstalls offer the Western novels of Karl May to yet another generation of Polish children.[46]

Poles take pride in those of Polish descent who have made contributions to American culture, particularly that of the West. Thus they honor Helena Modjeska, who, as a Shakespearean actress, lived in California where she met Henryk Sienkiewicz. They remember Korczak Ziołkowski, who labored long and hard to have a colossal sculpture of Chief Crazy Horse blasted out of Thunderhead Mountain in South Dakota. Ziołkowski also helped Gutzon Borglum carve the faces of the four presidents on Mount Rushmore. Another Polish artist with a strong interest in the West was Bolesław Cybis, who came to the United States in 1939 for the World's Fair, where he was commissioned to paint two murals for the Hall of Fame. Cybis traveled to the West and made sketches of American Indians, which he later turned into portraits and sold in limited editions. The emigration of many young people in the aftermath of the establishment of martial law in 1981 has brought to the United States a highly educated group of young Poles whose effect on their new homeland and whose loss to the country they left behind have yet to be fully realized. Among those talented Polish expatriates are outstanding poster artists such as Rafał Olbiński, Jan Sawka, and Janusz Kapusta.

Garry Wills, in his recent book *John Wayne's America*, points out that it was the disappearing frontier rather than an existing one that has been the most powerful myth in American history. We love the West and Westerns, he notes, because America was "all frontier." It has been our field of dreams, the "purifying landscape." Though the frontier has long since disappeared, Americans go to the movies and watch their television sets to see it again and again. The movie-going public named John Wayne their favorite actor many years after his death and identified him as a star of Westerns even when his films were not about the West.[47] The international popularity of Larry McMurtry's many books about Texas (especially *Lonesome Dove* and its sequels) offers proof that the fictional West continues to fascinate all of us. The image of America that comes across in Westerns has its own reality. Westerns gave Americans and people elsewhere a lesson in nation-building and offered the hope, if not the expectation, that good would triumph over evil. The attachment felt by Poles to the American West will undoubtedly continue regardless of any geographical frontier. Reasonably or not, Westerns taught us that the cavalry will arrive in the nick of time, and that guys wearing white hats win.

Images of the West have a way of appearing in the most unexpected places. My own

wartime experience serves as an example. Our division had just liberated a small Dutch town. The streets were still deserted, although one could see some people carefully stepping out of their homes as the American forces made their bivouac in one of the well-preserved houses in the city square. Bone-weary, I stumbled into what looked like an old movie house. It was dark and empty. The rows of seats were turned up in military precision. I put down a few and stretched out. I awoke as if in a dream to see Charlie Chaplin in the Klondike trying to cook a shoe. The classic 1925 film *The Gold Rush* was flickering on the screen. The projectionist must have preserved this reel through the years of occupation and was now playing it for the sole American soldier in the audience. It was a thanks offered by a Europe weary of the suffering years. And it was fitting that it was a scene that must have always given Europeans a glimpse of a continent where anything was possible, and where the genius of a filmmaker could stir people to laugh and to cry, to hope and to dream.

1. Peter Schweizer, *Victory: The Reagan Administration's Secret Strategy that Hastened the Collapse of the Soviet Union* (New York: Atlantic Monthly Press, 1994), xiii, 37, 58–61, 69, 130–32, 282–83.

2. Michael Dobbs, *Down with Big Brother: The Fall of the Soviet Empire* (New York: Knopf, 1997), 267.

3. Józef Hordynski, *History of the Late Polish Revolution, and the Events of the Campaign* (Boston: Carter and Hendee, 1832). See also James S. Pula, *Polish Americans: An Ethnic Community* (New York: Twayne Publishers, 1995), 4.

4. Joseph A. Wytrwal, *Poles in American History and Tradition* (Detroit: Endurance Press, 1969), 144.

5. Felix Paul Wierzbicki, *California As It Is, and As It May Be: or, A Guide to the Gold Region*, 1st ed. (San Francisco: Printed by W. Bartlett, 1849). The German edition was published in Bremen in 1850 by Verlag von Loning & Comp. The Tasmanian edition, also 1850, was published in Launceston & Hobart Town by Henry Dowling, Jr., & Walch & Son. See *The Henry H. Clifford Collection, Part One, The Zamorano 80*, Dorothy Sloan—Rare Books Auction Catalog (Austin, Tex.: Printed by W. Thomas Taylor, 1994), 79, 79A, 79B, 12B. See also Frank Renkiewicz, *The Poles in America, 1608–1972: A Chronology and Fact Book* (Dobbs Ferry, N.Y.: Oceana Publications, 1973), 4.

6. Alexander Holinski, *La Californie et les routes interoceaniques* (Brussels: Meline, Cans et Cie, 1853). See also Bogdan Grzelonski, *Poles in the United States of America, 1776–1865* (Warsaw: Interpress, 1976), 134.

7. Florian Stasik, *Polska emigracja zarobkowa w stanach zjednoczonych Ameryki, 1865–1914* (Warsaw: Panstwowe Wyndawn. Nauk, 1985), 23.

8. Renkiewicz, *Poles in America*, 5.

9. John J. Bukowczyk, *And My Children Did Not Know Me: A History of the Polish-Americans* (Bloomington: Indiana University Press, 1987), 9–20. See also Wytrwal, *Poles in American History*, 146. T. Lindsay Baker has produced the best studies of the Silesian Poles in Texas. See his *The Early History of Panna Maria, Texas* (Lubbock: Texas Tech University Press, 1975); *The First Polish Americans: Silesian Settlements in Texas* (College Station: Texas A&M University Press, 1979); and *The Polish Texans* (San Antonio: University of Texas, Institute of Texan Cultures, 1982).

10. Grzelonski, *Poles in the United States*, 130–31.

11. *Portrait of America: Letters of Henryk Sienkiewicz*, edited and translated by Charles Morley (New York: Columbia University Press, 1959).

12. Henryk Sienkiewicz, *With Fire and Sword*, translated by W. S. Kuniczak, introduction by Jerzy R. Krzyzanowski (Fort Washington, Penn.: Copernicus Society of America; New York: Hippocrene Books, 1991), xii–xiii.

13. Sienkiewicz, *Portrait of America*, 58–59.

14. Ibid., 59–61.

15. Ibid., 193, 281, 291.

16. William I. Thomas and Florian Znaniecki, *The Polish Peasant in Europe and America*, 2d ed., 2 vols. (New York: Knopf, 1927), 1:818, 867, 1068; 2:1550, 1630.

17. See Hugh Honour, *The New Golden Land: European Images of America from the Discoveries to the Present Time* (New York: Random House, 1975), 279–81.

18. The standard overview of this topic remains Carolyn Thomas Foreman, *Indians Abroad, 1493–1938* (Norman: University of Oklahoma Press, 1943).

19. William H. Goetzmann and William N. Goetzmann, *The West of the Imagination* (New York: W. W. Norton, 1986), ix; Louise L. Serpa, *Rodeo: No Guts No Glory*, notes by Larry McMurtry (New York: Aperture, 1994), 83 n. 25.

20. Richard Slotkin, *Gunfighter Nation: The Myth of the Frontier in Twentieth-Century America* (New York: Atheneum, 1992), 10, 13, 61.

21. Slotkin, *Gunfighter Nation*, 2–5; Gretchen M. Bataille and Charles L. P. Silet, eds., *The Pretend Indians: Images of Native Americans in the Movies* (Ames: Iowa State University Press, 1980), 3; Richard Slotkin, *The Fatal Environment: The Myth of the Frontier in the Age of Industrialization, 1800–1890* (Middletown, Conn.: Wesleyan University Press, 1986), 532.

22. Richard White, *"It's Your Misfortune and None of My Own": A History of the American West* (Norman: University of Oklahoma Press, 1991), 613–14.

23. L. G. (Lester George) Moses, *Wild West Shows and the Images of American Indians, 1883–1933* (Albuquerque: University of New Mexico Press, 1996), 12ff.

24. Simon Schama, *Landscape and Memory* (New York: Knopf, 1995), 54–56.

25. Moses, *Wild West Shows*, 12–18.

26. The best studies of Catlin and his Indian Gallery are Brian W. Dippie, *Catlin and His Contemporaries: The Politics of Patronage* (Lincoln: University of Nebraska Press, 1990), and William H. Truettner, *The Natural Man Observed: A Study of Catlin's Indian Gallery* (Washington, D.C.: Smithsonian Institution Press, 1979).

27. Slotkin, *Gunfighter Nation*, 69–74.

28. Don Russell, *The Wild West: Or, a History of the Wild West Shows* (Fort Worth, Tex.: Amon Carter Museum of Western Art, 1970).

29. Raymond W. Thorp, *Spirit Gun of the West: The Story of Doc W. F. Carver* (Glendale, Calif.: Arthur H. Clark Co., 1957), 107–24.

30. Moses, *Wild West Shows*, 189.

31. Based on personal observations in Poland and conversations with numerous Poles over the years. See also http://www.cis.udel.edu/~markowsk/beatles/ironCurtain/posterHistory.html (comments by Andrzej Szyszkiewicz). Additional information provided by Mariusz Knorowski, former curator of the Polish Poster Museum, Wilanów; Paweł Potoroczyn, consul general of the Republic of Poland, Los Angeles; and Aneta Zebala, paintings conservator, Los Angeles.

32. Edward Buscombe, ed., *The BFI Companion to the Western* (London: André Deutsch/BFI, 1988), 338.

33. Elena Millie and Zbigniew Kantorosinski, *The Polish Poster: From Young Poland Through the Second World War* (Washington, D.C.: Library of Congress, 1993), 3.

34. On the history of Polish posters, see Szymon Bojko, *Polska sztuka plakatu: Poczatki i rozwoj do 1939 roku* (Warsaw: Wyndawn. Artystyczno-Graficzne, 1971), and Anna Rutkiewicz, ed., *Das Polnische plakat von 1892 bis heute* (Münsterschwarzach: Vier-Turme Verlag, 1980).

35. Anna Husarska, "Post No Bills: Polish Artists Mourn Their Good Life Under Communism," *New Yorker* 69 (January 10, 1994): 62.

36. See Szymon Bojko, *Polski plakat współczesny [wystawa]. Polish Poster Today* (Warsaw: Agencia Autoska, 1972).

37. Edmund P. Lewandowski, "Like a Fish Needs a Bicycle," in Krzysztof Dydo, *Polski plakat filmowy: 100-lecie kina w Polsce, 1896–1996 = Polish Film Poster: 100th Anniversary of the Cinema in Poland, 1896–1996* (Kraków: K. Dydo: Galeria Plakatu, 1996), 25ff.

38. Husarska, "Post No Bills," 65.

39. Aleksander Ford was a significant figure in the history of Polish cinema. In 1930 he helped establish Stawarzyszenie Miłośników Filmu Artystycznego (Society of Devotees of Artistic Film), or START, which was the forerunner of France's New Wave and Britain's Free Cinema. It called for a film based on "Social reality, higher artistic and technical standards and support from the state." START was short-lived, but it provided the basis for the postwar Polish cinema, and Ford then became the head of Film Polski. See Ginette Vincendeau, ed., *Encyclopedia of European Cinema* (London: Cassell/British Film Institute, 1995), 336–38.

40. Lewandowski, "Like a Fish," 30.

41. Zdzisław Schubert, "The Glorious Years," in Dydo, *Polish Film Poster*, 40ff.

42. "Film i formy narracji wizualne," *Projekt 6* (1970): 10ff.

43. Frank Fox, "Polish Posters Triumphant," *The World & I*, November 1988, 275.

44. McMurtry quoted in *New York Times Book Review* May 17, 1998, 16.

45. Małgorzata Niezabitowska and Tomasz Tomaszewski, *Poszukiwanie Ameryki* (Warsaw: Wydawn. Artystyczne i Filmowe, 1993).

46. Personal observations during visits to Poland in 1997 and 1998. See also the World Wide Web site of the Polish Music Reference Center, University of Southern California, at http://www.usc.edu/go/polish_music/festival/foskfest.html.

47. Garry Wills, *John Wayne's America: The Politics of Celebrity* (New York: Simon & Schuster, 1997), 14, 30ff.

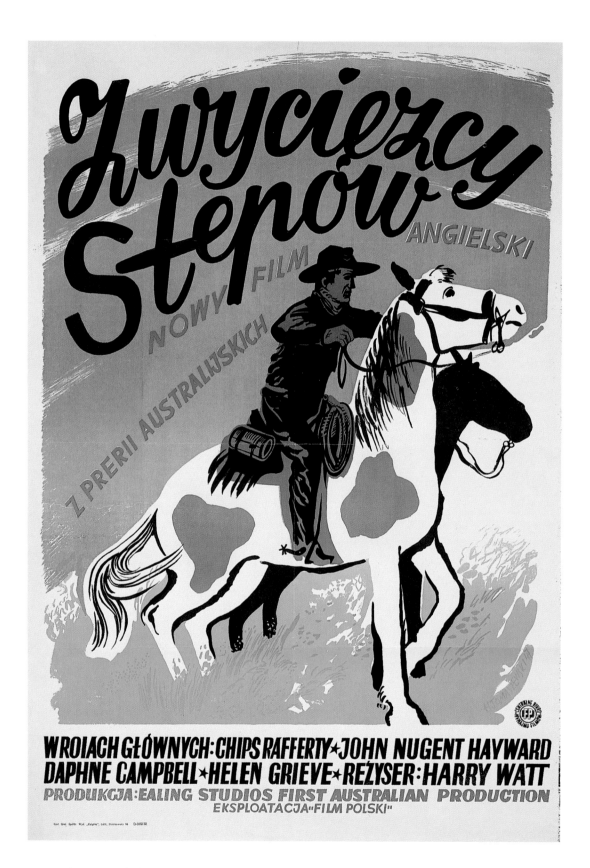

98. Henryk Tomaszewski (b. 1914)

Zwycięzcy stepów, 1947

Polish poster for the British film

The Overlanders (1946)

Lithograph: 86 × 61 cm

TWO LEGENDS:
THE AMERICAN WESTERN
AND THE POLISH POSTER SCHOOL

Mariusz Knorowski

Translated by Aneta Zebala

I N 1952, WHILE *HIGH NOON* SHONE IN FULL GLORY ON AMERICAN theater screens, the long dark night of Stalinism had fallen over much of Eastern Europe. In the revolutionary turmoil that followed Stalin's death in 1953, an ideological war was declared, pitting the bourgeois West against the proletarian East. Artists were required to pay homage to socialist values. Independent thinking was condemned, individualism rejected. The American Western, with its triumph of justice over official law, was excluded from distribution because it was not a useful propaganda tool.

The interment of the ghost of Stalinism brought about a change. Just after October 1956, on the swell of the political thaw and after many years of absence, the American film returned to the Polish big screen. This official acquiescence went hand in hand with a gradual opening up to western cultural values. Between 1949 and 1953, these had been ignored, strictly regulated, or condemned outright. Italian neorealist films and works of European cinematography containing elements of critical realism were shown in Poland, but mainly because they exposed the indigence of ordinary people living on the margins of urban society. It was also during this thaw that Westerns began to appear regularly. They were accompanied by posters announcing them to the public.

The first screening of an authentic American Western in Poland had taken place in the second half of the 1920s. John Ford's monumental fresco *Iron Horse* (1924), called "Fiery Monster" in Polish, was shown. Audiences saw other "A" Westerns, such as *Cimarron* (1931), the first of the genre to win the Oscar for best picture, as well as Hollywood's mass productions, the "B" Westerns. It is known that *Ersatzwesterns*, German serial cinematic productions, were also being distributed. When queried, Polish graphic artists have

unanimously confirmed that they watched Westerns in their childhood. These were their initiation into the world of the Wild West, the extension of which were the cowboy games every child played.

Not much can be said, however, about the posters promoting these films. Private distributors were unwilling to commission pieces, but would use posters included in the promotional package. Such posters, of course, were of foreign origin and did not reflect local aesthetics. During the 1920s and 1930s the film poster did not rise high artistically as a genre, catering instead to mediocre tastes. Renowned graphic artists considered a request to design such an advertisement an affront, and for this reason many hundreds of film posters remained unsigned. Especially in the 1930s, film posters in most of Europe exhibited no regional traditions. Illustrating the star's physiognomy became the universal standard. In Poland, portrait painters sometimes made such posters. It was a popular practice, not only in the provinces, for local amateur designers to create painted posters. These one-of-a-kind originals were placed near the cinema or in its vitrine. If one wanted to illustrate "kitsch," this type of art would fulfill all the requirements. A "sugary" color palette, plus a complete repertoire of melodramatic effects, including sentimentalism, violence, greed, and anger, resulted in posters that exhibited more emotion than artistic form.

In 1950, by an administrative mandate of unknown origin, it was decided to destroy all evidence of the existence of Polish posters for American films. Although it has been difficult to document this event, it seems probable that the decision was made during the propaganda offensive against America. Contemporary collectors are convinced that it did occur because when they compare the list of films shown during that period with the surviving posters, they note that many early posters cannot be found. According to archival sources in Poland, *Jesse James* (1939), shown in 1946, was the most popular movie in the country. In 1948, John Ford's *My Darling Clementine* (1946) appeared under a Polish title which translates as "The City of Lawlessness," featuring Henry Fonda's unforgettable portrayal of Wyatt Earp. In both instances, the posters have not survived and their artists remain unknown.

The iconography of the Western in its pure form was introduced in Polish posters by Henryk Tomaszewski. His first image, created in 1947, was *Zwycięzcy stepów* for the English film *The Overlanders* (1946), its Polish title translating as "Conquerors of the Steppes" (plate 98). This film imitates a Western but takes place in an Australian setting. The poster features a wonderful figure of a rider on horseback leading another horse across the prairie. The image accurately represents the plot of the film, and if the composition, painterly qualities, and unusually romantic aura are taken into account, the poster can be considered a prototype of the genre.

Regardless of the tone and character of the film, Western European art critics considered the Polish poster of the second half of the 1940s to be an interesting visual phenomenon in itself. Despite the unfavorable times, these works were not politically infected

but presented a novel pictorial convention that was as concerned with composition as with subject matter. This was the decisive moment in the development of a new format and new poetics in film advertising. The trend rejected the graphic stereotypes of the 1930s. The method of presenting a single frame of the film reel was abandoned in favor of interpreting the entire work in the form of a metaphor and a naive, grotesque, or fantastic stylization. The poster was now based on the motif of a hero or presented as an interaction of meaningful props, which created a semantic composition that was humorous or suffused with solemnity. What soon became evident was that an individual artist was discernible in each image. His style, means of expression, and working methods became his unmistakable signature. The subject matter was accented by formal values. A distinct facture, or finish, the sweeping gestures attacking the picture plane, and expressive color—all liken the poster to painting. Also, the unconventional freehand treatment of typography became an inseparable part of the structure, adding a new dynamic. An image was born that was fully identifiable with an artist and whole in inventiveness and execution. This took place despite the imperfections of the existing printing technology, which often forced the artist to relinquish his original vision, and create a design to match the ability of the printers.

For the artists of the Polish school (1947–65), the poster became a way to satisfy ambitions that could not always be expressed within the canon of official art. Stepping outside the rigidly precise graphic arts, the artist was inclined toward an expressive, emotional, and thus individual style. Even though the phenomenon was conventionally defined as a "school," in truth the group was a constellation of individuals traveling down their own paths, an association of personalities and temperaments, each inspiring the others and provoking one another to artistic rivalry. As the graphic artists confirm in unison, the diversity of methods of expression resulted from the attitude that one's work was created as "a challenge to one's colleagues." This was done to magnify the individuality of each work, a practice once called "the effect of separateness" by Jan Lenica, an important Polish school artist and informal theoretician of the movement.

The mechanism of film advertising in Poland was quite different from that in other countries. The film distribution system was completely monopolized by the state. The state also paid for printing and distributing posters. Waldemar Świerzy reminds us that, as the saying goes, "The state means nobody." The central institution in charge of film distribution was called Film Polski (FP) in its first years (1946–48), then renamed Central Film Leasing (CWF) in 1949. After several more name changes, it finally became known as Polfilm between 1984 and 1990. From 1964 on, a separate agency called Polish Film was in charge of exporting and promoting Polish films abroad. Commissions for film posters were given to known artists to ensure quality. Sometimes two different images for Polish films were produced, one for domestic distribution and the other for export. Those created for use outside Poland were produced using superior printing and paper and were akin to the standard poster in the West.

By all accounts, Anna Prawinowa, the director of CWF, played a positive and critical role in closing the gap between film and the visual arts. Acting on her own initiative, and on behalf of CWF, she organized free screenings for a select group of artists so they could familiarize themselves with the repertoire. Most of the artists remember that they avidly attended those screenings almost daily, seeing approximately 300 motion pictures a year. During the 1960s, 30 percent of the films shown in Poland were American. The artists confirmed their presence at each screening by signing an attendance book. This was proof that they knew the film from firsthand experience and that they were ready to submit a proposal for a poster commission. On request, other materials were made available to the artists, but for the most part they did not use them. They placed the highest value on viewing the film itself. The film distribution agency included a review board, consisting exclusively of graphic artists. The board sent out commissions for posters to the artists on the attendance list. The board's membership, which changed over time, initially included Wojciech Fangor, Eryk Lipiński, Józef Mroszczak, and Henryk Tomaszewski. Later they were joined by Julian Pałka, Waldemar Świerzy, and Stanisław Zamecznik. In recent years, Jan Młodożeniec also sat on the panel.

The young artists were invited to submit proposals in the form of an unlimited number of sketches. Generally artists submitted no more than ten sketches. These were considered by the board members and one was chosen. The submitted works were discussed only by the board, and its selection was final. A board member could suggest changes, but these related exclusively to the formal and visual aspects of the image and usually had a positive effect on its aesthetic appearance. As the younger artists became better known, no changes were necessary. Świerzy recounts that after the early 1960s he abandoned sketches altogether. The process became more routine as regard for his talent grew. He created and submitted a clean, final project, which was then approved. There was never need to gain approval from any other agency, as there was no censorship. Even though the overwhelming belief is that the censor's domain encompassed all aspects of social life, it did not make a mark on the film poster. Obtaining permission for printing became a formality; the design simply had to be seen in order to get the stamp of approval. Every poster, however, has a censor's coded stamp located at the bottom of the sheet. Included is the printing edition, the quality of paper used, the publisher, and the censor's identification, which can be used to date the piece. There were instances, in later years, when several different posters were created for one film. One may have been a purely typographic composition, while another was an illustration. There could also be multiple images by one artist, or by two different artists. A very interesting initiative was the creation of posters in several different formats, using serigraphy, for exhibition at international film festivals. Customarily, the poster used the "A1" format (86 × 61 cm). A typical edition for popular films varied from between five to thirty thousand copies. Artists who received these commissions were paid handsomely, and with the constant flow of new assignments, they were guaranteed a good standard of living.

The appearance of the Western in the film repertory produced a euphoric reaction in prospective audiences. One could not miss such an opportunity, for going to a Western was in a sense one's natural duty. Full theaters best expressed an affirmation of the West, and the Polish viewer never boycotted a Western. Generally, "all that was American" in early 1950s Poland conferred elevated social status. This included everything from wearing military fatigues, available because of demobilization, to smoking cigarettes. Jazz, having been suppressed and forced underground, easily recaptured its fans and found new ones, especially among students. This great enthusiasm for things American was expressed in public aversion to the slogan "All that is Soviet is best," a sentiment persistently proposed to the skeptical population. The poster became an additional attraction, especially for the young, whose imaginations were ravenous after the meager Stalinist diet. Youthful minds were fertile ground for the previously unknown iconography of the Wild West. In place of the demonic caricature of the effigy of Uncle Sam, which became a target for the ideological crusade against the West, a gallery of types and characters—including exotic Indians, gunmen, cowboys, trappers, and gold miners—emerged in the Polish poster. While in the concepts of the East they amounted to a phantasmagoria, the cinema showed instead that these were ordinary people, not without imperfections of character and evil inclinations. They were disinclined to avoid fights or showdowns, romance or bourbon, but at the same time were not afraid of hard work. While their system of ethics might be akin to that of medieval knights, they were also capable of villainy.

The Western as a genre was such a magnetic force that the poster itself was not needed to boost attendance, at least not in the 1950s and 1960s. In fact, it was determined empirically that the film poster in Poland was not a significant factor in persuading people to attend a particular film. Starting in 1959 and financed by CWF, systematic research was conducted on the influence of the film poster. A representative group of people were asked what had prompted their decision to go to the movies—newspapers, magazines, posters, stills, or a friend's opinion. In order to legitimize its findings, the agency organized special exhibits of examples of the various media. In these displays, the poster lost out against all other media regardless of the social class or age group polled. The CWF researchers concluded, "We have reasons to believe that in most cases it was not the poster that encouraged the individuals to see a film, but having seen the film brought an interest in the film poster." Furthermore: "The role of the poster is to a large extent associated with the formation and preservation of one's memories and recollections about a film one has seen."

Initially at least, there seemed to be a tendency to select films that portrayed discrimination against and extermination of American Indians. It is difficult to determine today where the center of that decision making was located, if in fact it existed. It is known, however, that the selection committee—consisting of film connoisseurs and critics of great authority such as Jerzy Płażewski, Bolesław Michałek, Leon Bukowiecki, and Zygmunt Kałużyński—was responsible for choosing the Westerns that reached Polish audiences. Their choices may have simply been coincidental with Hollywood's reevaluation of the

Western, rather than related to any hidden ideological agenda. Concerns about racial justice and social and moral commentary resulted in films being selected that viewed Indians sympathetically. Since such portrayals threatened American ideals, even discrediting some of them, the Indian Westerns could have been viewed as a useful tool in the East's ideological campaigns. The positive aspect of this body of work was the consistently high artistic quality of all the selected films, which saved the Polish cinema from the flood of banal pictures available elsewhere at very low cost. The graphic artists agree that films of quality were imported, often without regard to cost.

It is no coincidence, then, that among the first Westerns distributed in Poland we encounter those that raise the issue of the Indian as a person. *Złamana strzała*, the 1957 poster by Roman Cieślewicz for the 1950 film *Broken Arrow*, represents the humanization of the Indian (plate 99). It contains a portrait that reveals the emotions of the subject, a woman with an arrow piercing her image. The picture plane is completely filled. The portrait does not clearly reveal the ethnic identity of the model; only the decorative border suggests a design of Indian origin. The artist's focus is the woman's face. Her penetrating gaze assures us of her humanity, which is further emphasized by her innocent beauty. We are under the impression she stares, with pride and dignity, directly into the eyes of her executioner. The film recounts the brutality of a white aggressor who does not hesitate to murder helpless women and children.

The anonymous 1957 poster *Indiański wojownik* (*The Indian Fighter*) has been attributed to several artists, such as Adam Bowbelski, Witold Chmielewski, Jerzy Cherka, and Jerzy Treutler (plate 100). It is a glorification of freedom, personified by a rider gliding across a vast prairie. Nothing confines him, nothing holds him back. The very rhythmic composition and almost tactile organic harmony fuse into one. Although it can be accused of naïveté, this representation is an archetype. It bears clear signs of romanticism, and by glorifying the Indian as a fearless warrior it alludes to knightly epics, putting it in the tradition of equestrian monuments that have decorated the main squares of European cities since the Middle Ages. The *Broken Arrow* and *The Indian Fighter* posters are both executed in an illustrative manner with strong graphic accents. Color fulfills an expressive function, and space is approached in a novel manner. In the case of *The Indian Fighter*, the space is quite neutral and decorative, and is constructed with small forms uniformly dispersed across the surface. Larger forms in a dynamic arrangement are oriented to the left. Coupled with the direction of the Indian's movement, these elements symbolize the act of "leaving home" and going out into the world, just as Wassily Kandinsky once interpreted his *Der Blaue Reiter*, or *Blue Rider*. Wojciech Fangor used a completely different technique in his 1957 design for *Apache* (1954) (plate 101). This was a very modern interpretation of the subject matter, as the artist created a balance between photographic citations and gesture painting. By using black and white film frames as dynamic sequences not connected with action but as an integrating element of the composition, and by delineating the forms

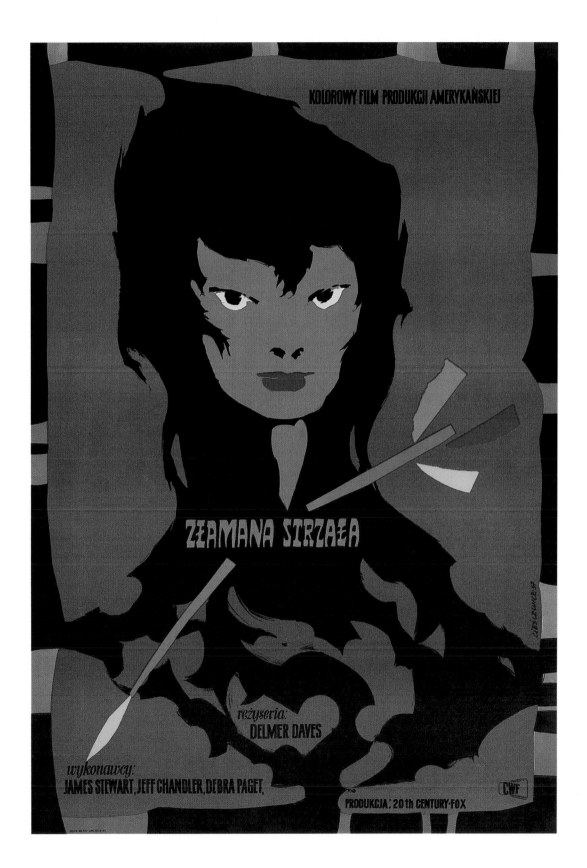

99. Roman Cieślewicz (1930–1996)

Złamana strzała, 1957

Polish poster for the American film

Broken Arrow (1950)

Lithograph: 85 × 55 cm

100. Adam Bowbelski (1903–1968)

Indiański wojownik, 1957

Polish poster for the American film

The Indian Fighter (1955)

Lithograph: 59 × 85 cm

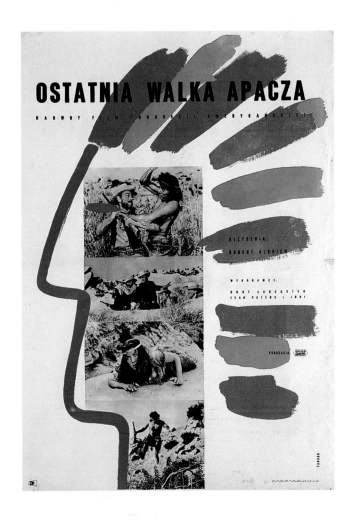

101. Wojciech Fangor (b. 1922)
Ostatnia walka Apacza, 1957
Polish poster for the American film *Apache* (1954)
Lithograph: 87 × 62 cm

102. Jerzy Flisak (b. 1930)
Winchester 73, 1958
Polish poster for the American film
Winchester 73 (1950)
Lithograph: 86 × 59 cm

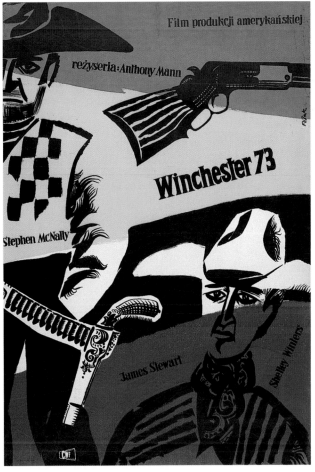

with thick impasto, Fangor locked the photographic stills within a highly stylized profile of a feathered Indian.

An American cowboy appeared in all his glory for the first time in Jerzy Flisak's 1958 poster *Winchester 73* for the 1950 film of the same title (plate 102). The rifle, the hidden "hero" of the film, was the lethal production of Oliver F. Winchester. It advanced the defeat of the Wild West and gave dominance over it to the white man. In this story, the rifle symbolizes the struggle for revenge between two brothers. Flisak's grim portraits reveal the desperation and obsession of the main characters. The legendary *Shane* (1953), whose monumental portrait was created by Wojciech Wenzel in 1959, has something of the ancient hero or the biblical David in him (see frontispiece). The film was shown under its Polish title, *Jeździec znikąd*, which in English is "the man from nowhere." In Polish literary dictionaries the character of Shane is put in a separate category. This "man from nowhere" is defined as a prototypical Western character. Alan Ladd plays a "psychologically credible personification of goodness," yet he holds a revolver in his hand. The resemblance of the poster portrait to the film hero is rather sketchy, both in physiognomy and in costume. The artist concentrated instead on the expressive qualities of the figure, which dominates the background.

Seven years after its 1952 American debut, Polish audiences were able to see the classic Western *W samo południe* (*High Noon*). The film, which won a best actor Oscar for Gary Cooper, was considered by critics to be an allegory of American society during the McCarthy era. It described the drama of a guardian of the law who found himself alone in a difficult situation. The film is a sociological analysis in which the hero is confronted with a society paralyzed by fear. Świerzy has commented that to make a poster for such a cult film becomes a double challenge. For the artist it remains "a dream comparable to an actor's dream of playing Hamlet." The artist of this 1959 poster, Marian Stachurski, chose to feature the moment of triumph at the finale (plate 103). The intense red background operates as scenography. The figures of Will Kane (Cooper), the slain Frank Miller (Ian MacDonald), and the sheriff's wife Amy (Grace Kelly), who is running forward, compose a triangle that is offset by a sun-like circle at top left. The opponents remain in a relationship of opposites suggested by their vertical and horizontal planes, while the victor stands facing the viewer. He is marked with the badge of his office, the sheriff's star, and is dressed in a white shirt and black vest, a timepiece hanging from a watch chain in his pocket. We can see his belt buckle, but no holster, no gun. It is not his weapon that wins this duel, but the moral values that he personifies. Meanwhile, the horizontally sprawled villain, clad in black and wearing a gun belt, has lost his grip on his revolver. He is lying in the bottom right corner of the poster, at the tip of the triangle, in opposition to the sun, which symbolizes all that is good. The female figure, in a white wedding dress, is in motion, while the antagonists are motionless. Both the composition and the attributes of the characters create a concise statement with unequivocal meaning. This film, considered a masterpiece of the genre, encourages deeper reflection of both group and individual behavior patterns in

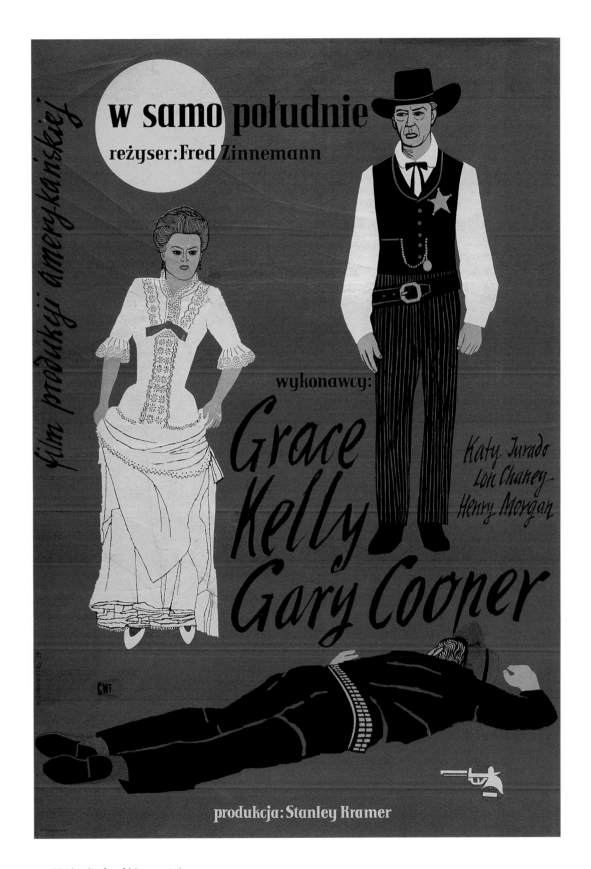

103. Marian Stachurski (1931–1980)

W samo południe, 1959

Polish poster for the American film

High Noon (1952)

Lithograph: 85 × 59 cm

the face of danger. After fulfilling his responsibility, the sheriff throws his star at the feet of the townspeople and walks away.

The year 1962 brought the Polish premiere of *Dyliżans*, the 1939 classic *Stagecoach* by John Ford. Based on a short story by Ernest Haycox, "The Stagecoach to Lordsburg," the film surpassed the stereotypical primitive Western of the 1930s by ideally balancing elements of history and mythology in a spectacle. *Stagecoach* offered an anthology of Western motifs, such as the posse, gunfights, and attacking Indians. It also displayed an interesting gallery of sharply delineated character sketches representing extreme positions. For the illustrator, this film proved quite a challenge. The very dynamic poster created by Jerzy Treutler in 1962 abandoned convention and introduced the motif of the stagecoach itself, observed from the front at the level of the carriage's harness (plate 104). Sitting on the buckboard are two men. Flailing his arms is the coachman Buck, and hugging a rifle is Curley Wilcox, the marshal from Dry Fork. Above, in the loop of a lasso, appears an icon of an Indian rider. Arrows are flying from all sides toward the centrally positioned stage-coach, and flanking the carriage, as if in response, are two revolvers suspended in space. The drama of the scene is emphasized by the expressive contrast between the yellow back-ground, the black of the figures, and the cinnabar tone of the flying arrows. The arrows focus our attention on the center of the composition, heightening the effect of the stage-coach, which seems about to run over the viewer. Despite the simplicity of the image, it invokes terror. The interpersonal relations of the dramatis personae are ignored. When, in 1966, a bland version of *Stagecoach*, shown as *Ringo Kid* in Poland (1967), was made, Stanisław Zamecznik created a much more macabre poster for it (plate 105). Inspired by the suggestive force of the original poster, he all but eliminated the human figures and retained only the stagecoach. A ghost carriage glowing in blood-red colors speeds by with a nebulous, dream-like afterglow. The film oozed sadism and cruelty, which was a reflec-tion of the Spaghetti Western aesthetic. The romanticism that had given epic character to the original was missing.

Actually, the Italian imitations, known as Spaghetti Westerns, did not find approval among the members of the film selection committee and, outside of a few isolated cases, such as *Gringo* (*A Bullet for the General*, 1966) and *Konie Valdeza* (*Chino*, 1973), they were not distributed in Poland (plates 106 and 107). Jerzy Flisak created posters for both films in 1968 and 1977 respectively. In the journal *Ekran* (*The Screen*), film critics subjected Spaghetti Westerns to shattering analysis, denouncing them as repetitive and derivative. Polish television, however, took advantage of the profusion of these productions, show-ing them in abundance, but with an "R" rating.

By the mid-1960s, the Polish poster had already told the story of the Wild West in various narrative images and had appropriated the basic Western iconography. A search for new methods outside simple figuration and anecdote began. A typographic style of poster appeared, which imitated documents of the epoch of the Western. The film's title and credits were written in a decorative typeface, and the letters were often

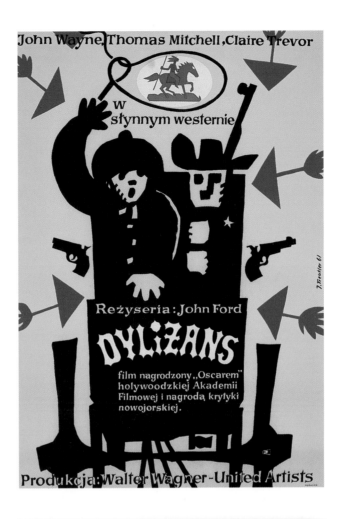

104. Jerzy Treutler (b. 1931)
Dyliżans, 1962
Polish poster for the American film
Stagecoach (1939)
Lithograph: 84 × 59 cm

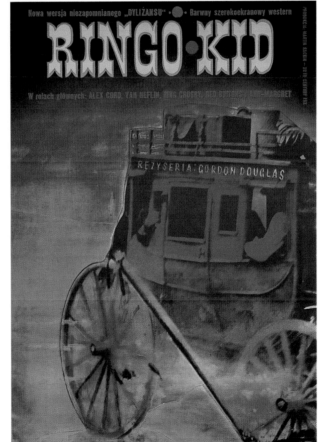

105. Stanisław Zamecznik (1909–1971)
Ringo Kid, 1967
Polish poster for the American film
Stagecoach (1966)
Lithograph: 83 × 58 cm

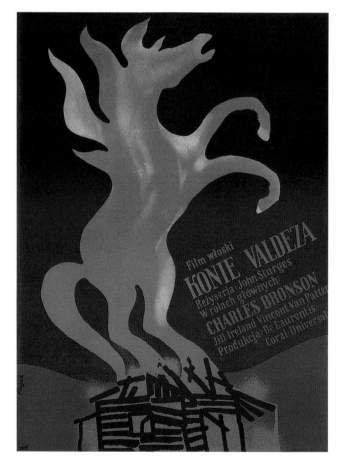

106. Jerzy Flisak (b. 1930)

Gringo, 1968

Polish poster for the American film

A Bullet for the General (1966)

Lithograph: 85 × 59 cm

107. Jerzy Flisak (b. 1930)

Konie Valdeza, 1977

Polish poster for the Italian-Spanish-French

co-production *Chino* (1973),

also released as *The Valdez Horses*

Lithograph: 80 × 58 cm

108. Witold Janowski (b. 1926)

Gwiazda szeryfa, 1963

Polish poster for the American film

The Tin Star (1957)

Lithograph: 85 × 59 cm

crosshatched and shaded. Sometimes additional ornamentation and symbols, such as stars, were included. This treatment created an authentic "wanted poster" look. Witold Janowski's 1963 poster *Gwiazda szeryfa* (*The Tin Star*, 1957) is a good example of this typographic style (plate 108). A reduction of the format during this time was dictated by a temporary paper shortage. In order to save paper, it was decided to use an unorthodox vertical format which, as Świerzy explains, worked well with the typographic system.

In the meantime, in Hollywood, serious reevaluation of the Western genre took place, and a tendency toward a deeper psychological analysis of characters was evident. The Western did not recoil from searching for heroes in the criminal underworld of outlaws. One notices an escalation of dramatic tension, and the grotesque also appears. The genre subjects its own legends to critical analysis and exposes the fictions and myths of earlier films. New types of Westerns appear—the anti-Westerns, super-Westerns, and adult Westerns. Pure fiction is superseded by an allusion to actual events. In some films, the story is transported beyond the pioneer epoch and the gold rush to the beginning of the twentieth century, and even to more recent times. Sometimes, the cowboy dismounts and gets into a car. It seems, however, that most poster artists could not cope with this metamorphosis on a visual level. There was a kind of mutiny in 1965 among the graphic design students of the Warsaw Academy of Fine Arts. Tired of the painterly type of poster, they turned to the contemporary style, in which expressiveness was restrained. They insisted on being graphic artists, not painters making posters. In the sphere of the poster's formal transformations, this reevaluation had clear consequences. The most radical change was the introduction of photography and other graphic experiments, which were grafted onto the structure of the image. In most cases the photographs were either simplified for maximum contrast or, using tonal and separation printing techniques, purposely grainy.

Jerzy Flisak's 1961 poster for the cult film *15:10 do Yumy* (*3:10 to Yuma*, 1957) shows a train departing toward the horizon (plate 109). The last car is a photographic still from the film's final scene. It was in this work that the word "Western" appeared for the first time in a Polish poster. The word was used to describe the type of film and preceded the slogan "unlike all others!" Another example of photo inclusion is provided in a 1963 poster by Stanisław Zamecznik for the film *Dwa oblicza zemsty* (*One-Eyed Jacks*, 1961) (plate 110). The ghostly silhouettes of riders were printed in negative and tinted red to heighten the atmosphere of horror. The film tells the story of a friendship between two men that turns to hatred, which is also a transformation from positive to negative. A similar image is found in Stanisław Zagórski's 1970 *100 karabinów* (*100 Rifles*, 1969) (plate 111). Maria Syska's 1965 poster *Osiodłać wiatr* (*Saddle the Wind*, 1958) featured an enlarged silhouette of a rider at a gallop (plate 112). The illusion of motion was achieved through multiple layering of the photo still, with a slight shift of frames. Artists used other graphic elements, including texturing effects that imitate raw linen, or superimposing an open screen on the figures illustrated in the poster. The 1965 poster *Złoto Alaski* (*North to Alaska*, 1960),

Facing page, top

109. (*left*) Jerzy Flisak (b. 1930)
15:10 do Yumy, 1961
Polish poster for the American film
3:10 to Yuma (1957)
Lithograph: 81 × 59 cm

110. Stanisław Zamecznik (1909–1971)
Dwa oblicza zemsty, 1963
Polish poster for the American film
One-Eyed Jacks (1961)
Lithograph: 84 × 58 cm

Facing page, bottom

111. (*left*) Stanisław Zagórski (b. 1933)
100 karabinów, 1970
Polish poster for the American film
100 Rifles (1969)
Lithograph: 83 × 57 cm

112. Maria Syska-Dąbrowska (b. 1932)
Osiodłać wiatr, 1965
Polish poster for the American film
Saddle the Wind (1958)
Lithograph: 82 × 57 cm

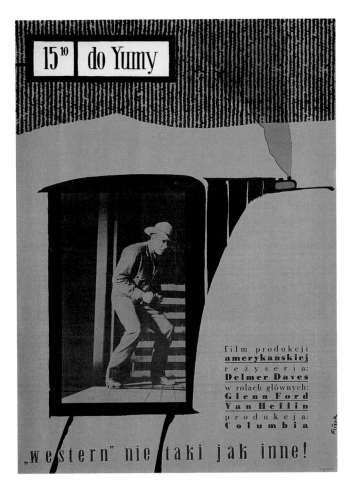

15.¹⁰ do Yumy

film produkcji
amerykańskiej
reżyseria:
Delmer Daves
w rolach głównych:
Glenn Ford
Van Heflin
produkcja:
Columbia

„western" nie taki jak inne!

Barwny western amerykański — w rolach głównych

dwa oblicza zemsty — MARLON BRANDO

„ZŁOTA MUSZLA" W SAN SEBASTIAN — Karl Malden, Pina Pellier

Produkcja „Paramount"

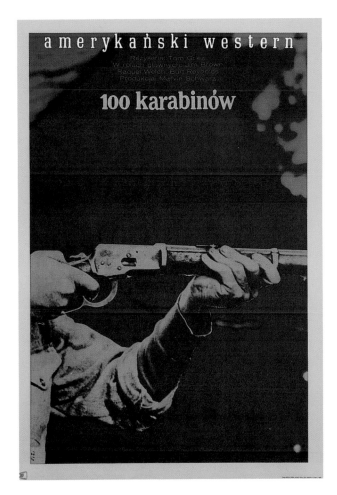

amerykański western

Reżyseria: Tom Gries
W rolach głównych: Jim Brown
Raquel Welch, Burt Reynolds
Produkcja: Marvin Schwarz

100 karabinów

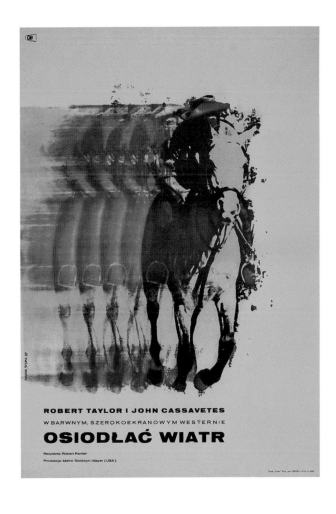

ROBERT TAYLOR I JOHN CASSAVETES

W BARWNYM, SZEROKOEKRANOWYM WESTERNIE

OSIODŁAĆ WIATR

Reżyseria: Robert Parrish
Produkcja: Metro-Goldwyn-Mayer (USA).

by Jolanta Karczewska, exemplifies the latter technique (see plate 63). The gunfighters in Jacek Neugebauer's 1967 *Rio Conchos* (*Rio Conchos*, 1964), meanwhile, look like a charcoal sketch (plate 113).

The main motif in a poster could also be an object, one which identified the genre both semantically and unequivocally. Often this was the six-gun, among the most recognized of Western icons. In Maurycy Stryjecki's 1966 *Samotny jeździec* (*Ride Lonesome*, 1959) and Maciej Żbikowski's 1969 *Hombre* (*Hombre*, 1967), a revolver is all that is needed to announce the film (plates 114 and 115). The moment of violence is past, as illustrated by the drifting smoke, which is employed by both artists to frame attractively designed typography. Żbikowski's poster for *Hombre* was considered very important by Jan Młodożeniec, probably because of its graphic simplicity and lack of figurative representation. The use of the arabesque line was significant, as it became a popular graphic symbol in poster art. Reminiscent of elements of Art Nouveau and the Secessionist movements that broke away from academic style at the turn of the century, the arabesque was a link between the past and present. It later became one of the components of Pop Art. In Andrzej Krajewski's 1973 poster *Odstrzał* (*Shootout*, 1971), the gun, seen from the viewer's perspective, looks more like a cannon (plate 116). More stylized than in *Ride Lonesome* or *Hombre*, the trail of smoke is again used to describe the action and present the title and stars. Młodożeniec's 1989 *Młode strzelby* (*Young Guns*) illustrates the gunshot itself, together with a skull, an indication of a deadly aftermath (plate 117).

The horse was another important element of the Western legend, the embodiment of unrestrained speed and triumph over infinite space. This beloved symbol of freedom continues to be one of the most significant and romanticized aspects of the West's history and mythology. The animal was of extraordinary importance in Western film, and the term "horse opera" was coined to describe inexpensive serials. An inseparable companion and true friend, the horse often shared fame with the hero. Among the most memorable partners were William S. Hart and Fritz, Tom Mix and Tony, and Gene Autry and Champion. Many heroes talked to their four-legged companions, and mourned their deaths. One of the characters in *Jubal* (1956) utters a memorable line, "The death of a horse is perhaps worse than the death of a man. . . . Man can be evil." In the use of the horse motif, one can find a specific kinship between the Polish and the Americans imaginations. The admiration for the horse, the gallop, and the charge has a long and continuous tradition in Polish painting. Beginning in the nineteenth century, when Aleksander Orłowski (1777–1832) started portraying the exotic riders of the East, such as the Kirghiz, Czerkas, and Tatars, and continuing through romantic visions of battle scenes by Piotr Michałowski (1800–1855), Cossack scenes by Józef Brandt (1841–1915), and horse and rider ethnographic studies in the paintings by the Kossak family (two generations of artists active from the mid-1800s to the 1940s), the horse becomes an indispensable element of the Polish fantasy. Wiktor Górka admits that there is an emotional connection between the Polish and the Western passion for the horse.

113. Jacek Neugebauer (b. 1934)

Rio Conchos, 1967

Polish poster for the American film

Rio Conchos (1964)

Lithograph: 84 × 59 cm

114. (*below*) Maurycy Stryjecki (b. 1923)

Samotny jeździec, 1966

Polish poster for the American film

Ride Lonesome (1959)

Lithograph: 83 × 57 cm

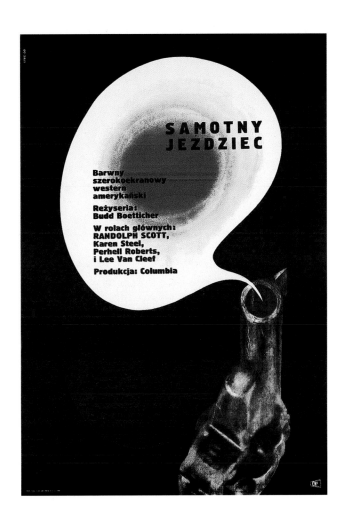

115. (*right*) Maciej Żbikowski (b. 1933)

Hombre, 1969

Polish poster for the American film *Hombre* (1967)

Lithograph: 83 × 58 cm

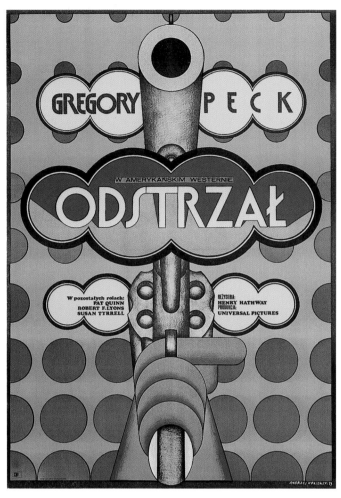

116. Andrzej Krajewski (b. 1933)
Odstrzał, 1973
Polish poster for the American film
Shootout (1971)
Lithograph: 81 × 58 cm

117. Jan Młodożeniec (b. 1929)
Młode strzelby, 1989
Polish poster for the American film
Young Guns (1988)
Lithograph: 96 × 67 cm

The most haunting image of a horse was created by Jerzy Jaworowski in 1962 in the poster *Skłoceni z życiem* (*The Misfits*, 1961), the film starring Marilyn Monroe and Clark Gable (plate 118). In this famous adaptation of Arthur Miller's play into a contemporary Western, all that the mustang represents is compromised. The horses, too small for riding, are to become dog food. The creator of this poster chose to picture an unforgettable scene during the hunt for wild horses. The poetics and stylization of this work bring to mind expressive paintings by Pablo Picasso, who so suggestively immortalized the physicality of suffering in *Guernica* (1937). In Górka's 1969 poster *Szalony koń* (*The Rounders*, 1965), the wild horse has terror in its eyes (see plate 87). The simple gesture of the cowboy's unseen hand on its neck is enough to convey its fate to both the horse and the viewer. The wild stallion, as illustrated in Maria Ihnatowicz's 1968 poster *Czarny mustang* (*Smoky*, 1966), meanwhile represents wildness tamed but not forgotten (plate 119). In both Treutler's 1972 poster *Ostatni wojownik* (*Flap*, 1970) and Żbikowski's 1974 poster *Rodeo* (*J. W. Coop*, 1972), the depiction of a rearing horse with a man's head goes beyond the traditional portrayals (plates 120 and 121). The fighting stance of the two creatures represents the power struggle fought by the main characters of both films.

The iconographic canon of the Wild West also incorporates portraits of cowboys wearing hats. Generally, a wide brim shades the face of the protagonist, amplifying the gloom of his psyche. Intuitively we sense his unpredictability, determination, and desperation. This stereotypical icon has remained vital for many years with only minimal modifications. One can find it in many Polish posters, including works by the master of the poster portrait, Świerzy (plate 122). His 1961 poster *Vera Cruz* (*Vera Cruz*, 1954) is rough and coarse, and his 1978 work *Przełomy Missouri* (*The Missouri Breaks*, 1976) is fantastic and organic (see plates 75 and 77). In both cases, one can identify the main characters, and the artist himself admitted that this was an opportunity to do portraits of his idols without asking their permission. Equally superb is the 1963 work of Marek Freudenreich *Rancho w Dolinie* (*Jubal*, 1956) (plate 123). Two detached elements, a mysterious head and a hand holding a gun aimed at the viewer, are the only forms on an otherwise empty sheet. Equally obscure, but inspiring respect, is Freudenreich's 1975 poster of Clint Eastwood in *Mściciel* (*High Plains Drifter*, 1973) (plate 124). There is no doubt that this individual would seek revenge and would not hesitate to be cruel. He appears to be leaning over an overpowered victim, who in a daze cannot make out the features of his assailant. Maciej Hibner's 1966 poster for the modern Western *Czarny dzień w Black Rock* (*Bad Day at Black Rock*, 1955) is a dark portrait of the main character, the heir of Shane, and thus entitled to a classical Western costume (plate 125). Andrzej Onegin Dąbrowski's 1975 poster *Joe Kidd* (*Joe Kidd*, 1972) contains a large hat that covers all but the cowboy's chin (plate 126). A second motif is represented by the broken medallion on the hatband and the jigsaw edges of the sky. The symbolic rejoining of pieces in the plot of a Western often provides the answer to a puzzle.

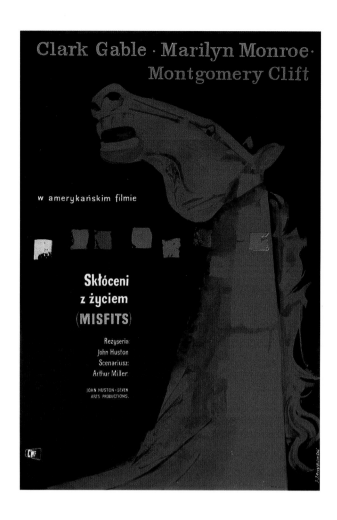

118. Jerzy Jaworowski (1919–1975)
Skłóceni z życiem, 1962
Polish poster for the American film
The Misfits (1961)
Lithograph: 84 × 58 cm

119. Maria "Mucha" Ihnatowicz (b. 1937)
Czarny mustang, 1968
Polish poster for the American film
Smoky (1966)
Lithograph: 83 × 58 cm

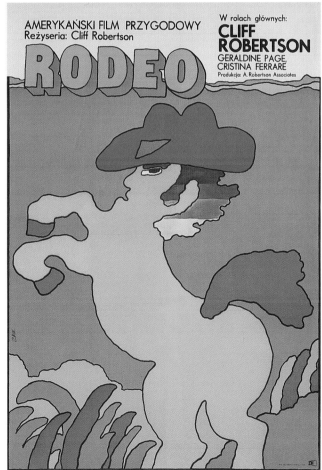

120. Jerzy Treutler (b. 1931)
Ostatni wojownik, 1972
Polish poster for the American film
Flap (1970)
Lithograph: 84 × 58 cm

121. Maciej Źbikowski (b. 1933)
Rodeo, 1974
Polish poster for the American film
J. W. Coop (1972)
Lithograph: 83 × 59 cm

122. Waldemar Świerzy (b. 1931)
at work in his studio, circa 1975
Photograph by H. Sielewicz, copyright PAI/EXPO

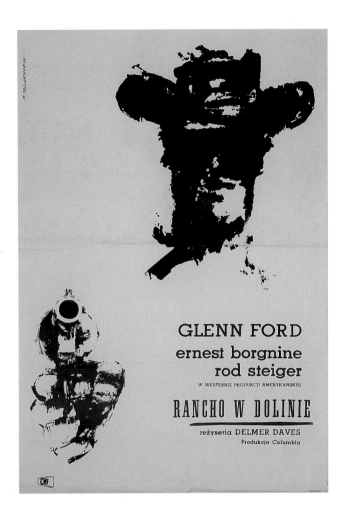

123. Marek Freudenreich (b. 1939)
Rancho w Dolinie, 1963
Polish poster for the American film
Jubal (1956)
Lithograph: 86 × 59 cm

124. Marek Freudenreich (b. 1939)
Mściciel, 1975
Polish poster for the American film
High Plains Drifter (1973)
Lithograph: 59 × 84 cm

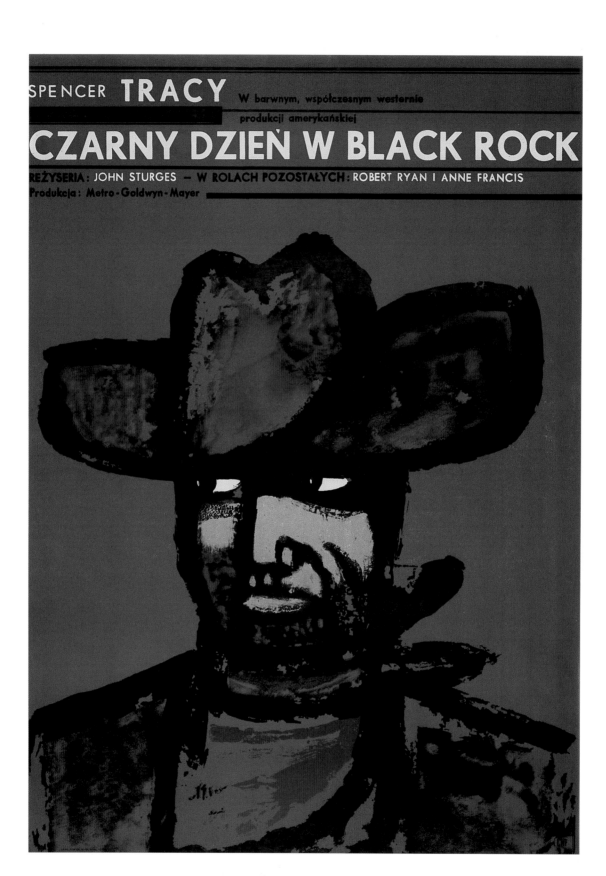

125. Maciej Hibner (b. 1931)

Czarny dzień w Black Rock, 1966

Polish poster for the American film

Bad Day at Black Rock (1955)

Lithograph: 81 × 58 cm

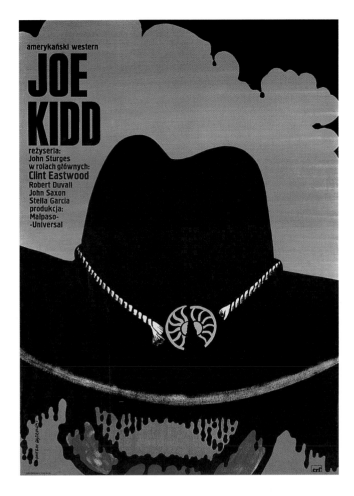

126. Andrzej Onegin Dąbrowski (1934–1986)

Joe Kidd, 1975

Polish poster for the American film

Joe Kidd (1972)

Lithograph: 83 × 59 cm

127. Kazimierz Królikowski (1921–1994)

Twarz zbiega, 1966

Polish poster for the American film

Face of a Fugitive (1959)

Lithograph: 84 × 59 cm

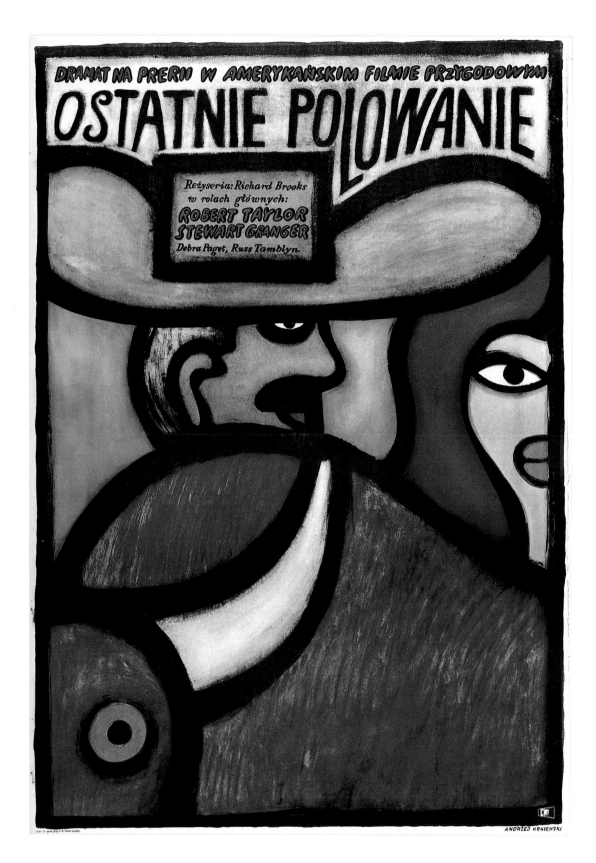

128. Andrzej Krajewski (b. 1933)

Ostatnie polowanie, 1967

Polish poster for the American film

The Last Hunt (1956)

Lithograph: 85 × 60 cm

The hat worn by the cowboy in Kazimierz Królikowski's 1966 poster *Twarz zbiega* (*Face of a Fugitive*, 1959) is pushed away from his face, revealing only film credits where human features should be (plate 127). This faceless image aptly describes the main character's situation. Accused of a crime he did not commit, he runs away and assumes a new identity. In the 1967 poster *Ostatnie polowanie* (*The Last Hunt*, 1956), by Andrzej Krajewski, the cowboy's large hat contains film titles (plate 128). The illustration also includes the face of a woman and a fragment of the head and back of a bison, alluding to the psychopathic obsession of the main character. With a butcher's passion, he delights in murdering herds of bison, the basis of existence for Indian tribes. Some posters emphasize the psychological aura of the hero. An interesting example is Jacek Neugebauer's 1967 *Major Dundee* (*Major Dundee*, 1965), in which a Civil War Yankee appears for the first time on a Polish film poster (see plate 64). Major Amos Dundee, played by Charlton Heston, divested of the characteristics of the epic hero and portrayed as a cynical rough brute, is nevertheless graced with an aura of soldier-like romanticism. The image in the poster is somewhat blurry, leaving the viewer guessing as to the man's true nature.

Another style among the Polish Western posters is the symbolic composition. *How the West Was Won* (1962), the great historic epic directed by Henry Hathaway, was conceived as an anthology of classical Western themes. Such a wide range of motifs demands that the artist select the visual concept carefully. In his 1965 poster for the film, *Jak zdobyto Dziki Zachód*, Jerzy Treutler contrasts the equipment typical of the warring sides (plate 129). The Indian totemic feather mask, representing the spiritual culture of the native peoples and their world of transcendental values, is juxtaposed with the revolver, a symbolic tool of death that blazed the trail of expansionism. Despite the simplicity of the graphic presentation, the conflict between these two cultures has tragic connotations, formulated here through a concise means of expression. The 1965 poster by Jerzy Flisak, *W kraju Komanczów* (*The Comancheros*, 1961), contains an image of poetic symbolism (plate 130). The film tells a dramatic story of desperate Indians attempting to defy the white aggressor. The Comanches, despite their feats of heroism and sacrificial acts, cannot defend their territory and are forced to leave. Employing a similar reduction of elements, a centrally suspended sun-like circle over a dark plane is the backdrop for a stylized bird with an Indian profile. In place of a noble Indian warrior is the ghost of an Indian outcast or a wanderer on his way to the Happy Hunting Grounds. In Polish, the word "wanderer" is associated with the Pole's loss of his homeland, and it found expression in both literature and the visual arts.

Andrzej Onegin Dąbrowski's 1966 poster for *Z piekła do Texasu* (*From Hell to Texas*, 1958) is a symbolic portrait (see plate 96). A footprint in place of the nose and a tibial bone in place of the mouth are inscribed into the contour of a devil's head. The image as a whole creates a penetrating, ghastly physiognomy. *Comes a Horseman* (1978) pits an empire-building cattle baron against ranchers in the post–World War II West. *Przybywa jeździec*, Lech Majewski's 1980 poster for this film, portrays one of the owners of a small

JAK ZDOBYTO DZIKI ZACHÓD

*barwna,
szerokoekranowa
epopeja
historyczna*

J. TREUTLER

HENRY FONDA, GREGORY PECK, JAMES STEWART, JOHN WAYNE

Reżyseria: H. Hathaway, J. Ford, G. Marshall - Prod.: Metro-Goldwyn-Mayer

129. Jerzy Treutler (b. 1931)

Jak zdobyto Dziki Zachód, 1965

Polish poster for the American film

How the West Was Won (1962)

Lithograph: 76 × 52 cm

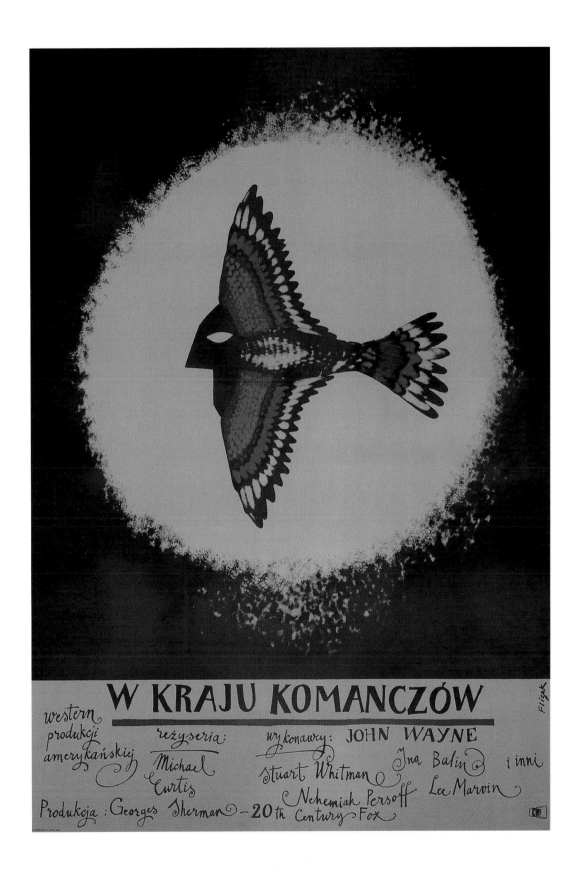

130. Jerzy Flisak (b. 1930)

W kraju Komanczów, 1965

Polish poster for the American film

The Comancheros (1961)

Lithograph: 85 × 58 cm

ranch whose idyllic vision of the past is symbolized by a rainbow emanating from his eye (plate 131). The horseman riding inside a bullet-riddled marshal's badge in Jakub Erol's 1975 *Aresztuję cię przyjacielu* (*Catlow*, 1971) symbolizes the eventual confrontation of the outlaw and the lawman (plate 132).

In addition to these ambitious interpretations of the Western theme, there were also more naive presentations, often colored with humor. In some instances the humorous interpretation was justified by the film's script. The musical *Annie Get Your Gun* (1950) tells the story of Annie Oakley, the legendary Wild West show star. She toured the world with Buffalo Bill, showing off her exceptional shooting abilities. Frank Butler was also a pretender to the title of best marksman. Ultimately, he had to give in to Annie's superior abilities and their rivalry ended in marriage. Annie's unique ability as a markswoman was best demonstrated in a scene at the royal court in Berlin, where she shot the ash off the cigar the emperor was smoking. The 1958 poster *Rekord Annie* by Stachurski lauds this first great show cowgirl as she stands triumphantly between Buffalo Bill and Pawnee Bill, the conquered Frank Butler at her feet (see plate 71). Above, as if levitating, is an image of a smiling Indian looking into the barrel of a rifle held by Annie. The scene elevates these characters to a god-like status and is an attempt at illustrating the idealization of the Wild West. Annie's rivals are represented in buckskins, and the Indian is wearing a fabulous costume with an imposing headdress. Buffalo Bill's variety show was truly a costume spectacle that informed worldwide audiences of the historic and ethnographic color of this exotic place known as the Wild West.

Witold Janowski's condensed 1964 poster *Oklahoma* for the Western musical *Oklahoma!* (1955) did away with all the gallantry of the film (plate 133). Full of bravado and enhanced with plein-air scenery, the film, conceived in the style of a folkloric operetta, tells the story of rivalry for a woman. For the artist, the most convincing approach turned out to be the lone figure of a guitar singer simplified to the greatest possible extent. Janowski used the initial "O" of the title *Oklahoma* as singing lips, and transcribed the film credits as guitar strings. The image is an excellent graphic expression of the nature of the film. Janowski designed other posters for Westerns, such as his 1966 piece *Ostatni zachód słońca* (*The Last Sunset*, 1961) and the 1967 work *Synowie Katie Elder* (*The Sons of Katie Elder*, 1965) (plates 134 and 135). Both of these posters present grotesque images of belligerent cowboys.

Górka's 1967 poster *Kasia Ballou* (*Cat Ballou*, 1965) humorously portrays an "accidental murderess," the leader of a cowardly group of bandits (see plate 69). Standing with legs apart, her pose would be that of a typical challenging gunman were she not a woman. In contrast to her stance, the artist emphasized the feminine aspects of her body, giving her stylish blonde hair, breasts, and painted lips. Her smile is both seductive and threatening. The 1973 poster *El Dorado* (*El Dorado*, 1967), by Flisak, contains a similar element of humor (see plate 82). A cowboy, in the same challenging pose, is holding a crutch in place of a gun, the crown of his hat topped by a whiskey bottle. He represents both the aging lawman and the sheriff featured in this ambitious Howard Hawks film in which

131. Lech Majewski (b. 1947)
Przybywa jeździec, 1980
Polish poster for the American film
Comes a Horseman (1978)
Lithograph: 68 × 98 cm

132. Jakub Erol (b. 1941)
Aresztuję cię przyjacielu, 1975
Polish poster for the European co-production
Catlow (1971)
Lithograph: 81 × 57 cm

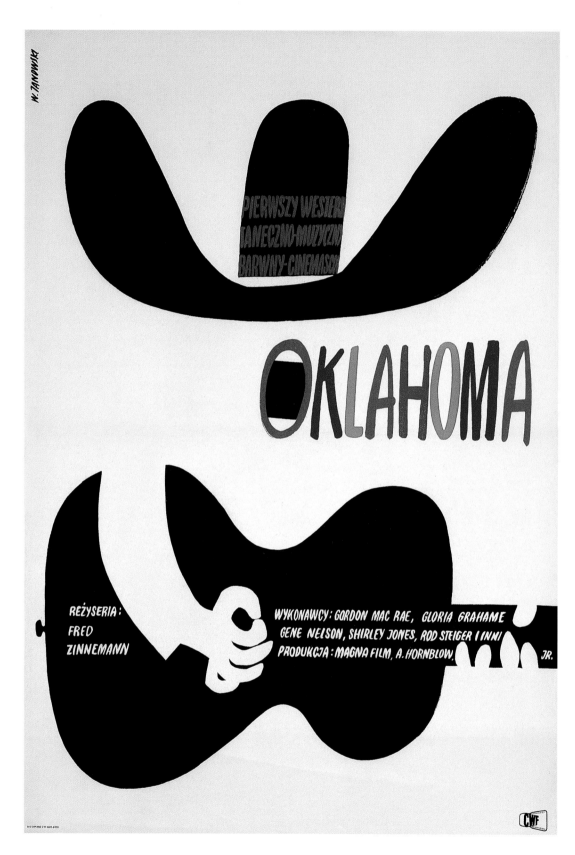

133. Witold Janowski (b. 1926)

Oklahoma, 1964

Polish poster for the American film

Oklahoma! (1955)

Lithograph: 85 × 58 cm

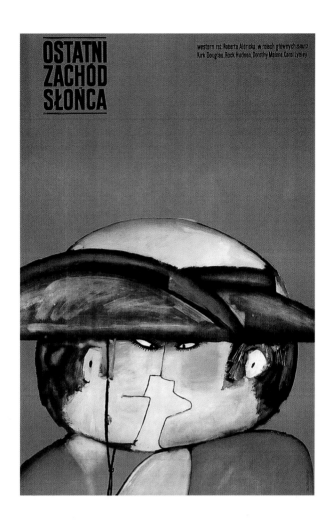

134. Witold Janowski (b. 1926)
Ostatni zachód słońca, 1966
Polish poster for the American film
The Last Sunset (1961)
Lithograph: 90 × 57 cm

135. Witold Janowski (b. 1926)
Synowie Katie Elder, 1967
Polish poster for the American film
The Sons of Katie Elder (1965)
Lithograph: 83 × 57 cm

loyalty and obligation motivate the characters. The 1969 movie *Support Your Local Sheriff* is a great parody that gradually reveals its satirical character through the unconventional behavior of the lawman. Equally unconventional is the 1970 poster *Popierajcie swego szeryfa* designed for it by Bronisław Zelek. It portrays a hand turning into a gun; the thumb becomes the hammer and the index finger the barrel (plate 136). This image aptly reflects the satire and comedy of the film.

By the end of the 1960s, the Western was in decline in Hollywood. Much of what was produced parodied the genre or bemoaned the closing of the frontier. The cowboy life of a bygone carefree rider becomes more and more banal and tiresome. Rarely can he show off his marksmanship, and most of his time is spent driving cattle from Texas to Kansas. Only rarely does one encounter any spirited episodes. The number of Westerns shown in Poland increased perceptibly during this time. Many of them, including the classics, were seen on television. This offered the opportunity to replay the history of the genre in the quiet of one's home. It became a ritual to watch *Bonanza* on television. The show's heroes were the guests of Polish viewers every weekend. Western fiction written by Polish authors also enjoyed popularity.

American films of the early 1970s reflected the growing disenchantment of a society questioning its past and present. Racism continued to be an important theme, but the stories ended in tragedy rather than justice. Western heroes were regularly deconstructed. The films reflect the turbulent times in which they were made. This degradation of the myth was accompanied by the invasion of Pop Art into the visual arts. At the beginning of the 1970s, Poland, emerging from political isolation, became open once again to Western European and American culture. The expansion of popular and artistic traditions in culture created the illusion of participation in the global village and shed any notions of provincialism. Stylistically, Pop Art was naturally assimilated by the poster arts. Aggressive contrasts, psychedelic colors, with red dominant, and delicate arabesques became the favorite means of expression. Using color fields led to the preference for large-scale, often full-figure, motifs, sometimes with a heavy outline. The first signs of this fascination appear in the 1965 poster by Górka, *Dwaj z Teksasu* (*The Tall Men*, 1955) (plate 137). Żbikowski's 1967 poster *Rzeka czerwona* (*Red River*, 1948), Górka's 1968 poster *Zawodowcy* (*The Professionals*, 1966), and Neugebauer's 1970 poster *Złoto MacKenny* (*MacKenna's Gold*, 1969) can be considered standards of this style (plates 138, 139, and 140).

In Żbikowski's poster for *Red River*, two men merge and emerge from a searing background of large color areas. Howard Hawks's 1948 film is a story of authority, defiance, continuity, and change in the post–Civil War West. One can almost feel the intensity of the film's passions in the poster. Richard Brooks's great 1966 film *The Professionals* could seduce the artist's imagination with its magnificent scenery and complex moral problems. The critics found in the characters' behavior the dilemmas of ancient tragic heroes rather than the resolutions of men of the Wild West. None of these aspects of the film found their way into the poster. Instead, the phantom figures of three gunmen float

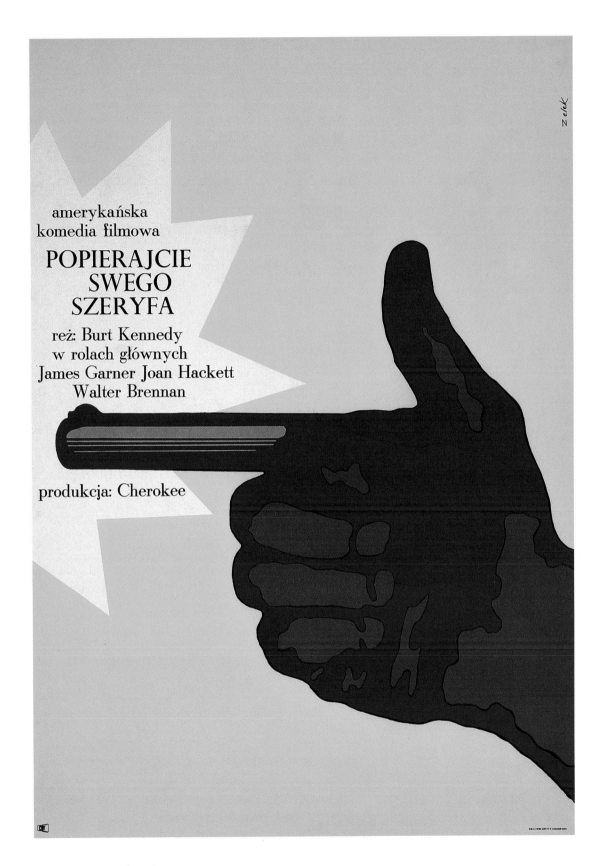

136. Bronisław Zelek (b. 1935)

Popierajcie swego szeryfa, 1970

Polish poster for the American film

Support Your Local Sheriff (1969)

Lithograph: 84 × 59 cm

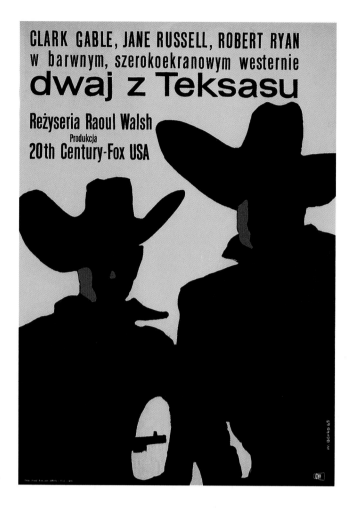

137. Wiktor Górka (b. 1922)

Dwaj z Teksasu, 1965

Polish poster for the American film

The Tall Men (1955)

Lithograph: 83 × 58 cm

138. Maciej Żbikowski (b. 1933)

Rzeka czerwona, 1967

Polish poster for the American film

Red River (1948)

Lithograph: 82 × 58 cm

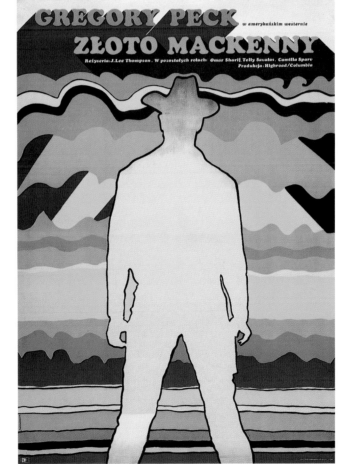

139. Wiktor Górka (b. 1922)
Zawodowcy, 1968
Polish poster for the American film
The Professionals (1966)
Lithograph: 83 × 58 cm

140. Jacek Neugebauer (b. 1934)
Złoto MacKenny, 1970
Polish poster for the American film
MacKenna's Gold (1969)
Lithograph: 85 × 58 cm

above a red desert. Although the film is about four mercenaries, the artist admitted to having reduced the number of portrayed figures to three for compositional reasons. Similar incongruities can be found in Hibner's 1968 poster *Strzały o zmierzchu* for Sam Peckinpah's *Ride the High Country* (1962) (see plate 67). Peckinpah's elderly, nostalgic gunmen accept the job of transporting gold from a mining camp to a distant bank, aware that they are living their last big adventure in the Wild West. The poster presents the full-figure image of a single gunman at the door of a saloon. This rather banal image may represent the "good old days" of the two heroes. In the poster for *MacKenna's Gold*, Neugebauer shows only the outline of a standing figure about to draw his guns. His monumental scale is emphasized by a highly stylized and almost monochromatic landscape made up of bands of color and a low-angle perspective.

Unquestionably the dominant icon of the Western of the 1970s became the figure of the gunman. In Polish posters, we encounter attempts at unconventional portrayals of the hero. One example is illustrating a back view of the protagonist, as if he were going to meet impending danger head on and the viewer escorts him. In Z. Bobrowski's 1970 poster *Powrót rewolwerówca* (*Return of the Gunfighter*, 1967), a made-for-television Western, it is the purebred gunfighter Ben Wyatt (Robert Taylor) who has the role of avenger (see plate 95). A greedy trickster first dispossessed Wyatt's old friend of his land and then caused his death. The poster shows the moment of decisive confrontation. In Wasilewski's 1975 poster *Patt Garrett i Billy Kid* (*Pat Garrett and Billy the Kid*, 1973), and the earlier image by Stachurski for *Mścieciel z Laramie*, 1959 (*The Man from Laramie*, 1955), the main character also strides toward the moment of confrontation (plates 141 and 142).

The image of the gunman in Erol's 1970 poster *Pojedynek w słońcu* for the scandalous *Duel in the Sun* (1946), which tells of two brothers' rivalry over a woman, undergoes a far-reaching Pop Art transformation (plate 143). Rather than employ a narrative illustration, the artist, despite using fragmentary scenery and including typography, captures the rhythm of movement superbly. The modest use of color splendidly accentuates both the scorching heat of the day and the internal, emotional fire of the hero. Ihnatowicz's 1977 poster *Mistrz rewolweru* for *The Master Gunfighter* (1975) is unconventional in that, notwithstanding its painterly brushwork, it is a work of low artistic value (plate 144). It intentionally borders on kitsch, and expert opinion tells us that this is how the long-lost amateur posters of the 1920s looked. This intended awkwardness and naïveté of interpretation were characteristic of the mannerism of Ihnatowicz, also known as "Mucha," who tried to replicate the accepted prototype. Her other posters, for example the 1973 *Wynajęty człowiek* (*The Hired Hand*, 1971) and the 1974 *Ostatni seans filmowy* (*The Last Picture Show*, 1971), are usually more idyllic images (plate 145 and 146). The "Iron Cowboy," John Wayne, appeared in another kitschy 1975 Ihnatowicz poster, *Synowie szeryfa* (*Cahill, United States Marshal*, 1973) (plate 147). While he was a matchless personification of the Western, the graphic representations of Wayne never did him justice. Despite his right-wing political views, he enjoyed a great deal of popularity in Poland, thanks mainly

141. Mieczysław Wasilewski (b. 1942)
Patt Garrett i Billy Kid, 1975
Polish poster for the American film
Pat Garrett and Billy the Kid (1973)
Lithograph: 82 × 58 cm

142. Marian Stachurski (1931–1980)
Mściciel z Laramie, 1959
Polish poster for the American film
The Man from Laramie (1955)
Lithograph: 85 × 59 cm

143. Jakub Erol (b. 1941)
Pojedynek w słońcu, 1970
Polish poster for the American film
Duel in the Sun (1946)
Lithograph: 83 × 59 cm

144. Maria "Mucha" Ihnatowicz (b. 1937)
Mistrz rewolweru, 1977
Polish poster for the American film
The Master Gunfighter (1975)
Lithograph: 92 × 67 cm

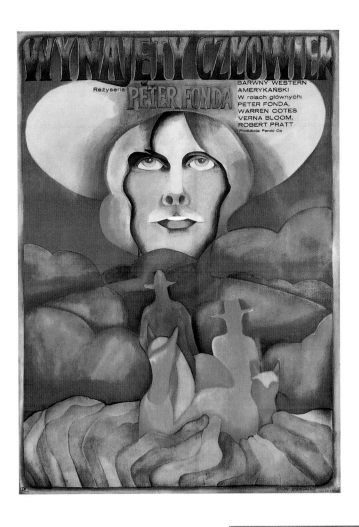

145. Maria "Mucha" Ihnatowicz (b. 1937)
Wynajęty człowiek, 1973
Polish poster for the American film
The Hired Hand (1971)
Lithograph: 81 × 58 cm

146. Maria "Mucha" Ihnatowicz (b. 1937)
Ostatni seans filmowy, 1974
Polish poster for the American film
The Last Picture Show (1971)
Lithograph: 81 × 58 cm

to television. Świerzy remembers that someone once tried to censure Wayne for his stand on Vietnam, but that person's opinion was ignored. For the Polish viewer, John Wayne was a big shot and his name could not be blemished.

In his 1972 poster *Pojedynek rewolwerowców* (*A Gunfight*, 1971), Andrzej Bertrandt presents a visual image of a reporter's live commentary (see plate 41). This monstrosity, constructed from a fusion of muscular legs and a fist, is holding up an entire prop room of the Wild West, including a sheriff's star with a bullet hole in it and a revolver. Perhaps the artist intended that this hybrid give expression to the fusion of an ancient hero and a fearless contemporary sheriff. A powerful portrayal of a cowboy is found in Erol's 1973 poster *McMasters* (*The McMasters*, 1970) (plate 148). In the film, a demobilized African American soldier from the Union Army returns to the South and, thanks to an old friendship, becomes a rancher. To work his land, he enlists the help of American Indians. After a period of idyllic coexistence, a conflict arises. The black rancher has ambitions not unlike those of the white landowners, and this arouses objections from the Indians, whose freedom would be restricted. The silhouette in the poster is outlined with barbed wire, a symbol of oppression and captivity for both African Americans and Indians. The 1973 photographic poster *Mały wielki człowiek* (*Little Big Man*, 1970), by Tomasz Rumiński, is yet another example of the unconventional portrait (plates 149 and 150). This film by Arthur Penn attacks American expansionism, diminishes the glory of the conquerors, and ridicules the defeated. In a powerful narration by Dustin Hoffman's character, the American hero General George Armstrong Custer is caricatured, and contrary to popular perceptions, turns out to be a grotesque clown. Many heroic myths of the West collapse under the sharp blade of satire, and the "honorable" deed seems of questionable merit. In Rumiński's poster, the gesture of the figure covering his face is an apt commentary.

Młodożeniec holds a special position in poster illustration of Westerns (plate 151). He designed images in 1970 for *Jesień Cheyennów* (*Cheyenne Autumn*, 1964), in 1972 for *Niebieski żołnierz* (*Soldier Blue*, 1970), in 1975 for *Sędzia z Teksasu* (*The Life and Times of Judge Roy Bean*, 1972) and *Taka była Oklahoma* (*Oklahoma Crude*, 1973), in 1976 for *Świat dzikiego zachodu* (*Westworld*, 1973) and *Oddział* (*Posse*, 1975), and in 1989 for *Młode strzelby* (*Young Guns*, 1988) (plate 152; see plates 68, 78, 79, 80, 81, and 117). Masterfully, seemingly clumsy contours and delectable colors go hand in hand with interesting compositional ideas and an exquisite, freehand typography. Despite using a very simplified figuration, Młodożeniec does not shy away from the grotesque or a dramatic approach. His works are distinguished by a high level of balance between the composition and subject matter, which allows us to perceive them as an integral whole. Even though he deprecates his poster work and considers it "semi-art," he is unusually sensitive in regard to a phenomenon he calls the "street aesthetic," the common grayness of the streets and the people on them. Everything is toned down so as not to jump out of the anonymous crowd. The only color is provided by posters and broken neon signs. Młodożeniec avoids images that are shocking, and creates works of art that are autonomous and harmonious.

147. Maria "Mucha" Ihnatowicz (b. 1937)

Synowie szeryfa, 1975

Polish poster for the American film

Cahill, United States Marshal (1973)

Lithograph: 85 × 59 cm

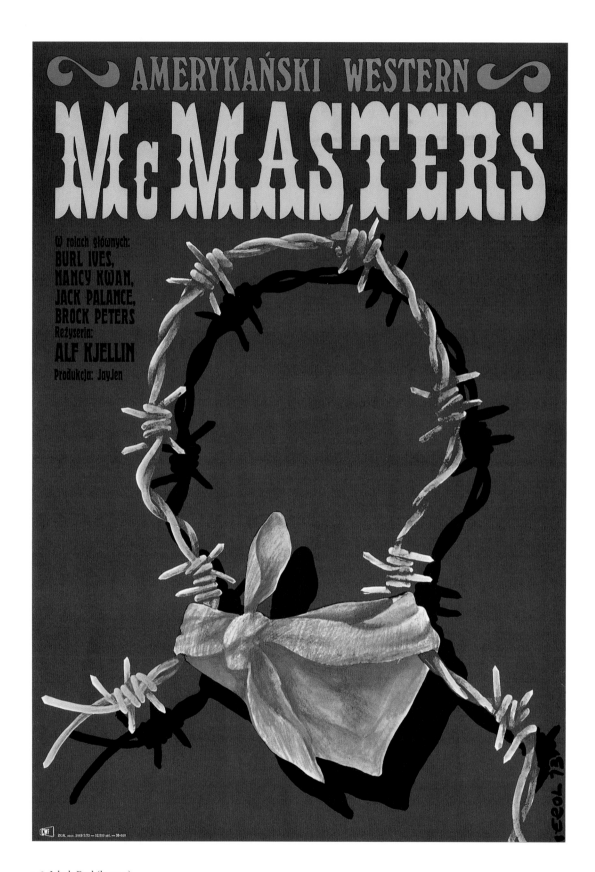

148. Jakub Erol (b. 1941)

McMasters, 1973

Polish poster for the American film

The McMasters (1970)

Lithograph: 84 × 59 cm

149. Tomasz Rumiński (1930–1982)
at work in his studio, circa 1965
Photograph by W. Kryński,
copyright PAI/EXPO

150. Tomasz Rumiński (1930–1982)
Mały wielki człowiek, 1973
Polish poster for the American film
Little Big Man (1970)
Lithograph: 85 × 61 cm

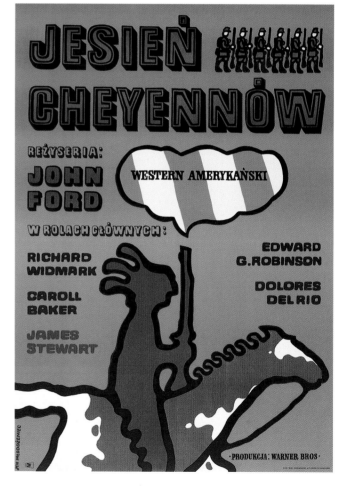

151. Jan Młodożeniec (b. 1929)
in his studio, circa 1980
Photograph by W. Kryński and T. Prażmowski,
copyright PAI/EXPO

152. Jan Młodożeniec (b. 1929)
Jesień Cheyennów, 1970
Polish poster for the American film
Cheyenne Autumn (1964)
Lithograph: 85 × 60 cm

He candidly announces that he is offended when suspected of hidden meanings in his work, though he admits that his work may have intuitive connotations. Color, for Młodożeniec, has mainly an emotional value justified by the overall composition. That is why his creative process is extensive and often encompasses close to forty sketches before the final version appears. As he concedes, the Western is not really the genre that inspires his imagination, but he has always genuinely attempted, sometimes with humor, to express his position on a film while maintaining the distinct character of his artistic language.

John Ford's *Cheyenne Autumn* is an example of a revisionist moral Western that expresses remorse for the extermination of the Indians. The plot of the 1964 film is based on events that took place in 1878. Forcibly settled on an Oklahoma reservation, the terrorized Cheyennes decide to depart for their old hunting grounds in the Dakotas. En route they suffer harassment from soldiers and sustain heavy losses. The dominant figure in the poster by Młodożeniec is an Indian on horseback, holding a rifle. His headdress indicates that he is a warrior. Above him, alongside the title, are six much smaller figures of U.S. Army infantrymen marching in the same direction as he. Although reminiscent of toy soldiers, their larger numbers clearly indicate their advantage, and it may be that the proportions carry a hidden meaning. To quote again from Kandinsky's visual vocabulary, the Indian warrior turned to the right seems poised to travel "home."

The Sand Creek Massacre of 1864 remains one of the most shameful episodes in the conquest of the western territories. This story is told in the violent 1970 film *Soldier Blue*. The victims were again the Cheyennes. Their village was attacked by a detachment of mounted militia during the absence of the warriors, and the assassins carried out a brutal massacre of the women, children, the sick, and the old men. The attack was supposed to be retaliatory, but in fact it was an attempt at pacification. Młodożeniec's anonymous blue-clad soldier is the main motif in the poster. He is visible from the waist down, as if seen by someone on the ground. He is not a hero worth remembering. The butt of his rifle, hanging down and dripping blood, is unequivocally a weapon of death. It was likely used by the cynical murderer as a club with which to kill the victim, suggesting that bullets were "too precious."

Interestingly, the Indian story also appeared in the Western imitations produced in European cinema beginning in the 1960s, mainly by both West and East Germany. The filmmaker relied heavily on the literary and creative output of Karl May and James Fenimore Cooper, even though the accuracy of both authors has been questioned. This acceptance of a romanticized version of history is intriguing, since serious German scholarship has always been interested in the Wild West. The setting of these films was also devoid of any authentic value and limited generally to Spanish plein-air scenery and town fronts built extemporaneously. It was more important to declare one's position on the side of the oppressed and humiliated Indian who, despite the circumstances, demonstrated the moral

superiority of his culture and tradition. We must accept these film creations as intentionally biased.

This orientation was mirrored in the posters. A wonderfully majestic figure of an Indian is presented in Hibner's 1966 poster *Ostatni Mohikanin* (*The Last Tomahawk*, 1965) (plate 153). Stoic and proud, he looks at the viewer with arms folded across his chest. He is wearing a beautifully decorated headdress and, for the first time on a Polish poster, the artist has depicted the man's complexion with red overtones. This type of presentation brings to mind Orthodox icons in which the figure is unmoved, dispassionate, and seeming to belong to eternity. Equally grand is the Indian profile image portrayed by Świerzy in his 1964 poster *Skarb w srebrnym jeziorze* (*Der Schatz im Silbersee*, 1962), which is unquestionably one of the best among the Polish Western posters (plate 154). Heavily stylized and decorative, it is reminiscent of a totem-like sculpture. Another of the more effective works is the 1980 poster by Danuta Bagińska-Andrejew, *Porwany przez Indian*, for the East German film *Blauvogel* (plate 155). With a scream, a rider in a grand headdress gallops toward the viewer.

Wiktor Górka taught art at major universities and institutes in Mexico from 1971 to 1991, and conducted an in-depth study of the history of the pre-Columbian culture. He has told me that his vision of the American Indian had undergone a significant evolution. In the days of his youth, his artistic, abstract notion of America was an image of a boisterous cowboy. If he were asked for an artistic rendition of the topic today, he would certainly use a Native American.

When, at the beginning of the 1980s, Poland was plunged into the darkness of martial law, the American government imposed economic sanctions in an effort to compel respect for democratic values. In response, a magnified propaganda campaign was initiated, aimed at discrediting those ideals that were the essence of American culture. It was also a personal attack on President Ronald Reagan, his acting past, and his "cowboy-like," rowdy lifestyle. In the anonymous 1982 quasi-film poster under the significant title *Świat po Amerykańsku* (*World, the American Style*), Reagan is given credit lines as the director, scriptwriter, producer, and lead character in the film (see plate 44). In a picture taken from a publicity still, Reagan, wearing a cowboy hat and brandishing a revolver, appears as the personification of evil. Yet at the same time, Polish television featured a year-long retrospective of sixty Westerns considered to be the canon. One film was shown each Saturday, the night most people watched TV. In contradiction to the propaganda campaign, American values came riding into Polish homes.

An exceptional double portrait in poster art was produced at that time. Created to resemble a patinated tintype, Świerzy's 1983 poster *Butch Cassidy i Sundance Kid* (*Butch Cassidy and the Sundance Kid*, 1969) seems to be trying to resurrect bygone times (plate 156). These disappearing figures represent the legends of the Western serials. Derived from a typical film still, this type of presentation clearly shows how much emotion its author places in the painterly interpretation of his work, and how great a distance is created between the

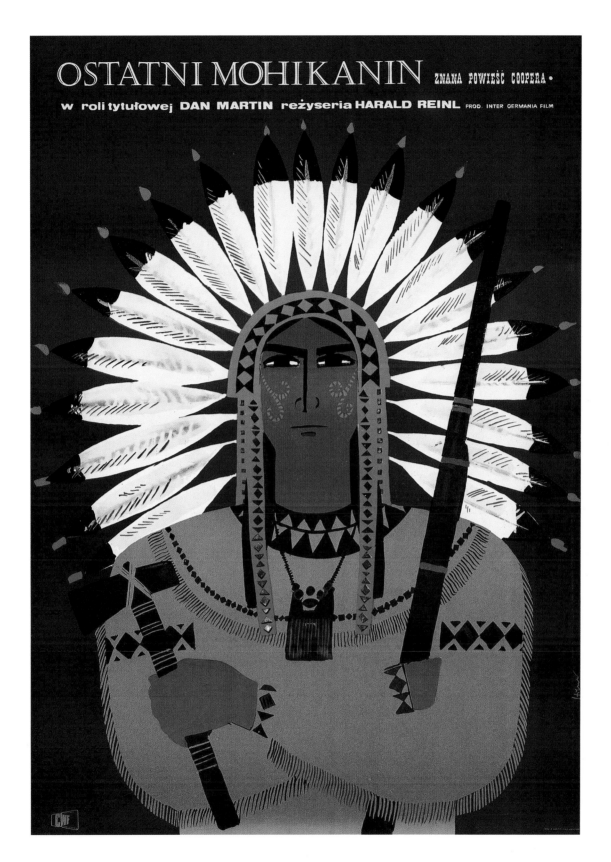

153. Maciej Hibner (b. 1931)

Ostatni Mohikanin, 1966

Polish poster for the West German-Italian-Spanish

co-production *The Last Tomahawk* (1965)

Lithograph: 82 × 58 cm

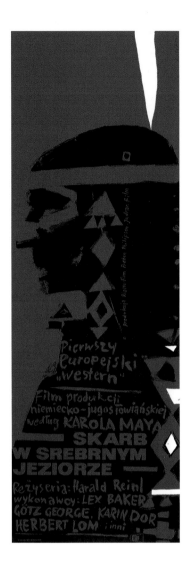

154. Waldemar Świerzy (b. 1931)

Skarb w srebrnym jeziorze, 1964

Polish poster for the West German–Yugoslav
co-production *Der Schatz im Silbersee* (1962),
also released as *The Treasure of Silver Lake*

Lithograph: 85 × 29 cm

155. Danuta Bagińska-Andrejew (b. 1951)

Porwany przez Indian, 1980

Polish poster for the East German film *Blauvogel*

Lithograph: 92 × 67 cm

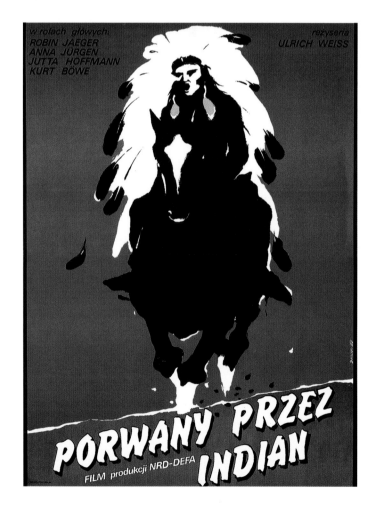

objective, mechanically fixed image and the subjective one that approaches the boundaries of fine art. Andrzej Pągowski designed two posters in 1983 for that same film, one being almost identical to Świerzy's (see plate 74). In the other, he uses the convention of the comic strip to show the typical behavior of the American audiences' favorite cowboys (see plate 73). This naive mannerism renders the atmosphere of the film and its rowdy characters very well indeed. It even gained the approval of such a demanding critic as artist Jan Młodożeniec.

When martial law was lifted and the wave of political emotions subsided, the Western returned to the screens of Polish movie theaters. *High Noon* was shown again in 1987 and a new poster was designed by Grzegorz Marszałek (plate 157). He illustrated the archetypal image of a sheriff about to engage in a gunfight. As the artist explained, "I thought of the loneliness of the hero stealing a glance at his watch, uncertain as to what was about to happen." Two years later, in 1989, the first free and democratic elections took place in Poland. Solidarity representatives encouraged the public to participate by creating a poster that reworked the Marszałek *High Noon* design. Artist Tomasz Sarnecki depicts a triumphantly striding Gary Cooper, who, along with his sheriff's star, wears a Solidarity logo pinned to his vest (see plate 42). The logo is repeated in large letters over the top of the background. He is holding his most formidable weapon, a voting card. The title of the poster was of course *High Noon*, supplemented with the election date. It was received enthusiastically by the public, not only because of sentiment for the almost mythical hero, but also because of the moral implications he personified. No one thought of his lack of internal resolution and doubts. The poster artist had no question about what was to take place. He predicted the inevitable fall of evil, personified by the epoch of the ancien régime. It was also an appeal to a shattered society, steeped in a state of entropy and sentenced to a life of fear and vegetation. Both the artists and the general public agree that Sarnecki's artistic debut stands as one of the most important images of the recent political past in Poland (figure 7).

Today, the nostalgic Western has yielded to the brutal action film. In most cases, the ancient battle between good and evil is modified and depleted of the naive plot constructions of more traditional works. While in the past it was enough to show the act of death without emphasizing the technology of inflicting pain, evil is now presented in an almost anatomical way. Symptomatic of this trend is the escalation of violence reflected in the terrifying criminal statistics also found in Poland. More and more, when the contemporary imported visual culture of Western Europe and the United States is placed under the critical scrutiny of public opinion, it is found to be a source of evil and a cause of demoralization. The Polish film poster succumbed to the same law of mimicry. It again became only a tool of advertising, and a poor tool at that. The difference between posters of domestic and foreign origin became indistinguishable. The Polish poster renounced its own past and legend. Today it usually serves only as an attractive photographic effect— an icon of mass media, universal in the cultural sense and global in the artistic sense, but

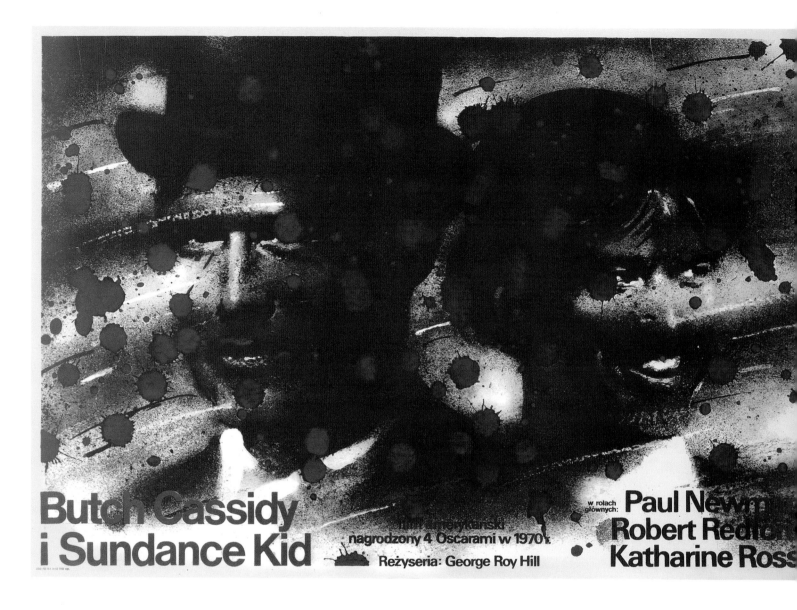

156. Waldemar Świerzy (b. 1931)

Butch Cassidy i Sundance Kid, 1983

Polish poster for the American film

Butch Cassidy and the Sundance Kid (1969)

Lithograph: 97 × 67 cm

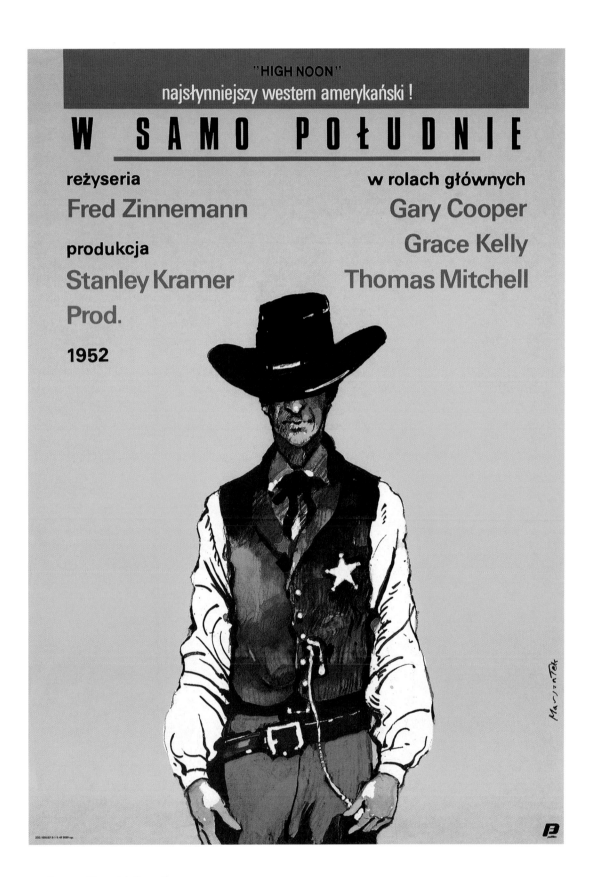

157. Grzegorz Marszałek (b. 1946)

W samo południe, 1987

Polish poster for the American film

High Noon (1952)

Lithograph: 96 × 68 cm

Fig. 7. On the eve of balloting during the 1989 elections,

Solidarity posters appeared all over Poland.

Photograph copyright Erazm Ciołek

in truth neutral and indistinct. Erol's 1986 *Niesamowity jeździec* (*Pale Rider*, 1985) is a good example of the decline of the Polish poster (plate 158). It is but a shadow of his earlier work. The Western poster has disappeared from the streets of Polish cities, probably forever. No one publishes posters for older films. An attempt at a poetic interpretation is a rarity now. One rare example is the 1991 poster *Tańczący z Wilkami* (*Dances with Wolves*, 1990), by Pągowski, who reconnects with the tradition of the "Polish school" through a metaphor (plate 159). It may be the last of its kind.

And not much remains of the romantic legend of the Western. The problem of westernization has appeared instead. Visual culture is the most noticeably infected area. During his frequent returns to Poland, Szymon Bojko, a lecturer at the Rhode Island School of Design since 1984, warns us of the violence committed with our permission in the Polish cultural sphere. His apprehensions are shared by the artistic community, which at present seems to be devoid of any means of preventing its spread.

At the beginning of the history of cinema, when the first Westerns were created, the good had to win. At the end of the millennium, it is evil that fascinates us and has the upper hand. Evil is seen as a necessary part of human nature, and at a time of moral relativism, it can be liberated and displayed in its full glory. Is it a symptom of the crisis of consciousness at the end of the millennium? Is it a sign of the devaluation of positive values? Or is it simply a commercial strategy of the dream factory, an industry geared for profit that manipulates the market and the dialectics of anticipation, to the delight of the people?

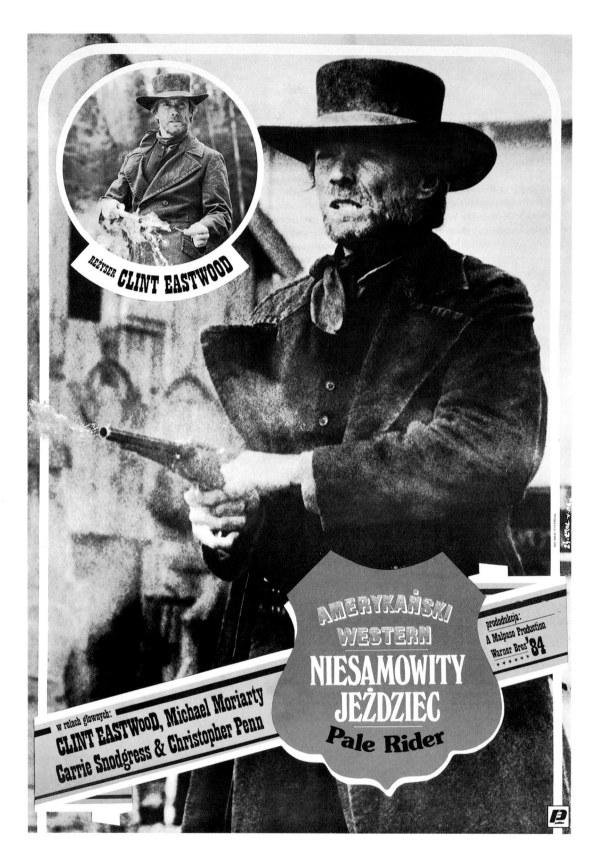

158. Jakub Erol (b. 1941)

Niesamowity jeździec, 1986

Polish poster for the American film

Pale Rider (1985)

Lithograph: 98 × 68 cm

159. Andrzej Pągowski (b. 1953)

Tańczący z Wilkami, 1991

Polish poster for the American film

Dances with Wolves (1990)

Lithograph: 67 × 98 cm

ARTISTS' BIOGRAPHIES

Compiled by Frank Fox

BAGIŃSKA-ANDREJEW, DANUTA, 1951–

Graduated from the Warsaw Academy of Fine Arts, 1975. Concentrated on graphic art and design, and posters. Participated in many group exhibitions. Designed a Western poster 1980. Living in Holland in 1993.

BERTRANDT, ANDRZEJ, 1938–

Graduated from the Warsaw Academy of Fine Arts, 1963. Excelled in graphic arts and designed posters. Took part in many group exhibitions. Designed Western posters 1970–72. His work was featured in *Projekt*, 1974.

BOBROWSKI, ZYGMUNT (OR ZDZISŁAW), 1932–

Born in Paris. Graduated from the Warsaw Academy of Fine Arts, 1960. Designed a Western poster 1970.

BODNAR-KACZYNSKA, HANNA, 1929–

Graduated from the Warsaw Academy of Fine Arts, 1955. Studied under Józef Mroszczak, majoring in graphic design and posters. Took part in more than a dozen group exhibits and was known for her film posters. Awarded the Toulouse-Lautrec prize in Paris, 1962. Designed a Western poster 1975.

BOWBELSKI, ADAM, 1903–1968

Born in Vladivostok. Studied architecture at Warsaw University 1924–28, and at the

Academy of Fine Arts under Edmund Bartłomiejczyk, 1930–32. Excelled in book design, interior architecture, and, after 1929, poster design. Member of the organization of graphic designers (KAGR) 1934–39. Grand Prix winner at the International Exposition of Arts and Technique in Paris, 1937. Participated in exhibits in Prague, 1934, Paris, 1937, Moscow, 1954, and Rome and London, 1956. Exhibited in West Berlin, 1966. Designed a Western poster 1957.

CIEŚLEWICZ, ROMAN, 1930–1996
Born in Lwów. Graduated from the Kraków Academy of Fine Arts, 1954. Designed a Western poster 1957. Awarded the Trepkowski Prize, 1955. Grand prize winner in the International Film Festival, 1964. City of Warsaw first prize at the 1st International Poster Biennale, Warsaw, 1966, and Gold Medal winner at the 2nd All-Poland Poster Biennale, 1967. Gold Medal 4th International Poster Biennale, Warsaw, 1972. Grand Prix winner for poster art, Paris, 1979. Grand Prix winner National d'art graphique, 1990. Known for photo montage and collage style.

CZARNECKI, ZBIGNIEW, 1948–
Born in Opole. Graduated from the Warsaw Academy of Fine Arts, 1974. Studied under Henryk Tomaszewski. Designed a Western poster 1975.

DĄBROWSKI, ANDRZEJ ONEGIN, 1934–1986
Born in Radom. Graduated from the Warsaw Academy of Fine Arts, 1961. A student of Henryk Tomaszewski, he designed numerous posters and was admired for his clear-cut designs. Designed Western posters 1966, 1975.

EROL, JAKUB, 1941–
Born in Zamość. Graduated with distinction from the Warsaw Academy of Fine Arts, 1968. Studied under Henryk Tomaszewski. Excelled in graphics, stage design, and posters. Designed Western posters 1970–78, 1986. Single-artist exhibit in Aachen, 1972. Trepkowski prize winner, 1970. Prize at the 5th Biennale of Polish Posters at Katowice, 1973.

FANGOR, WOJCIECH, 1922–
Born in Warsaw. Graduated from the Warsaw Academy of Fine Arts, 1946. Designed a Western poster 1957. Known for his paintings, interior architecture, display design, graphics, and posters. One-man shows in Warsaw, 1948, 1957. Received the State Prize, 1952. Took part in numerous group exhibits. Living in the United States in 1999.

FLISAK, JERZY, 1930–
Born in Warsaw. Graduated from the department of architecture at the Polytechnic Institute, 1953. Honorary mention for posters at the New York Art Directors Club. Won

the Second Degree Prize in the field of satire awarded by the Minister of Culture and Art, 1963. Known for his cartoon style, and took part in television productions. Prolific designer of Western posters during the twenty-year period 1958–78.

FREUDENREICH, MAREK, 1939–
Born in Poznań. Graduated from the Warsaw Academy of Fine Arts, 1963. Studied under Henryk Tomaszewski. Designed Western posters 1963, 1975. Winner of the Trepkowski prize, 1966. First Prize winner at the Film Biennale at Ljubljana, 1967. Silver Medal winner at the International Poster Exhibition in Sofia, 1968. Golden Plaque winner, Art Directors' Club, New York, 1974. *Hollywood Reporter* Award winner, Los Angeles, 1975. He has lectured at the Warsaw Academy of Fine Arts. Living in Austria in 1993.

GÓRKA, WIKTOR, 1922–
Born in Komorowice. Graduated from the Kraków Academy of Fine Arts, 1951. Designed Western posters 1965–69, 1973. Winner of the second prize at the International Poster Exhibition in Karlovy Vary, 1964. Awarded a prize at the Internationale Buchkunst Ausstellung, Leipzig, 1965. Prizewinner for the best advertising poster of the year, Warsaw, 1966. First prize winner at the International Exhibition of Tourism Posters in Milan, 1967. Prize for the best poster of the year in the category of cultural posters, Warsaw, 1968. Has had single-artist exhibits in Vienna, 1961, and Mexico City, 1970. Taught art in Mexico, 1971–91.

HIBNER, MACIEJ, 1931–
Born in Warsaw. Graduated from the Warsaw Academy of Fine Arts, 1955. Studied under Józef Mroszczak. Known for his poster, book, magazine, and industrial designs. Designed Western posters 1965–68. Has participated in many group exhibits.

IHNATOWICZ, MARIA "MUCHA," 1937–
Born in Brześć-on-the-Bug. Graduated from the Warsaw Academy of Fine Arts, 1963. Studied under Henryk Tomaszewski. Known for her poster and book designs. Designed Western posters 1968–77. Admired for the lyricism in her poster work. Has participated in numerous group exhibits, and been a subject of many articles.

JANOWSKI, WITOLD, 1926–
Born in Warsaw. Graduated from the department of architecture at the Warsaw Polytechnical Institute, 1950. Designed Western posters 1963–67. Prizewinner for the Best Poster of the Year, 1961. Prizewinner for the best graphic calendar, India, 1963. First prize winner for a tourism poster in Moscow, 1964. His designs are noted for a clean-cut style.

JAWOROWSKI, JERZY, 1919–1975

Born in Augustów. Completed studies at the Warsaw Academy of Fine Arts, 1955. Specialized in drawing, painting, and poster designs. Designed a Western poster 1962. One-man show in Montreal, 1963, and Warsaw, 1970. Took part in numerous poster competitions, such as Polish Contemporary Graphics 1900–1960, in 1960, The Theater and Film Poster in the Twentieth Century, 1964, Polish Film Poster 1947–67, 1969 in Poznań, and exhibits in West Berlin, Paris, London, Ottawa, and The Hague.

KARCZEWSKA, JOLANTA, 1933–

Born in Warsaw. Graduated from the Warsaw Academy of Fine Arts, 1955. A student of Henryk Tomaszewski, she specialized in poster design. Designed a Western poster 1965. Known for a distinctive humorous style and ideas drawn from contemporary sources.

KRAJEWSKI, ANDRZEJ, 1933–

Born in Poznań. Graduated from the Warsaw Academy of Fine Arts, 1963. Studied under Henryk Tomaszewski. Known for his posters, book and magazine designs, and satirical drawings. Designed Western posters 1967, 1973. One critic complimented his assimilation of new trends in modern painting into visual advertising. Has taken part in numerous group exhibitions.

KRÓLIKOWSKI, KAZIMIERZ, 1921–1994

Graduated from the Kraków Academy of Arts, 1954. Designed a Western poster 1967.

KRZYSZTOFORSKI, ANDRZEJ, 1943–

Born in Oświęcim. Graduated from the Warsaw Academy of Fine Arts, 1968. Designed a Western poster 1983.

LIPIŃSKI, ERYK, 1908–1991

Born in Kraków. Graduate of the Warsaw Academy of Fine Arts, 1939. Excelled in cartoon illustration, stage design, and posters. Designed a Western poster 1947. Award winner at the International Poster Exhibition, Vienna, 1948. Took third prize at the International Film Poster Exhibition, Vienna, 1965. Described by one critic as having "the gift of observation when it comes to the humorous layer in things, people and situations," he was often praised for "an ingenious graphic joke, sometimes with a metaphorical meaning."

MAJEWSKI, LECH, 1947–

Born in Olsztyn. Graduate of the Warsaw Academy of Fine Arts, 1972. Studied under Henryk Tomaszewski, and is on the faculty of graphic arts. Has excelled in posters,

illustration, and typography. Designed a Western poster 1980. Bronze Medal winner at the Polish Poster Biennale, Katowice, 1977, and Grand Prix and Silver Medal winner, 1983. A professor at the Academy of Fine Arts, he has taken part in numerous group exhibitions.

MARSZAŁEK, GRZEGORZ, 1946 –
Born in Świnna. Graduate of the State College of Visual Arts in Poznań, 1971. Currently teaches there in the Illustration and Typography Studio. Works in posters, illustration, graphic art, and publication design. Silver Medal Award winner at the Biennale of Graphic Design, 1978, and Silver Medal winner at the Polish Poster Biennale, Katowice, 1979. Has had single-artist exhibitions in Poland 1977, 1979, 1980, 1982, 1983, Toronto (Canada) 1980, and Utrecht (Netherlands), 1981. Designed Western posters 1984, 1987.

MŁODOŻENIEC, JAN, 1929 –
Born in Warsaw. Graduated from the Warsaw Academy of Fine Arts, 1955. Designed Western posters in the 1970s and 1989. Prizewinner for the best poster of the year in advertising, 1965, and for cultural posters, 1966. Silver Medal winner at the Internationale Buchkunst Ausstellung, 1971, Gold Medal winner at the 8th International Poster Biennale, Warsaw, 1980, and Gold Medal winner at the 5th International Poster Biennale at Lahti, 1983. Numerous single-artist exhibitions in Poland and in Austria, Czechoslovakia, the German Democratic Republic, Sweden, and West Germany.

NEUGEBAUER, JACEK, 1934 –
Born in Sosnowiec. Graduated from the Warsaw Academy of Fine Arts, 1959. Studied under Henryk Tomaszewski. Has specialized in poster, book, and magazine designs and participated in numerous group shows. Designed Western posters 1967–74.

PĄGOWSKI, ANDRZEJ, 1953 –
Graduated from the State College of Visual Art in Poznań, 1978. Studied under Waldemar Świerzy. Designed Western posters 1981, 1983, 1991. *Hollywood Reporter* Award winner, Los Angeles, 1986. Has had many single-artist exhibitions in Europe, including Stockholm, London, and Paris. Known for his prolific poster output, Pągowski has his own commercial studio in Warsaw and attracts an international clientele by means of the Internet. Designed the last original Polish poster for a Western in 1991.

PROCKA-SOCHA, ELŻBIETA, 1947 –
Graduated from the Warsaw Academy of Fine Arts, 1972. Known for her posters, paintings, graphic art designs, and illustrations. Designed a Western poster 1978. Has taken part in numerous group exhibitions.

RUMIŃSKI, TOMASZ, 1930–1982
Born in Zwierzyniec Lubelski. Graduated from the Warsaw Academy of Fine Arts, 1956.
Designed a Western poster 1973. *Hollywood Reporter* Award winner, Los Angeles, 1975
and 1977.

SARNECKI, TOMASZ, 1966–
Designed the Solidarity *High Noon* poster 1989.

SAWKA, JAN, 1946–
Born in Zabrze. Graduated from the architecture department of the Wrocław Polytechnic.
Attended the State College of Visual Arts in Wrocław. Known for his painting, drawing,
prints, illustration, stage design, sculptures, and posters. Designed a Western poster 1975.
Received the Gold Medal at the 7th International Poster Biennale, Warsaw, 1978.

STACHURSKI, MARIAN, 1931–1980
Born in Lazy. Graduated from the Warsaw Academy of Fine Arts, 1956. Studied under
Henryk Tomaszewski. Specialized in posters, drawings, book design, magazine, and
television production designs. Designed Western posters 1958–70. Participated in
numerous group shows. Many of his works originate in folk art, or as one critic put it,
"in a world of fairground pictures."

STRYJECKI, MAURYCY, 1923–
Studied at the Warsaw Polytechnical Institute, division of architecture, 1952–54. Designed
a Western poster 1966.

ŚWIERZY, WALDEMAR, 1931–
Born in Katowice. Graduated from the Kraków Academy of Fine Arts (Katowice Branch),
1951. Designed Western posters 1961–83. Trepkowski Prize winner, 1956, Toulouse-Lautrec
prize, Paris, 1959, and Best Poster of the Year prize, 1961. Gold Medal winner, 1st All-
Poland Poster Biennale, 1965. Prizewinner for the Best Poster of the Year in cultural
posters, 1968. Gold Medal winner, 6th International Poster Biennale, Warsaw, 1976, and
First Prize at the 2nd International Poster Biennale, Lahti, 1977. *Hollywood Reporter* Award
winner, Los Angeles, 1975 and 1985. Has had numerous single-artist exhibitions in Poland,
Austria, Brazil, Holland, and elsewhere.

SYSKA-DĄBROWSKA, MARIA, 1932–
Graduated from the Warsaw Academy of Fine Arts, 1957. Designed a Western poster 1965.

TERECHOWICZ, MARIAN, 1933–
Designed Western posters 1982–84.

TOMASZEWSKI, HENRYK, 1914–

Studied at the Warsaw School of Industrial Printing. Graduated from the Warsaw Academy of Fine Arts, specializing in commercial art, satirical illustrations, and stage design. Since 1938, he has devoted himself to poster design. He was appointed professor at the Warsaw Academy, and became highly influential there. Many of his students became leading poster artists in Poland. Designed a Western poster 1947. Member of the Alliance Graphique Internationale. Honorary member of Royal Designers for Industry. Winner of five gold medals, International Film Poster Exhibition, Vienna, 1948. First prize winner, 7th Biennale, São Paulo. Gold Medal winner, Internationale Buchkunst Ausstellung, Leipzig, 1965. Gold Medal winner 3rd and 12th International Poster Biennale, Warsaw, 1970, 1990. First Prize, Colorado International Poster Exhibition, 1981. Winner of the special prize of the ICOGRADA (International Council of Graphic Design). He has taken part in numerous single-artist and group exhibitions. One critic has cited his work for its "dadaistic humor" and for its "lightness and vitality," his "hand-written letters . . . [providing] a note of intimacy."

TREUTLER, JERZY, 1931–

Born in Beszyn. Graduated from the Warsaw Academy of Fine Arts, 1955. Studied under Professor T. Kulisiewicz. Has practiced applied art, book design, advertising, and poster art. Designed Western posters 1962–72.

WASILEWSKI, MIECZYSŁAW, 1942–

Graduated from the Warsaw Academy of Fine Arts and specialized in graphic design and illustration. Became a professor of poster design. Designed Western posters 1975, 1979. Gold Medal winner at the 6th International Poster Biennale, Warsaw, 1976, Silver Medal winner, 1994, and Silver Medal winner at the Polish Poster Biennale, Katowice, 1989. Has had numerous single-artist exhibitions in Poland.

WENZEL, WOJCIECH, 1925–

Completed studies in the graphics department at the Warsaw Academy of Fine Arts in 1955, working under Henryk Tomaszewski. Studied film animation, painting, and poster design. Designed a Western poster 1959. Took part in many poster exhibitions, including Theater and Film Posters in the 20th Century, 1964, and Polish Film Poster, 1947–67, 1969 in Poznań. Has had many exhibitions abroad, including Budapest, 1956, and West Berlin, 1966.

WIERZCHOWIAK, JULIAN

Designed a Western poster 1962.

ZAGÓRSKI, STANISŁAW, 1933 –

Born in Warsaw. Graduated from the Warsaw Academy of Fine Arts, 1967. Specialized in book illustration and graphic art. Received many prizes for posters, including two awards of the Trepkowski Prize, 1960 and 1961. Designed a Western poster 1970.

ZAMECZNIK, STANISŁAW, 1909 – 1971

Born in Warsaw. Graduated from the Warsaw Polytechnical Institute, division of architecture, 1949. Known for his architectural work, stage and book designs, illustration, and posters. His works have been exhibited in many shows, both in Poland and abroad. Designed Western posters 1963, 1967.

ŻBIKOWSKI, MACIEJ, 1933 –

Born in Przasnysz. Graduated from the Warsaw Academy of Fine Arts, 1960, following studies at Wrocław and Prague. Occupied himself with graphics, satirical drawings, and posters. Designed Western posters 1967–74. Prizewinner, 1979, for the best Polish poster for a Russian film, *Słoneczny Pył* (*Radioactive Dust*).

ZELEK, BRONISŁAW, 1935 –

Born in Nastaszow. Graduated from the Warsaw Academy of Fine Arts, 1961. Studied under Henryk Tomaszewski. Trepkowski Prize winner, 1967. Best Poster of the Year prizewinner in the category of political posters, Warsaw, 1968. Designed a Western poster 1970. Lecturer at the Warsaw Academy of Fine Arts.

SUGGESTED READING*

Compiled by Marva Felchlin

BOCZAR, DANUTA A. "The Polish Poster." *Art Journal* 44 (1984): 16–27. Traces the development of the Polish poster from its late nineteenth-century beginnings to the Solidarity posters. Illustrated.

Contemporary Polish Posters in Full Color. New York: Dover Publications, 1979. Consists of 46 color illustrations, selected and introduced by Joseph S. Czestochowski. Also includes biographies of the artists.

DYDO, KRZYSZTOF. *Mistrzowie polskiej sztuki plakatu* (*Masters of Polish poster art*). Polish-German-English edition. Bielsko-Biala: Buffi, 1995.

———, ed. *Polski plakat filmowy: 100-lecie kina w Polsce, 1896–1996* (*Polish film poster: 100th anniversary of the cinema in Poland, 1896–1996*). Polish-English edition. Kraków: Krzysztof Dydo, 1996. A history of the Polish film poster including essays by art historians, museum curators, and collectors; a bibliography; and over 800 color illustrations.

———, ed. *100 lat polskiej sztuki plakatu* (*100th anniversary of Polish poster art*). Polish-English edition. Kraków: Biuro Wystaw Artystycznych, 1993. This exhibition

* Only English language sources, or those containing English translations of the text, are included. For works in Polish, see the essay endnotes and the bibliographies in the sources listed.

catalog includes essays, color illustrations, artists' biographies, a bibliography, and a list of exhibitions.

FOX, FRANK. "Polish Posters." In Tony Fusco, ed., *Posters: Identification and Price Guide.* 2d ed. New York: Avon Books, 1994.

HUSARSKA, ANNA. "Post No Bills: Polish Artists Mourn Their Good Life Under Communism." *New Yorker* 69 (January 10, 1994): 62–65.

MILLIE, ELENA and ZBIGNIEW KANTOROSINSKI. *The Polish Poster: From Young Poland Through the Second World War.* Washington, D.C.: Library of Congress, 1993. Checklist of 136 of the approximately 3,000 Polish posters in the collection of the Prints and Photographs Division, Library of Congress. Includes biographical notes and a select bibliography.

MUZEUM PLAKATU W WILANÓWIE. *Muzeum ulicy: plakat polski w kolekcji.* Polish-English edition. Warsaw: Krupski I S-ka, 1996. Features over 300 posters from the Poster Museum in Wilanów, essays by its curators, and a list of medal winners at the International Poster Biennale in Warsaw, 1966 through 1994.

Poster Art in Poland, 1899–1978. Maryland Institute, College of Art, 1978. Exhibition catalog.

Polish Posters: Combat on Paper, 1960–1990. Katonah, N.Y.: Katonah Museum of Art, 1996. Catalog of the exhibition with an essay by Frank Fox.

WEILL, ALAIN. *The Poster: A Worldwide Survey and History.* Boston: G. K. Hall, 1985. Includes a chapter by Frank Fox devoted to postwar Polish posters.

ACKNOWLEDGMENTS

WESTERN AMERYKAŃSKI IS THE RESULT OF THE contributions of many individuals and organizations. At the Autry Museum, Joanne Hale, president and chief executive officer, had the vision and courage to support the building of the collection and the development of the book and exhibition. James Nottage, vice president and chief curator, provided valuable encouragement and counsel. Marva Felchlin, assistant director of the research center, organized the book's photography, provided editorial assistance, wrote the Polish poster captions, compiled the reading list, and served as an important link with our Polish contributors and consultants. Marva also is the project manager of the exhibition this book accompanies. Suzanne G. Fox, publications director, provided solid critiques of the essays and prepared the manuscript for publication. Leah Arroyo, research associate, unearthed some fascinating material for "The Western Worldwide." Kimberly Balcom, who has since left the museum, cataloged most of the posters.

The contributors to the book, Ed Buscombe, Frank Fox, Mariusz Knorowski, and Aneta Zebala, made a great team and have been a joy to work with. They have proven diligent, responsive, and united in the sense that they are contributing to something important. Susan Einstein produced the photography of items from the Autry Museum collection. Piotr Dąbrowski identified Polish artists and dated the posters.

Paweł Potoroczyn, consul, Consulate General of the Republic of Poland in Los Angeles, provided encouragement, leadership, support, and contacts for the project. John Bowlt, professor in the Slavic Studies department at the University of Southern California, and Elena Millie of the Prints and Photographs Division, Library of Congress, helped

identify and locate consultants. Teresa Bablok of the Polish Press Agency (PAP), Warsaw; Grzegorz Balski of the Filmoteka Naradowa Archives, Warsaw; Paul Fees and Elizabeth Holmes of the Buffalo Bill Historical Center; Mac McClelland of Brandt, McClelland, Vanoy and Partners, San Francisco; and Grazyna Rutkowska of PAI Expo Archives (Polish Information Agency), Warsaw, located and facilitated the use of imagery.

For assistance with "The Western Worldwide," the authors thank William Boddy, Deniz Göktürk, Alex Gordon, Ishikuma Katsumi, Stefan Kloo, Colin McArthur, Ann Miller, Don Reeves, Markku Salmi, Dorothy Sloan, Savio De Souza, Peter Stanfield, William Uricchio, Tise Vahimagi, and Elizabeth Wallenius. Tomasz Magierski provided Frank Fox with video on Jósef Kłyk and his Kiełbasa Westerns. Mariusz Knorowski and Aneta Zebala thank Piotr Dąbrowski; Krzysztof Dydo, owner of Poster Gallery, Kraków; Edmund Lewandowski, of Visual Studio, Warsaw; and Antoni Mathias. Special appreciation is expressed to the poster artists Wiktor Górka, Jan Młodożeniec, and Waldemar Świerzy for their cooperation and insights.

Grant Underwood helped the museum build its collection on Westerns in a worldwide perspective. Other dealers and collectors who have assisted the museum in acquiring outstanding Polish posters include Piotr Dąbrowski and Agnieszka Kulon, owners of Galeria Plakatu "The Art of Poster" in Warsaw; Frank Fox; John Hazelton, Mineola, New York; John Kisch, owner of Separate Cinema, Hyde Park, New York; Richard Koszarski, New York City; Sam Sarowitz, owner of Posteritati movie poster gallery, New York City; and Judy Sullivan, owner of the Eastern European Art Company, Carbondale, Colorado.

This catalogue has been made possible in part through the generous support of Lot Polish Airlines and Ed and Zee Marzec.

CONTRIBUTORS

EDWARD BUSCOMBE, former head of publishing at the British Film Institute in London, is an independent writer and teacher, most recently at Middlebury College, Vermont, and at Southampton Institute in England. Buscombe is the editor of *The BFI Companion to the Western* and wrote the volume on *Stagecoach* in the BFI Film Classics series. His most recent book is *Back in the Saddle Again: New Essays on the Western* (1998), edited with Roberta Pearson. Buscombe serves as co-editor of the Autry Museum–Indiana University Press series "The Western and Its Contexts."

MARVA FELCHLIN is assistant director of the research center at the Autry Museum of Western Heritage. She received her Master of Library Science degree from UCLA in 1982 and worked in academic and public libraries before joining the Autry Museum in 1993.

FRANK FOX came to the United States from his native Poland in 1937. A professor of Eastern European history, he has exhibited his collection of Polish posters in Philadelphia and New York. He has visited Poland on many occasions to conduct research and interview poster artists, and has written extensively on the Polish poster for such publications as *Affiche*, *Print*, *The World & I*, and the *Poster Quarterly*. He contributed a chapter on the Polish poster in Tony Fusco's *Posters* (2d ed., 1994), the definitive reference for poster collectors. He recently edited and translated from Polish the diary of a Jewish Ghetto policeman, published as *Am I a Murderer? Testament of a Ghetto Policeman* (1998). In June 1998, Fox addressed a symposium on "The Contemporary Poster and Creation of

New Symbols" at Poland's National Museum in Warsaw to celebrate the thirtieth anniversary of the Polish Poster Museum in Wilanów.

MARIUSZ KNOROWSKI is the international programs coordinator at the Center of Polish Sculpture in Oronsko. From 1985 to 1997 he served as curator of the Polish Poster Museum in Wilanów. Knorowski's expertise includes visual communication, advertising, graphic design, and the history of commercial art. He was a consultant and adviser on the international Poster Bibliography Project and for the Library of Congress's *The Polish Poster: From Young Poland Through the Second World War* (1993). Knorowski has curated exhibitions in Poland and Japan and serves on the organizing committee and program council of the International Poster Biennale in Warsaw. He has lectured and published widely in the field of Polish poster art.

KEVIN MULROY is director of the research center at the Autry Museum of Western Heritage. He is the author of the award-winning *Freedom on the Border: The Seminole Maroons in Florida, the Indian Territory, Coahuila and Texas* (1993) and a co-editor (with Lawrence de Graaf and Quintard Taylor) of *Seeking El Dorado: African Americans in California, 1769–1999*, to be published in 2000 by the University of Illinois Press in association with the Autry Museum. Mulroy serves as co-editor of the Autry Museum–Indiana University Press series "The Western and Its Contexts."

ANETA ZEBALA is a paintings conservator in Santa Monica, California. Educated at the Academy of Fine Arts in Kraków, she left Poland in 1981 to receive training at the Art Institute of Chicago and the Harvard University Art Museums. Zebala is active in professional associations focusing on the art and architecture of Eastern Europe, and retains strong links with her native Poland. She has taught and published on international conservation issues, and on the Russian and Polish avant-garde.

INDEX